W9-BHI-453

their basket-making to take me down to the blueberry barrens in Maine. Leslie gave me wild rice and homemade maple syrup. Marvin gathered cedar for me. Lorene's words were a gift that helped me keep going. Zane and Sandy made me feel at home. Marcus introduced me, advised me, drove me. Everywhere people took time to welcome me, to tell me their stories.

I listened to the local rez radio stations in the car. Country music, rodeo announcements, traditional singing, tribal council meetings. I listened to laughter everywhere. I listened to the wind, to the quiet, to the singers at the all-night ceremonies. The hogan was so beautiful in the dawn light. My camera was in the ceremonial basket during the Blessingway Laugher's Grandson sang over me.

Everywhere people talked to me about respect and tradition and language, about family and community and responsibility. John spoke about reality. Annie sang about spirit. Bently talked about pride and grief and hope. Norman talked about pain and healing. Leonard talked about raising his grandchildren from prison, and instilling pride in young people. Birgil reminded me that the Lakota never surrendered. Everywhere people know who they are.

The children buried in the cemetery from the boarding-school days at Haskell are still weeping. We cried with them. Before the victims of the Sand Creek Massacre were reburied after finally being returned by the museums, the women elders cradled in their arms the fetal skeletons that had been torn from their mothers' wombs because they'd never been held. After the kids of Anvik danced and sang to honor their repatriated ancestors, the brightest double rainbow any of us had ever seen positioned itself over the village for twenty minutes. Everyone stood outside and gradually stopped talking and just watched it.

Ralph told me that as the buffalo herd grows, the people become stronger.

Dawson had a dream that Custer was asking for forgiveness.　　—Gwendolen Cates

GWENDOLEN CATES

INDIAN COUNTRY

Grove Press

New York

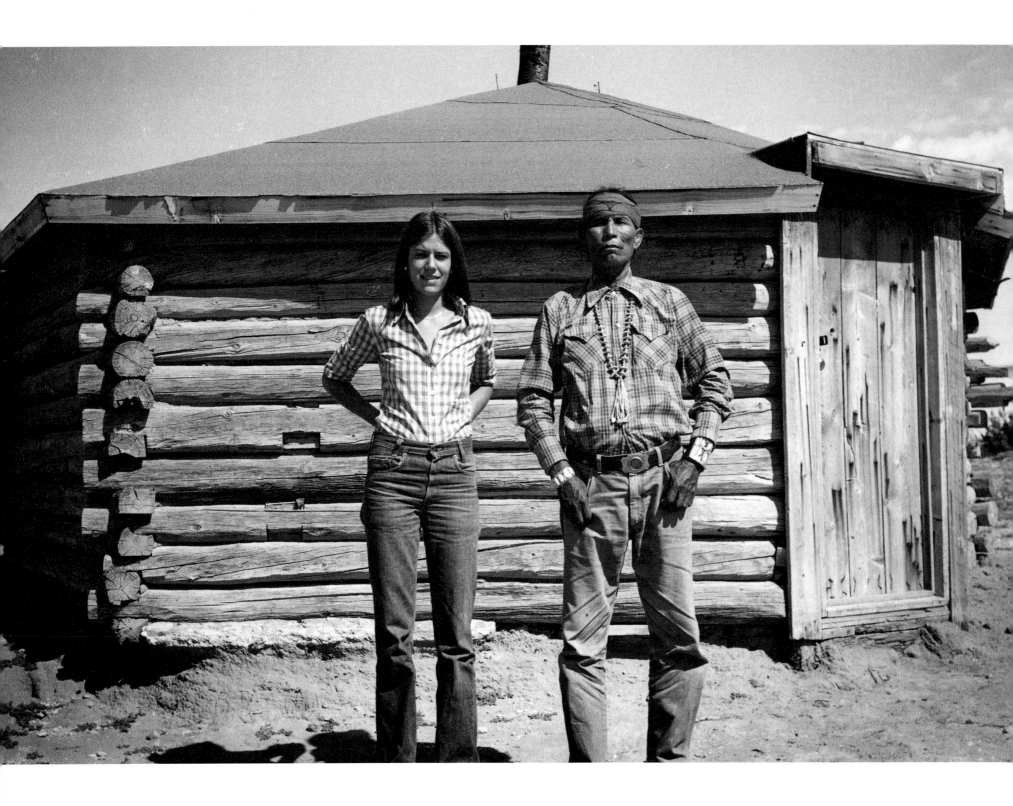

In memory of
Laugher's Grandson
1893–2000

'Ahe'hee' Shicheii

volution journey

gift of life

weaving the future

children of earth

carrying light

descendant lineage

the people the land

DNA memories

spirit travelers

bringing the past

living through

reality and image

the human beings

prayers and dreams

tending the present

John Trudell

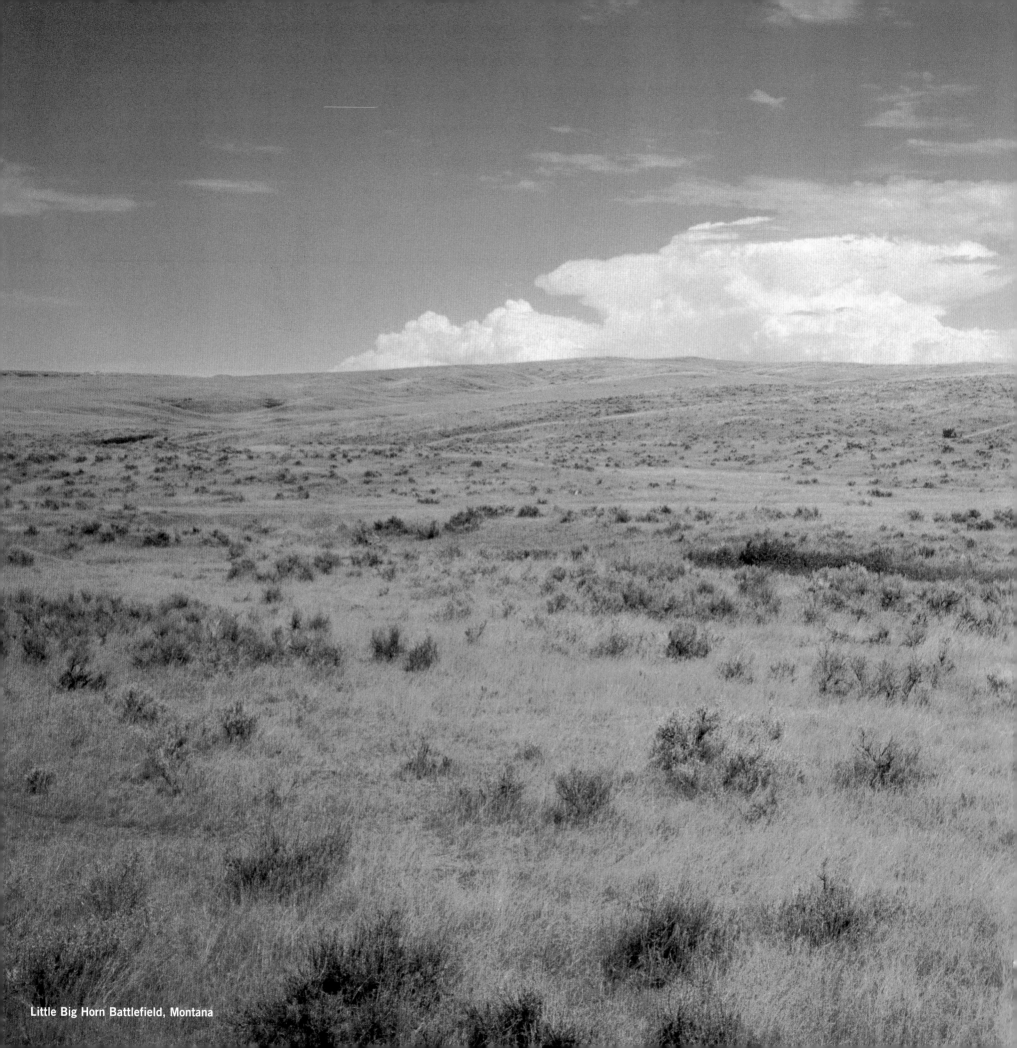

Little Big Horn Battlefield, Montana

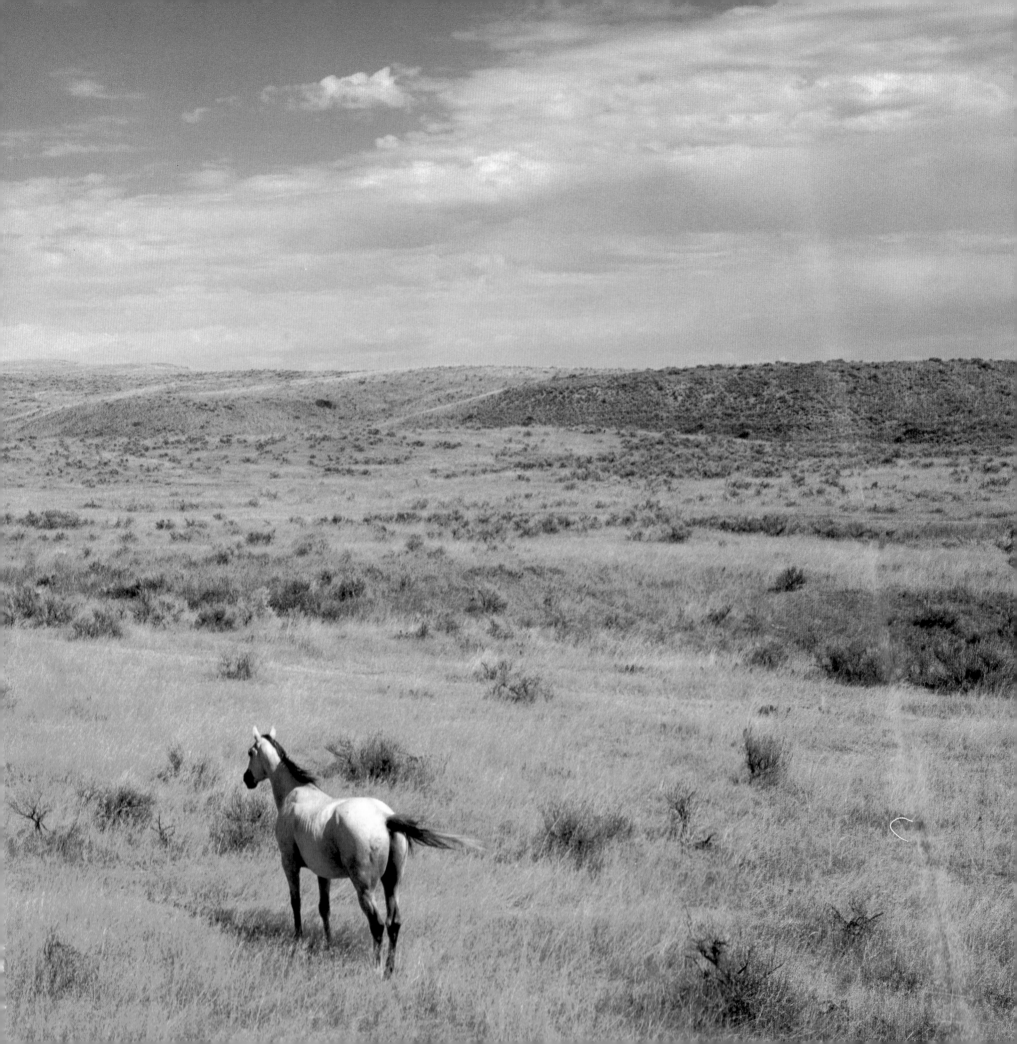

As I write this, I'm studying three photographs tacked to the wall above my desk.

In the first photo, my little brother James stands splay-legged and shocked, his eyes and mouth wide open, his arms flung out at amusing angles. One moment before that photograph was taken, my little brother had no idea a camera was present. His surprise is lovely and contagious. I rediscover his four-year-old joy each time I look at this seventeen-year-old image.

In the second photograph above my desk, I see a family portrait, or rather, a partial family portrait. My older brother Arnold, my sisters Kim and Arlene, twins 358 days younger than me, and I gather on a gold couch around our great aunt Lizzie Bee. None of us are smiling, though I don't know why not, since Lizzie Bee was our favorite relative, a woman quick with a joke, hug, or five-dollar bill. She was never a serious woman, and my siblings and I have never been stoic for longer than a few seconds.

Of course, old photographs have always been two-dimensional mysteries.

I don't know why we chose to look so damn serious. I don't remember what happened in the moments leading up to the photograph that might have caused us to lose our smiles. And to be honest, I don't remember the details of that first photograph of James, either. Perhaps the camera wasn't a surprise. Maybe he was just performing, perfecting the art of pretending to be surprised.

I don't know the answers to any of the questions these photographs ask.

All I do know is this: In that second photograph, I have much darker skin than Lizzie Bee and my siblings. It's funny how memory and melanin can work together. I used to be so much darker when I spent 90 percent of my time outdoors rather than spending it like I do now, perched ergonomically in front of various computers. Then, I was a reservation T-shirt Indian boy with skin so dark that my elbows looked black. Now, I'm a paler urban Indian with a closet full of suits.

Yes, I'm talking about the archaeology of photographs, how we can sift through layers of film hidden in the boxes and trunks of our attics, and find evidence of who we used to be. But we can never find cold, hard facts, only the disconnected, barely remembered details that allow us to make educated guesses, concoct wild theories, and hypothesize. And as we know, "hypothesize" is the third most dangerous verb in the English language, only slightly less violent than "revise" and "colonize."

In the third photograph above my desk, my cousin Eugene Boyd cooly smokes a cigarette as he stands in front of an Esso gas pump. I wasn't alive when this photograph was taken. I have no idea where it was taken, or why. I don't remember how this particular photograph came into my possession, and if pressed, I could only offer sentimental reasons for why I keep it close to me when I'm writing. Eugene was shot to death when I was twelve years old. I miss him. I barely knew him.

All three of these photographs are very private. But more than that, they're photographs of Indians taken by Indians. Besides the inexpert nature of their compositions, how can you tell the photographers are Indians?

Well, you can only know because I've told you so. Does it matter that these are images of Indians created by Indians? Of course it does. In a culture where Indians rarely, if ever, get to self-define—where Edward Curtis's moldy old photographs of pathologically stoic Indians are still the most dominant and defining images—we must pay attention to Indian voices and eyes.

You are holding in your hands a book of photographs of Indians taken by a white woman. So, here I am, looking at her looking at us, and what do I see? These photographs have a certain private feeling to them, as if Gwendolen was capturing private moments with private friends and family, as if these Indian women and men, elders and children, blue-collar folk and beaded-collar celebrities were revealing secrets to her camera. Unguarded, brash, witty, tender, shy, the subjects of these photographs sing out with their faces, hands, eyes, their whole bodies, really. But most important, these subjects cease to be objects when they are given the typographical and spiritual space to comment on their own images.

"This is what I saw," says Gwendolen. Then she turns to us, the Indians, and to all of you out there, Indian and not, and asks, "Now, what do you see?"

SHERMAN ALEXIE

Poet, filmmaker, and author of four books of fiction, The Lone Ranger and Tonto Fistfight in Heaven, Reservation Blues, Indian Killer, *and* The Toughest Indian in the World, *and the screenplay* Smoke Signals

Of all the great cultural shibboleths that have bedeviled the Native peoples of the Western Hemisphere, perhaps the most ultimately destructive is that the first citizens of the Americas *were* but no longer *are*. This characterization is not even necessarily ill intentioned, pinned as it often is on a romantic and frequently romanticized conception of Native peoples and cultures as very worthy cultural phenomena that suffered final extinction in history at the hands of European aggressors. This picture of Native peoples, however, is correct by less than half at best.

At the time of initial European contact, tens of millions of Native peoples occupied the Western Hemisphere from Tierra del Fuego in the South to the Arctic Circle in the North and created through time orders of civilization and a depth of culture that were diverse and complex. As example, during the Middle Ages an urban metropolis more populous than the London of the time grew and prospered near what is now St. Louis.

Popular conceptions of Native history also are correct in noting the devastating—and almost always intentionally so—impact of European contact on Native peoples and cultures. By 1900, the first year in which American Indians were included in the U.S. census, their total population had decreased from some 6 to 9 million people to approximately 250,000—an almost incredible depopulation of up to 95 percent. The decrease in numbers for the great urban civilizations of Meso and South America is equally horrifying and sometimes occurred within the space of mere generations. During a period of less than a half century, beginning in the late 1800s, the land holdings of Native nations in the United States decreased by almost 70 percent as Manifest Destiny rolled west.

Where popular cultural conceptions often stray from the truth, however, is in their perception of the Native present. The plain fact is that Native peoples and cultures did not pass from the stage of history as many predicted they would. They continued, almost always against great odds, but with an enduring and abiding persistence. The United States government still recognizes more than 500 distinct and discrete Native communities and nations, with many more acknowledged by various state governments. Since 1900, the Native population of the U.S. has rebounded to over 2 million. Perhaps most significant of all, an undeniable cultural renaissance is sweeping Native America, boding well for the cultural future of the hemisphere's first citizens.

Indian Country speaks powerfully—and visually—to this undeniable Native cultural present and future and, in doing so, does a great service to all who call themselves American. The Native peoples of the Western Hemisphere not only have protected their own culture but also have created a legacy that will benefit Native and non-Native alike. *Indian Country* documents through the discerning and revealing lens of the camera this human and cultural persistence and the great abundance of its gifts.

W. RICHARD WEST

Director, Smithsonian Institution, National Museum of the American Indian

My journey through Indian Country began when I was a child. My father lived on the Navajo reservation and learned the language before I was born. He first brought me down there to visit when I was eleven, and I have been going back ever since. I have also been taking pictures since I was nine. Throughout my life I have seen how many misconceptions there are about Indians, and how invisible they are in this society. This book was an opportunity to show what I see and experience out in Indian Country. It was also an opportunity to give back, to reciprocate for all I have been given, for all I have learned.

Indians are still here. They are in our midst. They have not vanished. We have rendered them invisible. Indians have been both romanticized and vilified throughout the history of this country. To romanticize is to prefer caricature over reality, and indeed Native people have been caricatured to such an extent that their humanity is obscured. For many, street signs, movie savages, and mascots are the only evidence of Indians. Their history, and the history of what was done to them during colonization, has been rewritten to better suit American mythology.

The current Native population of this country is 2.5 million. There are 561 federally recognized nations and tribes, 314 reservations and 226 Alaskan Native villages. Each is unique in its identity and its individual history. The landscape of Indian Country is rich in its complexity. There is remarkable diversity in language, lifestyle, and traditions. Their identity is as sovereign as their status under our constitution as individual nations. The efforts to exterminate, terminate, assimilate, and relocate have all failed to extinguish this profound identity.

I could not have done this book without the collaboration of the Native community. Everywhere people participated, helped me, supported me, but what they were really doing was coming together as a community and allowing me to portray that community.

Sometimes I have felt overwhelmed by the responsibility. There are so many stories, there is so much history and pain and dignity and strength and generosity and beauty and humor. I have tried to show the diversity and the reality of Indian Country today. I hope that when Native people look at this book they feel pride. I hope that this book reflects back to them all that I see and feel when I am in their midst. I hope that I have done them justice.

This book is a journey through Indian Country. It begins where I began, in Dinétah, the sacred land of the Diné or Navajo, and travels clockwise around the country. Because identity among Indian people is grounded in tribal affiliation and association to homeland, I have organized the book accordingly. My captions indicate where people live, and for the most part this is also where they were photographed. Any apparent inconsistencies in the names and spellings of tribes or nations are due to the fact that I chose to ask each individual how they name their tribe or nation. Native people have been spoken for and written about since first contact. However, only they can truly express their perspectives and experiences. For this reason, people speak in their own words throughout the book.

This book is my gift to the Native peoples of this country.

GWENDOLEN CATES

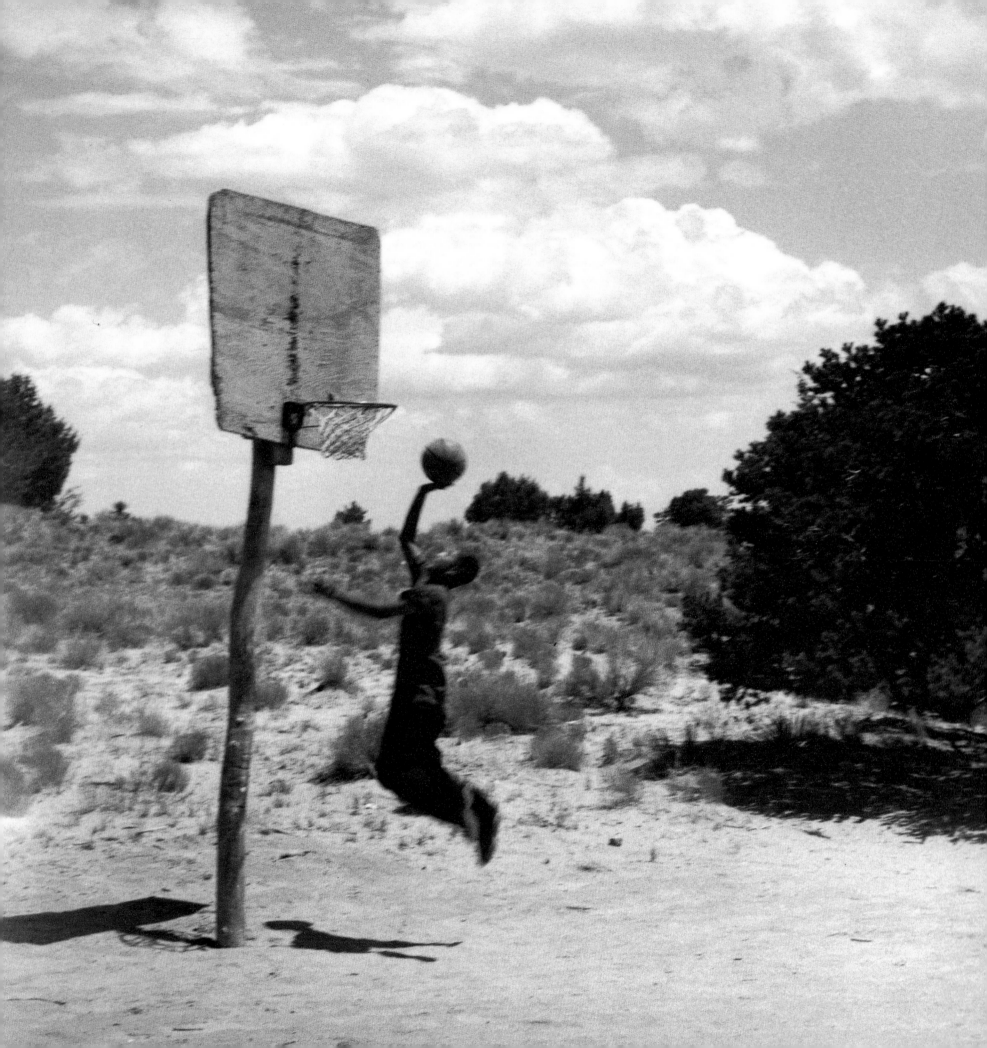

Navajo reservation, near Chilchinbito, Arizona

Thalia Williams, Navajo, great-granddaughter of Laugher's Grandson
Navajo reservation, near Chilchinbito, Arizona

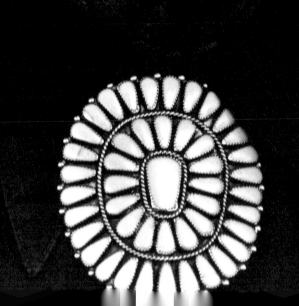

Laugher's Grandson, Navajo
Hataalii (medicine man, singer/healer)
Navajo reservation, near Chilchinbito, Arizona

RESTAURA

Derrick Henry, Diné
Journalist, Associated Press reporter, New York City

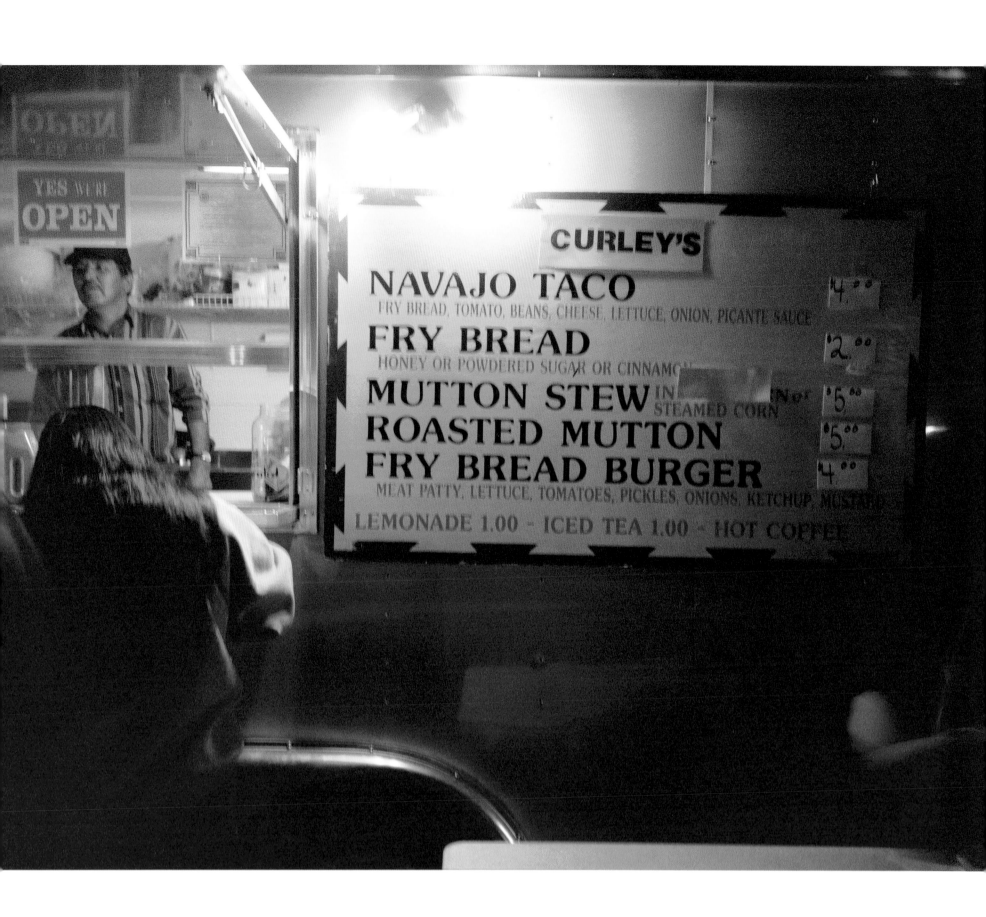

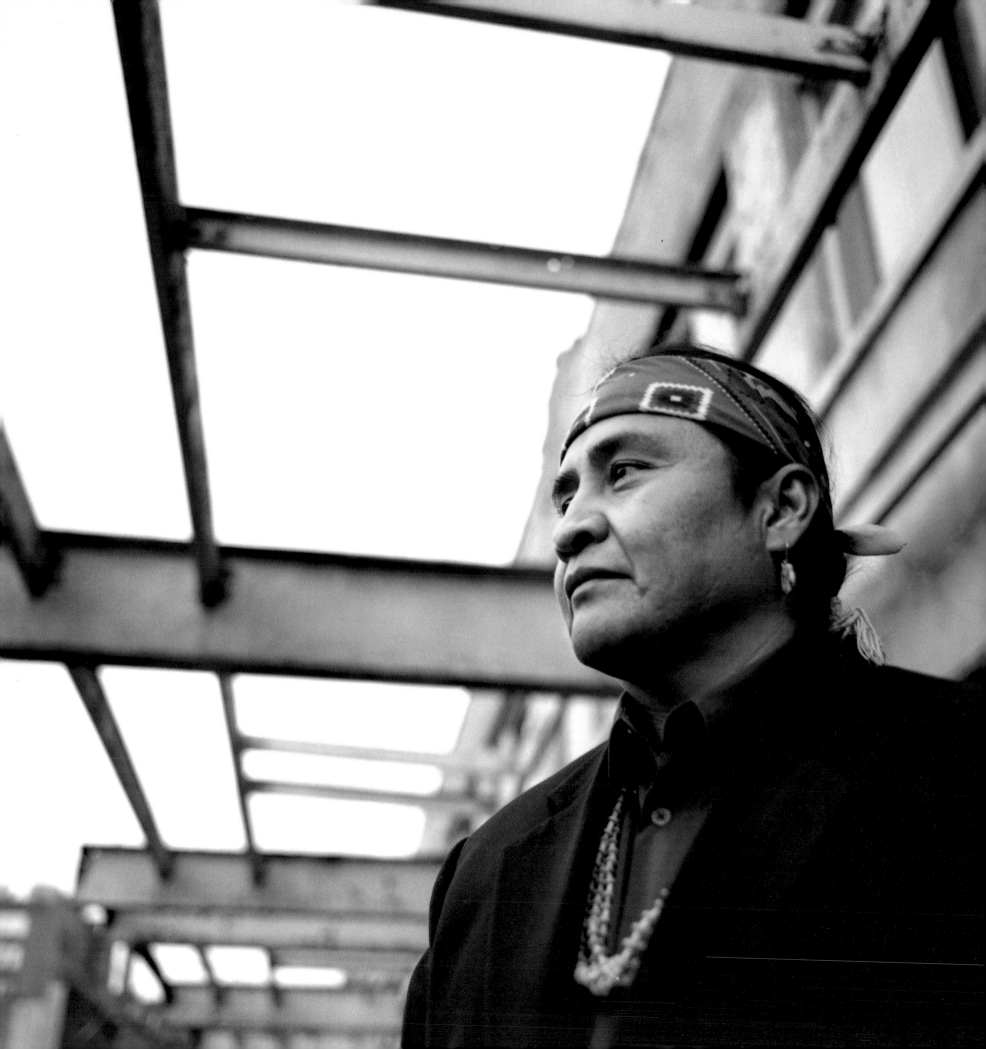

Your shield is your identity. Knowing your clan, where you came from, being a part of the land, that's your shield. No one can harm you. Most of my life I've been away from home, but I've always come home, I've always participated in ceremonies. Recently I've been learning the value of that worldview as a filmmaker. The language is my guide, you might say. Our ceremonies, our songs, our prayers, that's my foundation of storytelling. My father, who was a Code Talker, told me that all the answers are within our way of life. All the answers are within our stories, our prayers."

NORMAN PATRICK BROWN, DINÉ

Bitterwater clan
Filmmaker, screenwriter, actor
Navajo reservation, Chinle, Arizona

Radmilla Cody, Navajo, singer, Miss Navajo Nation 1997–1998,
with her grandmother, Dorothy Cody, Navajo
Navajo reservation, Leupp, Arizona

Notah Begay, Navajo
Professional golfer, Albuquerque, New Mexico

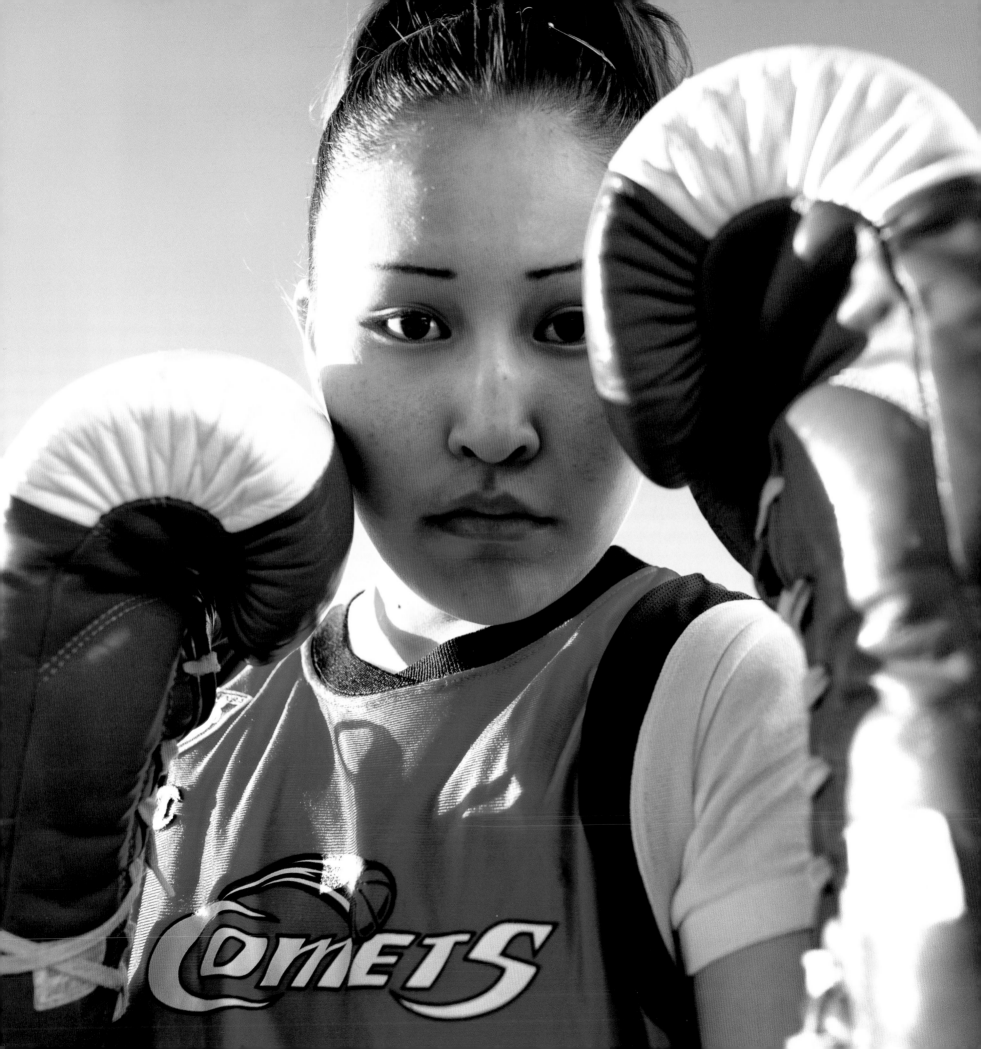

When I box, I'm representing my family, myself, the Shiprock Boys and Girls Club, and, most of all, the Navajo Nation. I've been boxing for about two years. I come here five days a week and practice for about two to three hours a day. It makes me feel good, helps me get through personal problems, and get a lot of feelings out of my system. It's a challenge. It takes a lot to get in that ring to fight another person. Some guys get offended that I'm a girl boxer, but that never gets me down. I want to encourage all Native American girls to try to do challenging things. All you need is to put your mind to it. There are hardly any Native pro-athlete stars. I'm hoping to be one of them, either a pro boxer or a pro bodybuilder."

KARRIE PHILLIPS, NAVAJO

Student, member of the Shiprock Boys and Girls Club boxing team
Shiprock, New Mexico

My mother left the reservation and went as far away as she could. She became a nurse in Philadelphia, and half a year later met a Puerto Rican man, fell in love, got married, and had two children. She wanted to go home to the reservation to show her children to her parents. My grandfather was standing at the edge of their property in Chinle with a shotgun. He had to let my mom and her kids get out of the car, and we walked the rest of the way. My dad had to sleep in the car. My grandfather was a famous singer and drummer. His name was Bud Town. My mom was the first Native American woman to do the Hoop Dance. She went to rodeos and powwows. At first she was not very well received, but she became pretty famous. They had to accept her because she was very good. She taught me how to do the Hoop Dance when I was three or four and we would dance together while my grandfather sang and drummed. I did it until I was probably nine or ten. I started ballet when I was five, when my family moved to Phoenix so that my parents could find work."

JOCK SOTO, NAVAJO

Bitterwater clan
Principal dancer, New York City Ballet
New York City

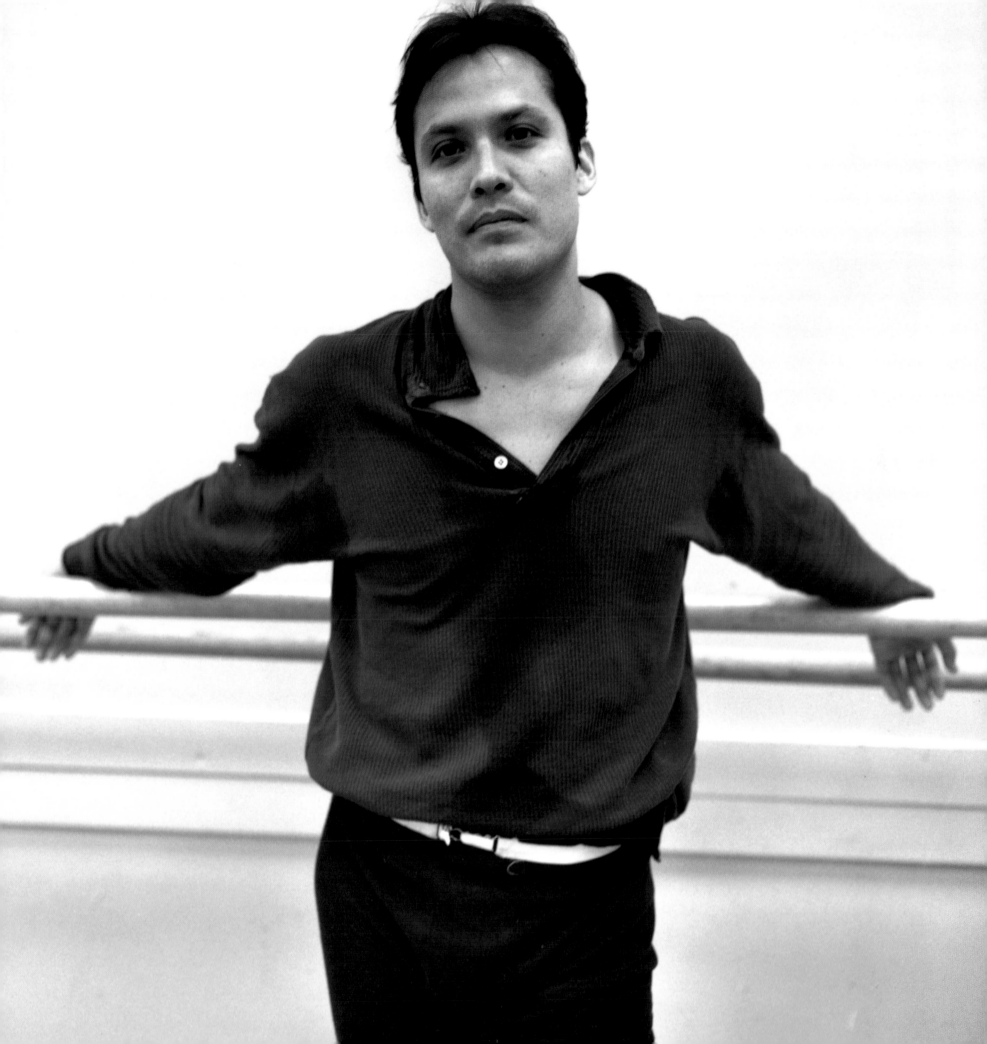

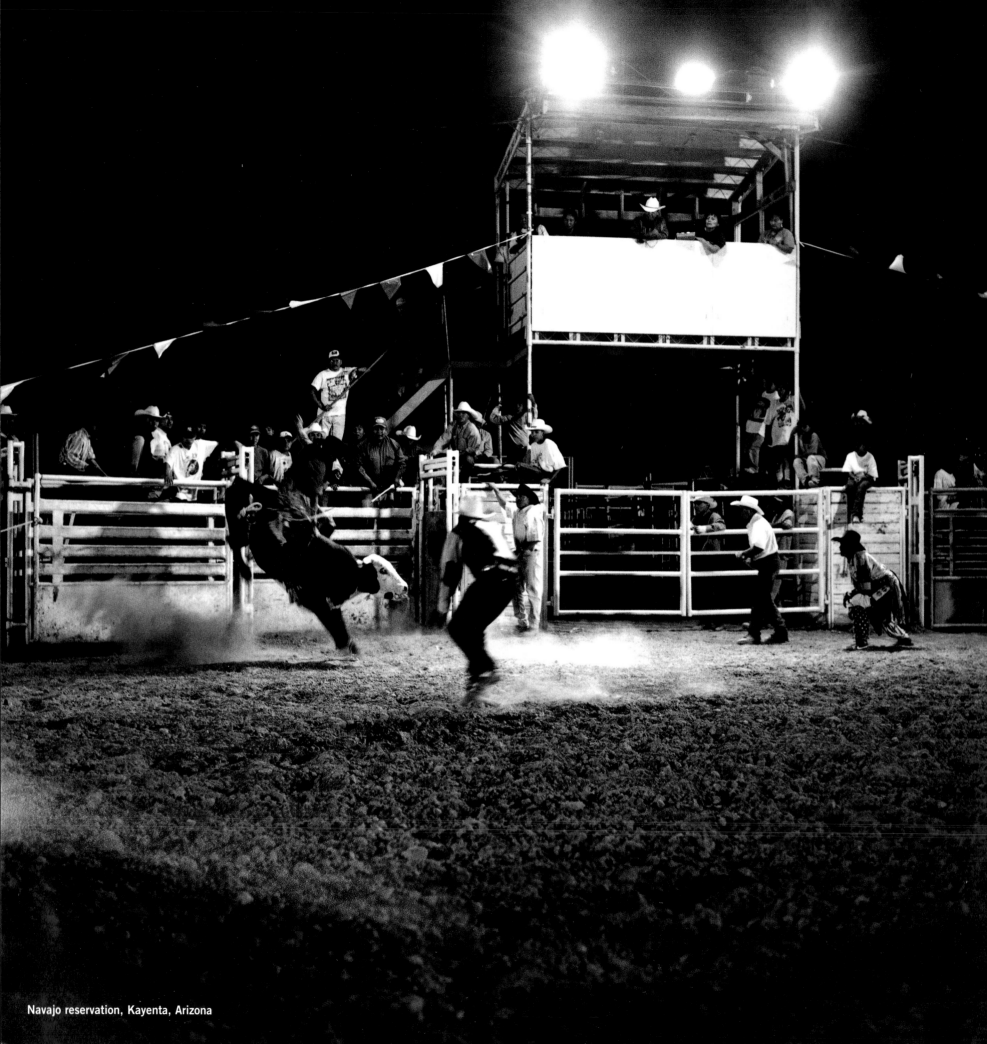

Navajo reservation, Kayenta, Arizona

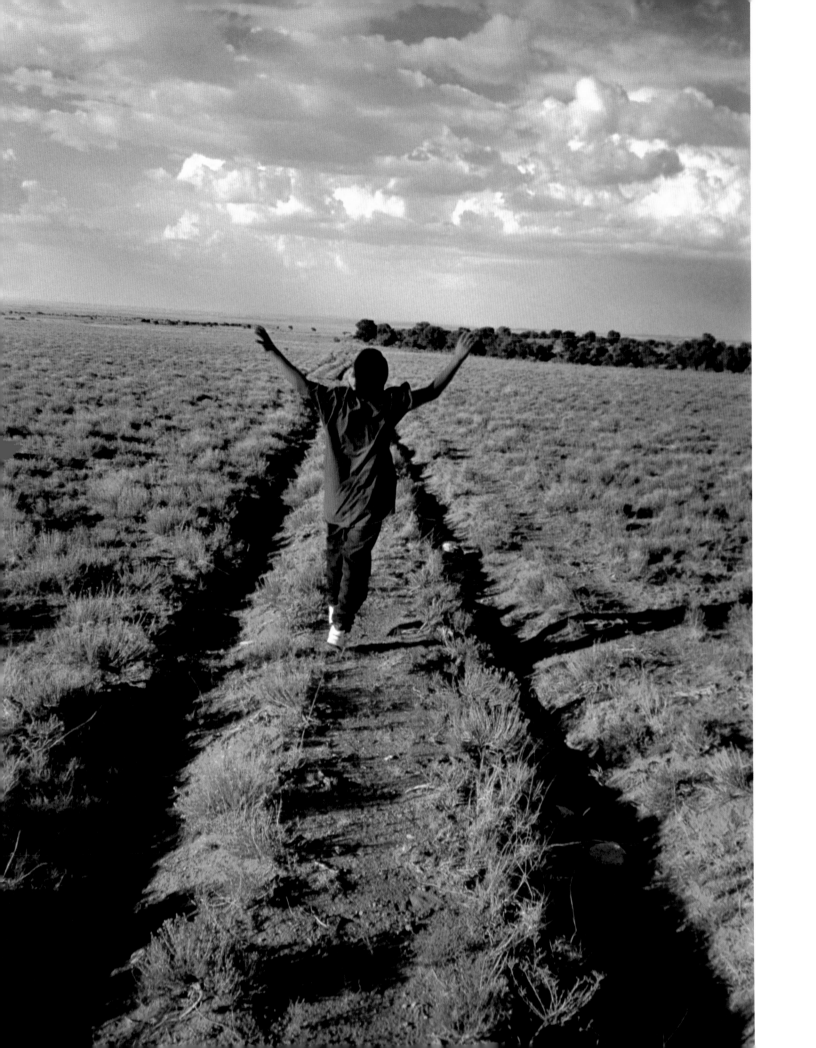

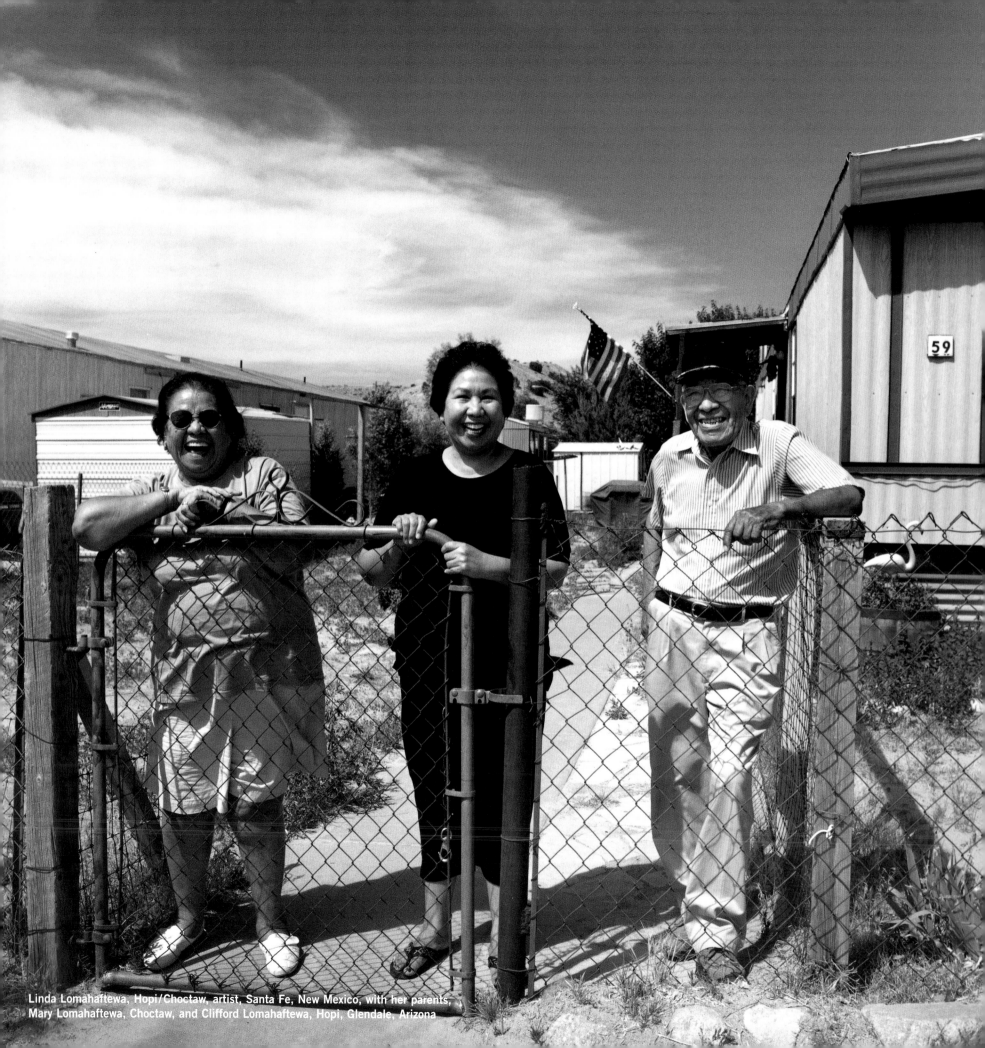

Linda Lomahaftewa, Hopi/Choctaw, artist, Santa Fe, New Mexico, with her parents, Mary Lomahaftewa, Choctaw, and Clifford Lomahaftewa, Hopi, Glendale, Arizona

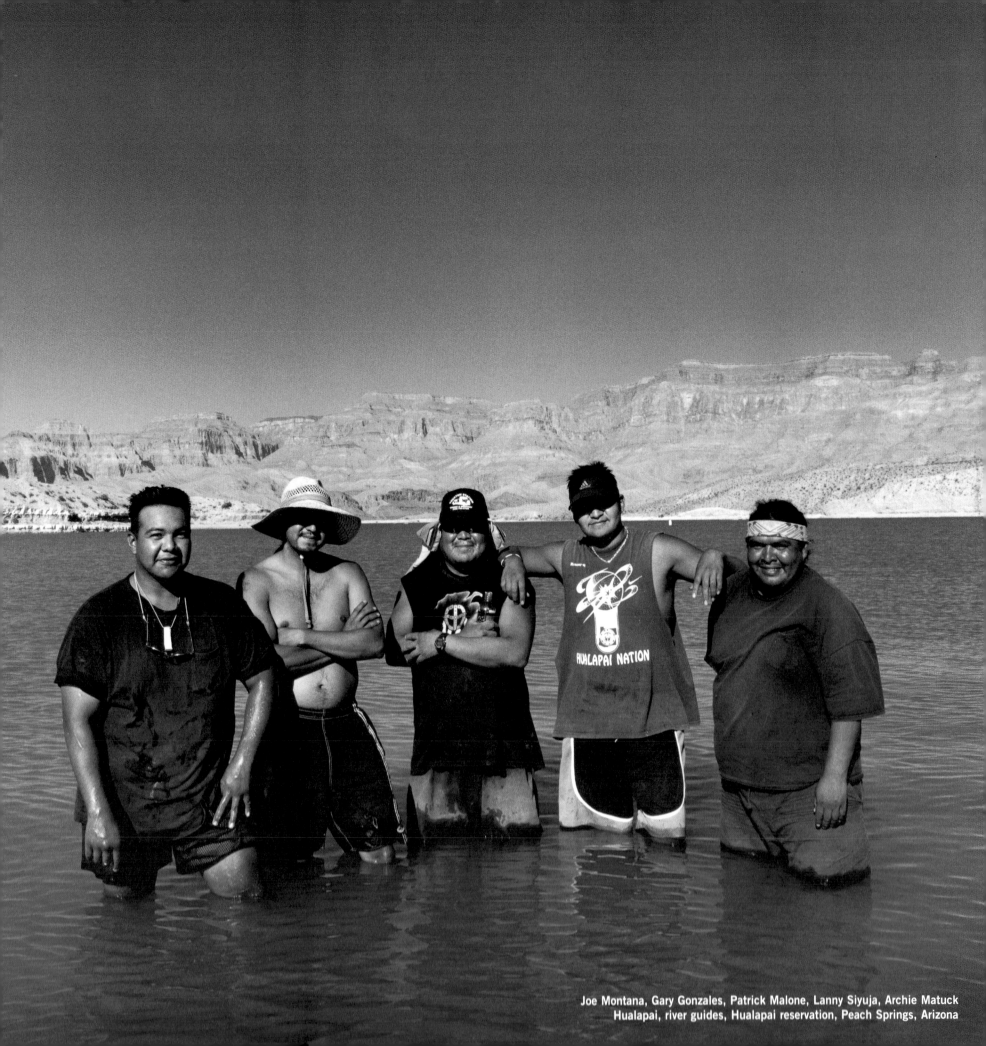

Joe Montana, Gary Gonzales, Patrick Malone, Lanny Siyuja, Archie Matuck
Hualapai, river guides, Hualapai reservation, Peach Springs, Arizona

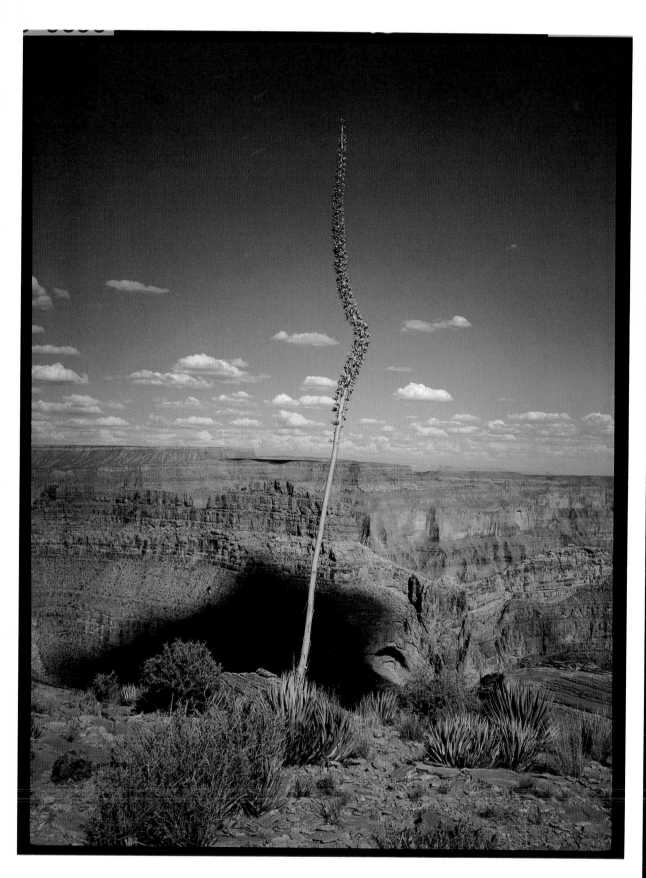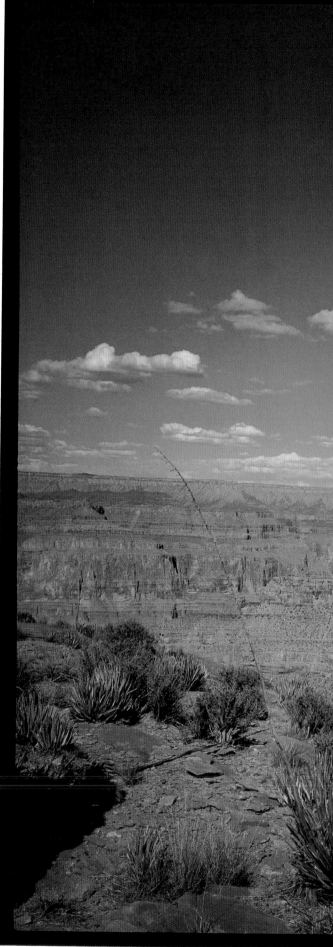

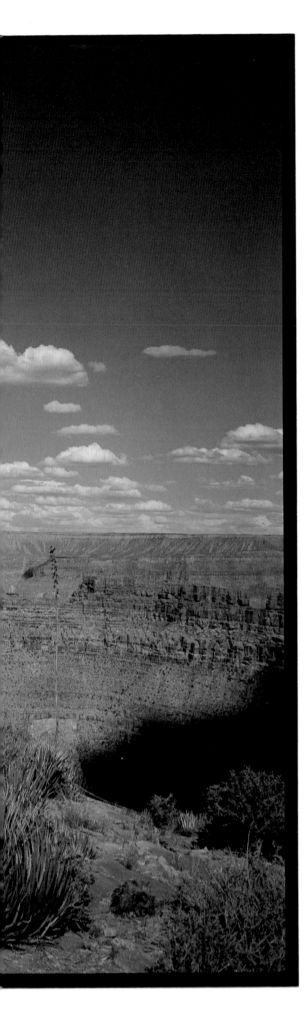
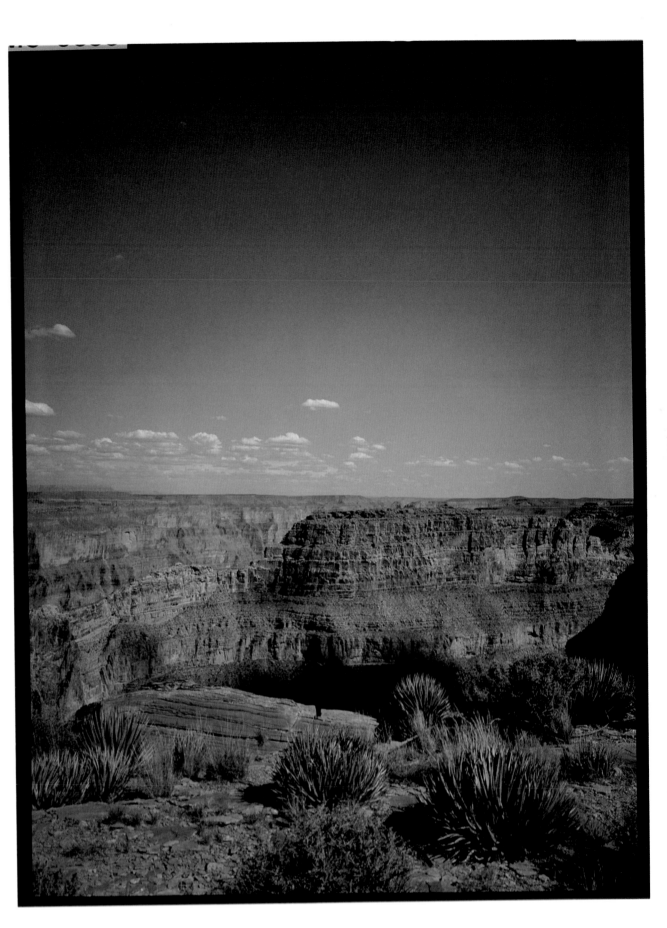

Hualapai reservation, Grand Canyon

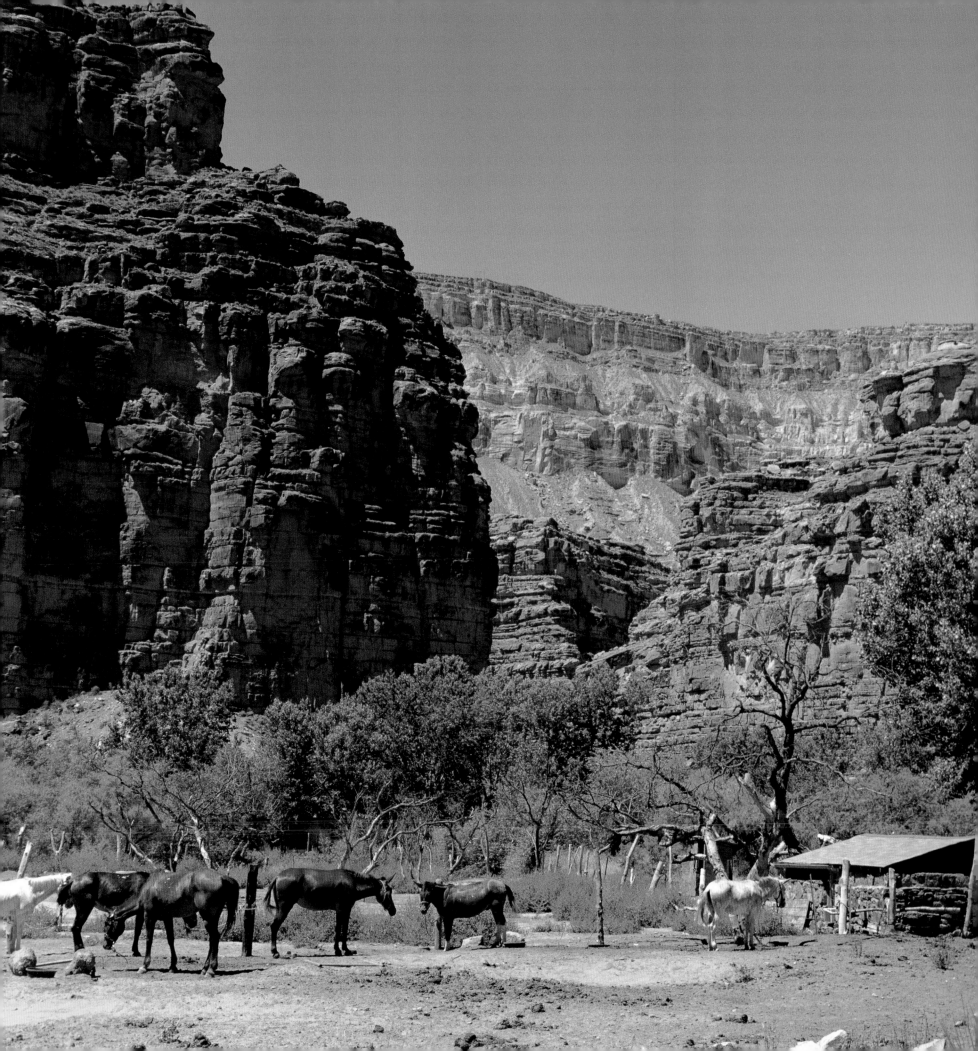

Havasupai reservation, Grand Canyon

Frances Manuel, Tohono O'odham
Basket maker, authority on indigenous plants
Tohono O'odham reservation, San Pedro Village, Arizona

David Carrillo, Sr., Tohono O'odham
Makai (medicine man)
Tohono O'odham reservation, San Pedro Village, Arizona

Gary Guacheno, Luiseno/Diegueno
James Luna, Luiseno/Diegueno
Tracy Lee Nelson, Luiseno/Diegueno,
Musician, lead singer of Native Blues
La Jolla reservation, Pauma Valley, California

I t's
so cool being an Indian."

JAMES LUNA
LUISENO/DIEGUENO

Performance artist
La Jolla reservation
Pauma Valley, California

"Screenwriting and documentary
filmmaking are a way to achieve
cultural preservation, as a tool
for Native communities to preserve language,
songs, stories, and Native philosophies.
Filmmaking can also be used to
help society overcome their stereotypes
of Native people."

Monique Sonoqui, Chumash/Apache/Zapotec
Documentary filmmaker, screenwriter, activist
Santa Barbara, California

Mele Viloria, Hawaiian
reggae musician, Oakland, California

"An angel decided to leave Hoopa. He stopped to rest atop Bald Hill and looked
down at the valley. The sunlight was reflecting like fireflies off the water. He said, 'Why am I leaving
this valley when it's so beautiful?' The angel came down from the hill and became medicine."

GEORGE BLAKE, HUPA

Artist

Hoopa Valley reservation, Hoopa, California

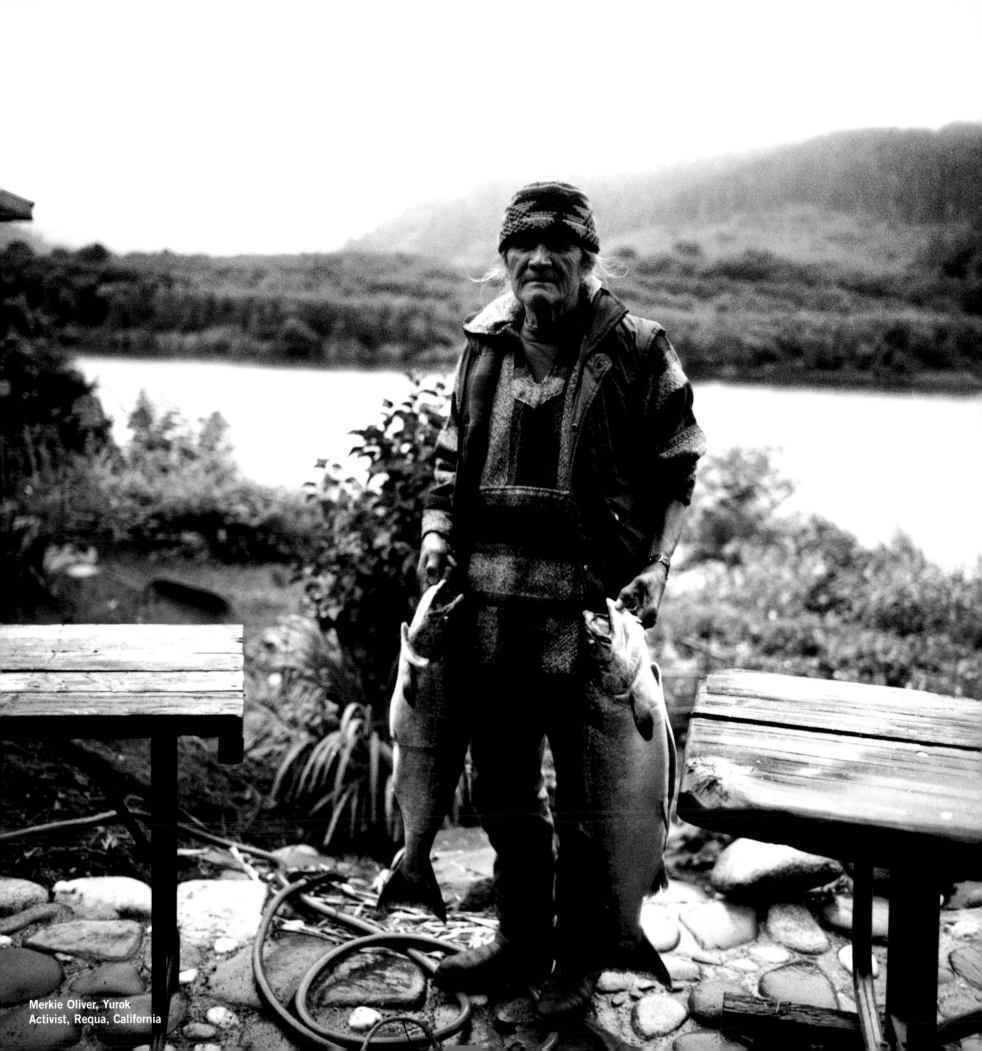

Merkie Oliver, Yurok
Activist, Requa, California

Forrest Salmans, Yurok
Bureau of Indian Affairs officer, Requa, California

Ed Archie Noisecat, Salish
Artist, Oakland, California

Florence Jones, Wintu
Spiritual leader of the Wintu people, near Redding, California

"When Grandpa Johnny was really young his family sent him north and he found work.
He walked back down to the Arcata area and then he walked back up with his family. I've lived in this house
my whole life, I'm the fifth generation living here. My great-grandfather, my grandfather,
my uncles, everyone dug clams in the mudflats at the end of this street. I take my son out there, but we'll
probably be the last ones because of the pollution."

RICK BARTOW, YUROK

Mad River band
Artist
Southbeach, Oregon

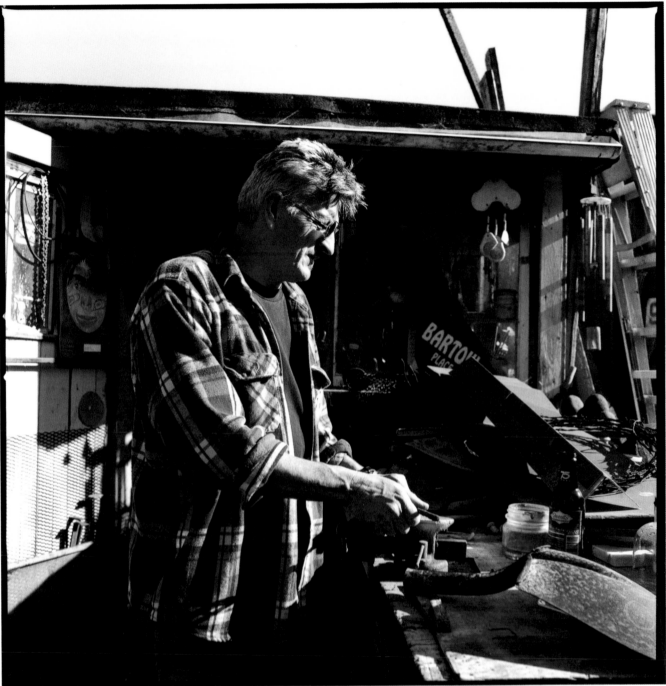

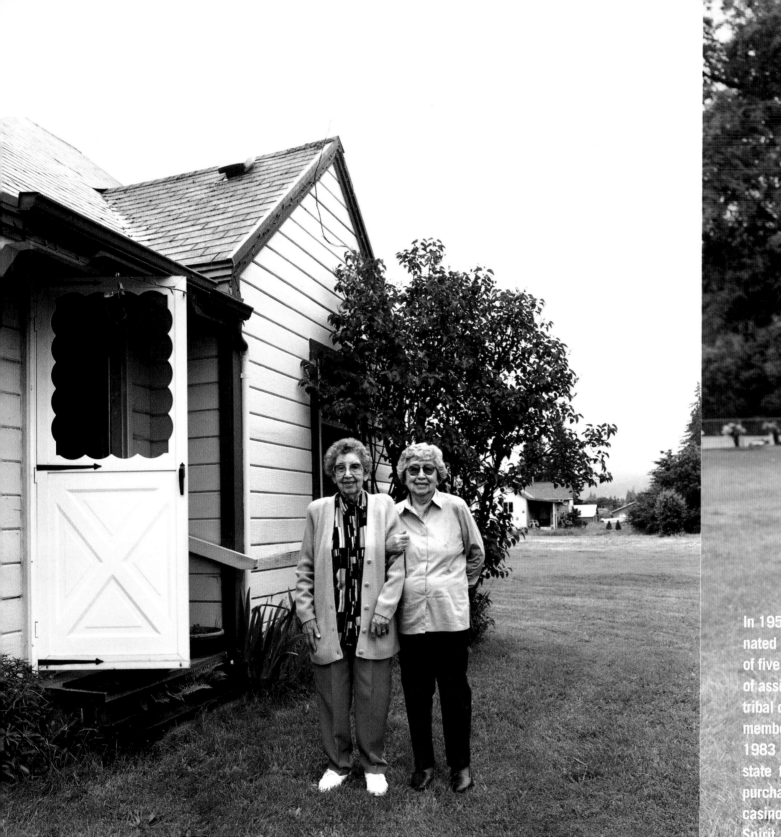

Ila Dowd and Verna Larsen, Grand Ronde
Grand Ronde reservation, Grand Ronde, Oregon

In 1954 the federal government terminated the Grand Ronde Confederation of five tribes in keeping with its policy of assimilation. All land except for the tribal cemetery was sold off, and tribal members were relocated to cities. In 1983 Congress finally agreed to reinstate the tribe, which has since repurchased much of the lost land with casino revenues. The revenues from Spirit Mountain Casino have also funded programs for elders, classes to revive the language, and housing. Tribal members, scattered for so long, are beginning to return home.

Russ Leno, Grand Ronde, World War II veteran
Grand Ronde reservation, Grand Ronde, Oregon

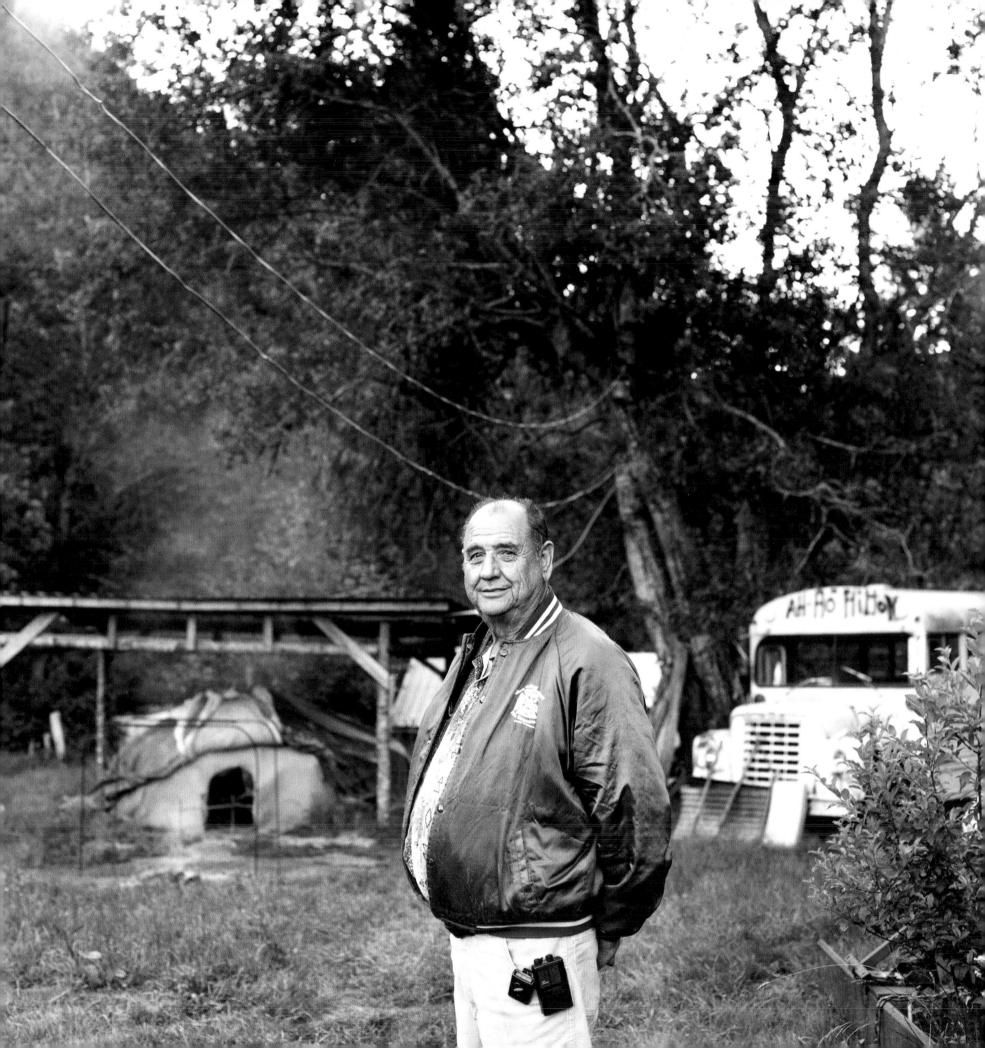

eople were moved from the Rogue River in 1856, some by ship, some had to walk it. Sixty made it on the march. Rogue River people were the first environmentalists. The Confederated Tribes of Siletz comprise thirty-two bands. We lived in bands, not tribes. Missionaries split the families up. The Siletz people were not allowed to speak their language. In schools, when the kids spoke their language, they stuck their lips to ammonia tubes."

WALT KLAMATH, SILETZ

Volunteer fireman, youth counselor

Siletz, Oregon

Maynard White Owl, Cayuse/Nez Perce
Marlene White Owl, Navajo, with their children,
LeAnder White Owl and Suzette White Owl, Navajo/Cayuse/Nez Perce
Artists, beadworkers, Umatilla reservation, Pendleton, Oregon

"So, you want to photograph us in our regalia?"

Leo Stewart, Willie Staconer, Tom Rodriguez, Vince McKay, Umatilla
Umatilla reservation, Pendleton, Oregon

Women's canoe-racing team going to practice on the Quinault River
Quinault reservation, Taholah, Washington

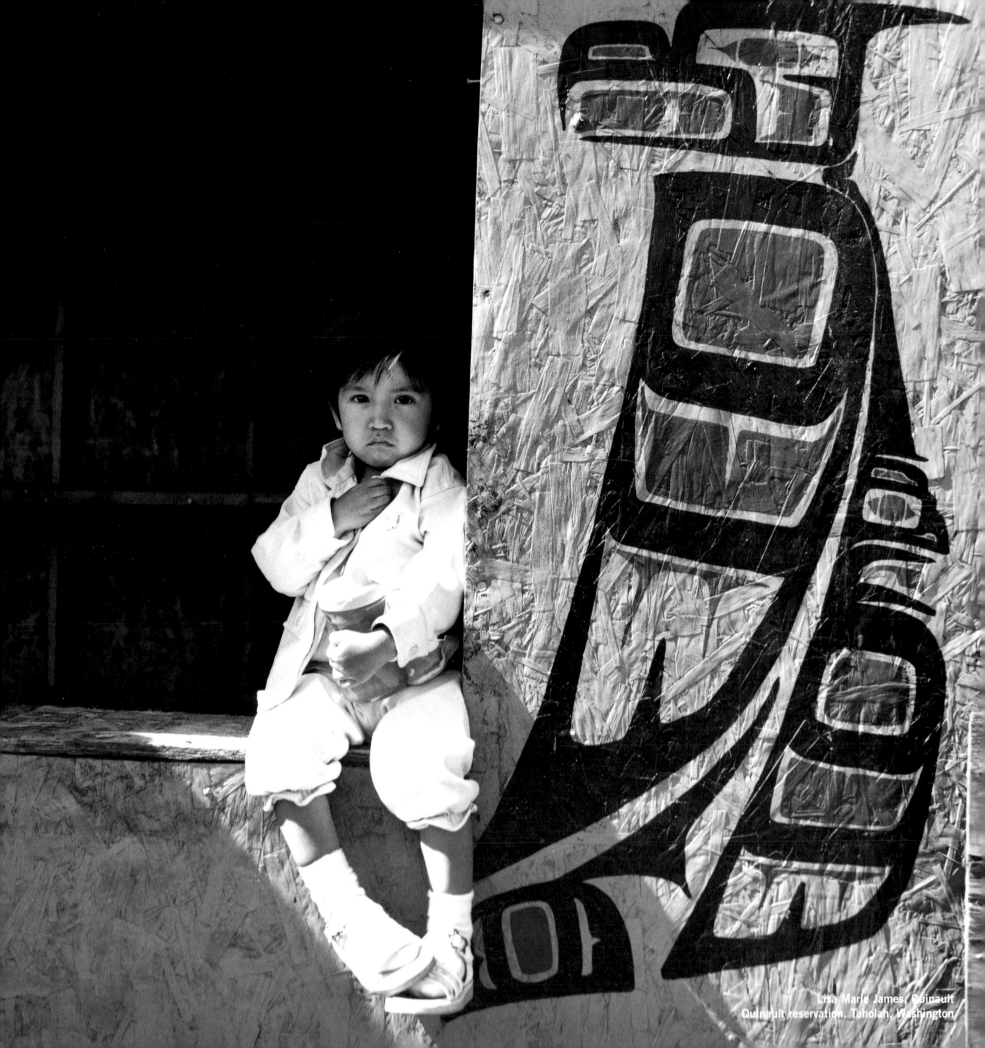

Lisa Marie James, Quinault
Quinault reservation, Taholah, Washington

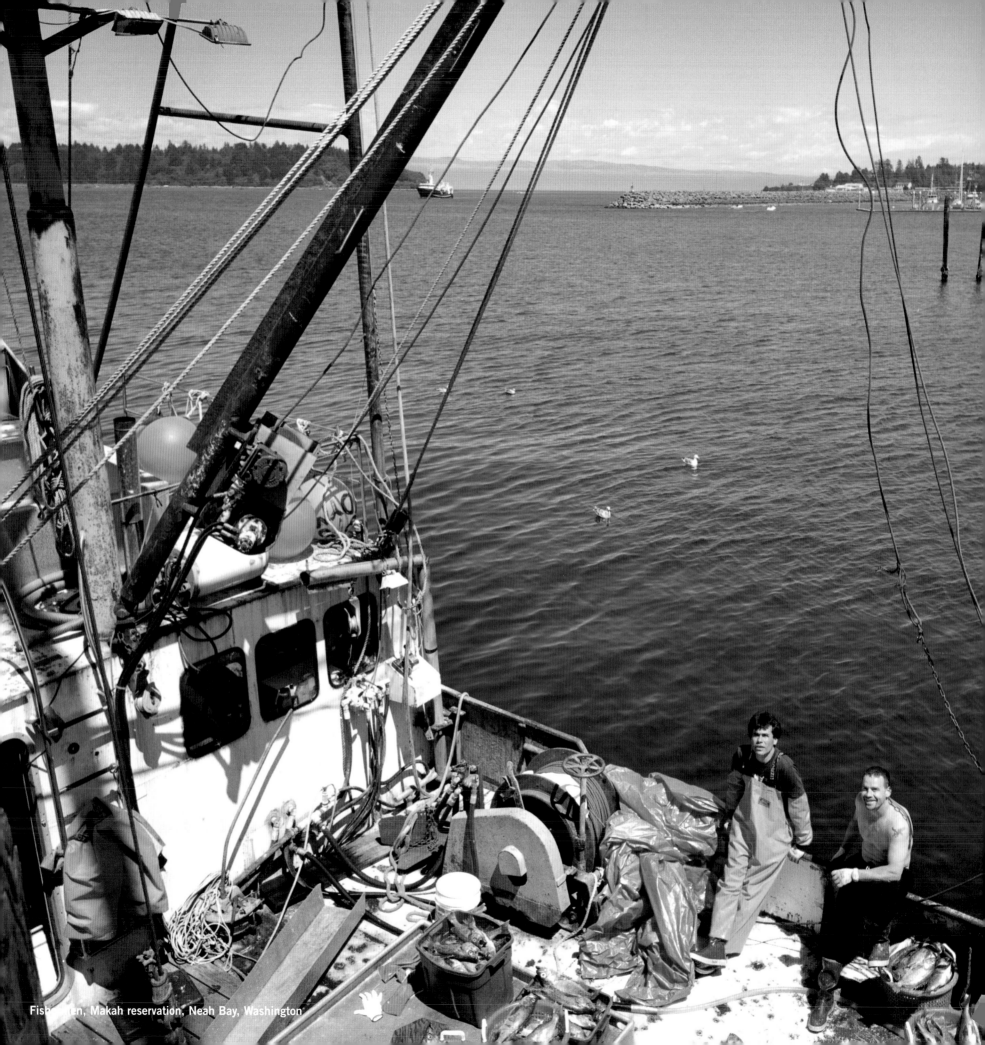

Fishermen, Makah reservation, Neah Bay, Washington

Drying salmon, Anvik, Alaska

We are all aboriginal, we all came from tribes, it's just that certain tribes have managed to keep their stories and songs and drums. As Native people, we view the earth as something living. We grow up knowing that we are part of something that is alive and that has knowledge way beyond what we as human beings can understand. But even the word *animism* does not describe the fact that from the time that you're born until the time you die, everything around you is living and has a spirit. The English language is very linear, whereas tribal language is pictorial and circular. Our language is not just words, it's a way of looking at the universe. It might take a paragraph to describe a concept in English, while it would take one word in my language. One word would describe a whole way of being."

IRENE BEDARD, INUPIAQ/MÉTIS CREE

Actor

Ojai, California

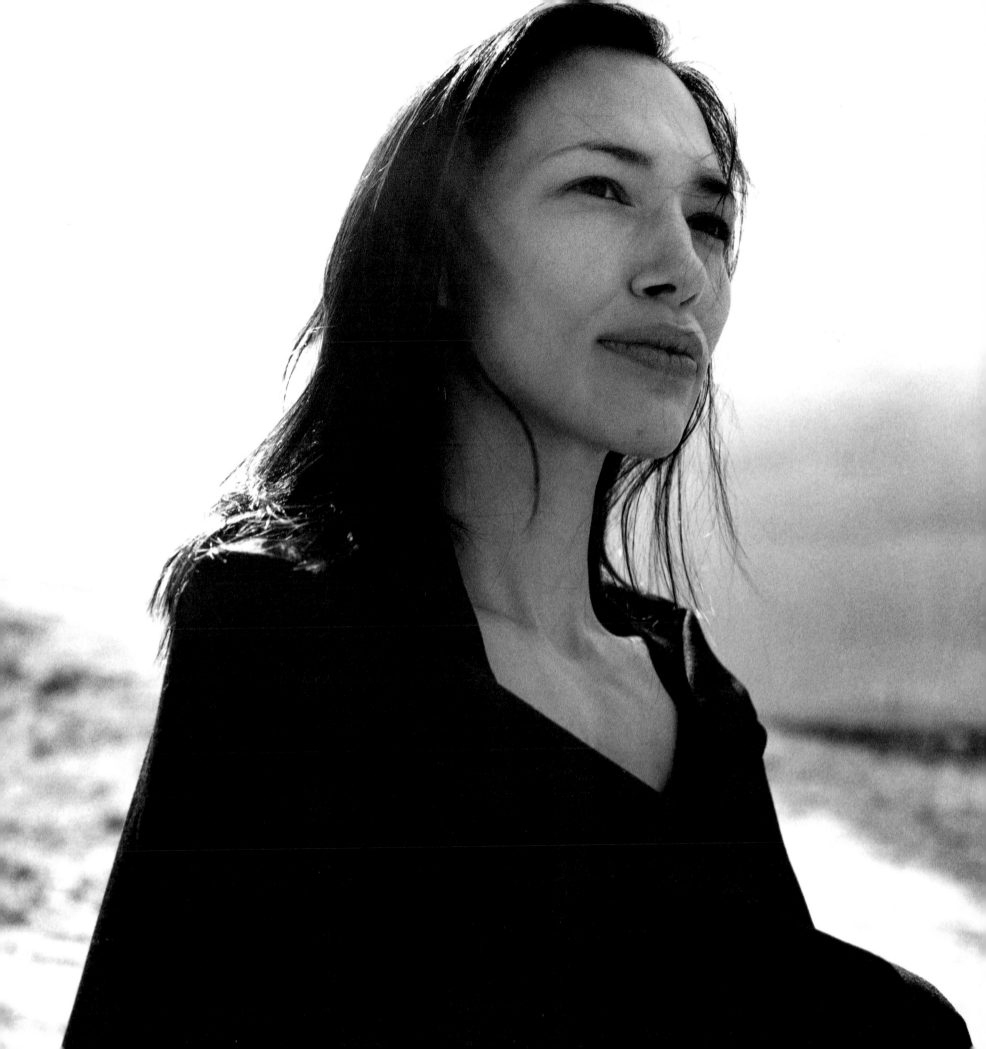

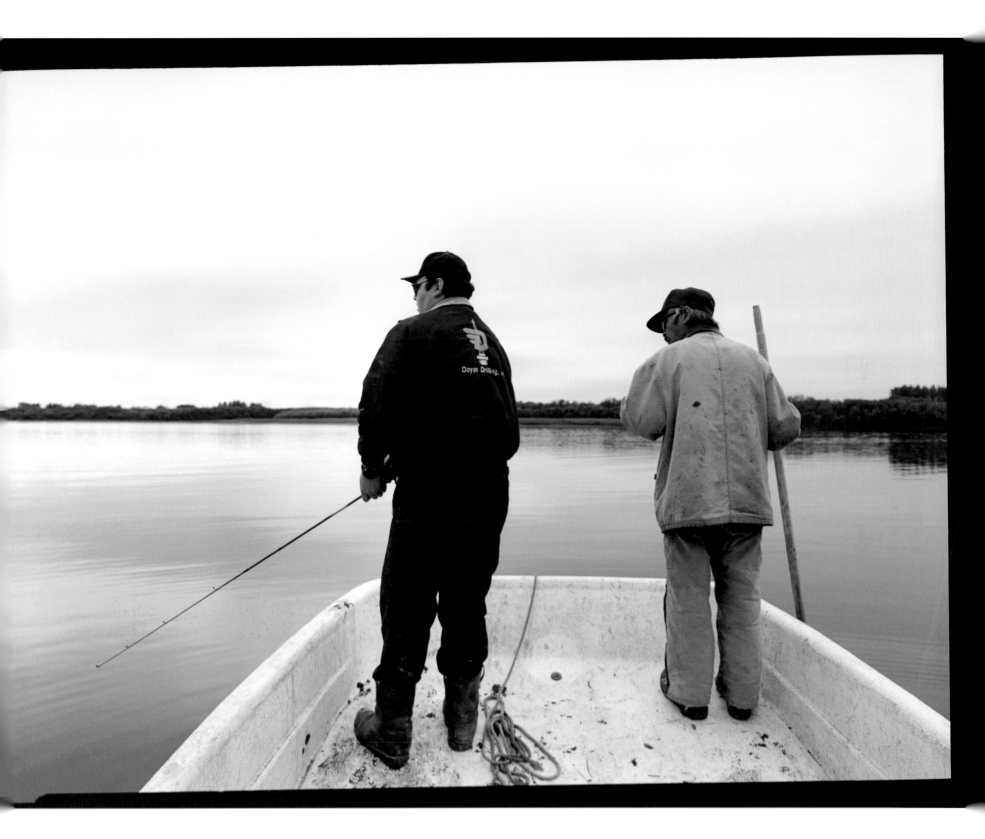

Athabaskan men fishing on the Yukon River, Anvik, Alaska

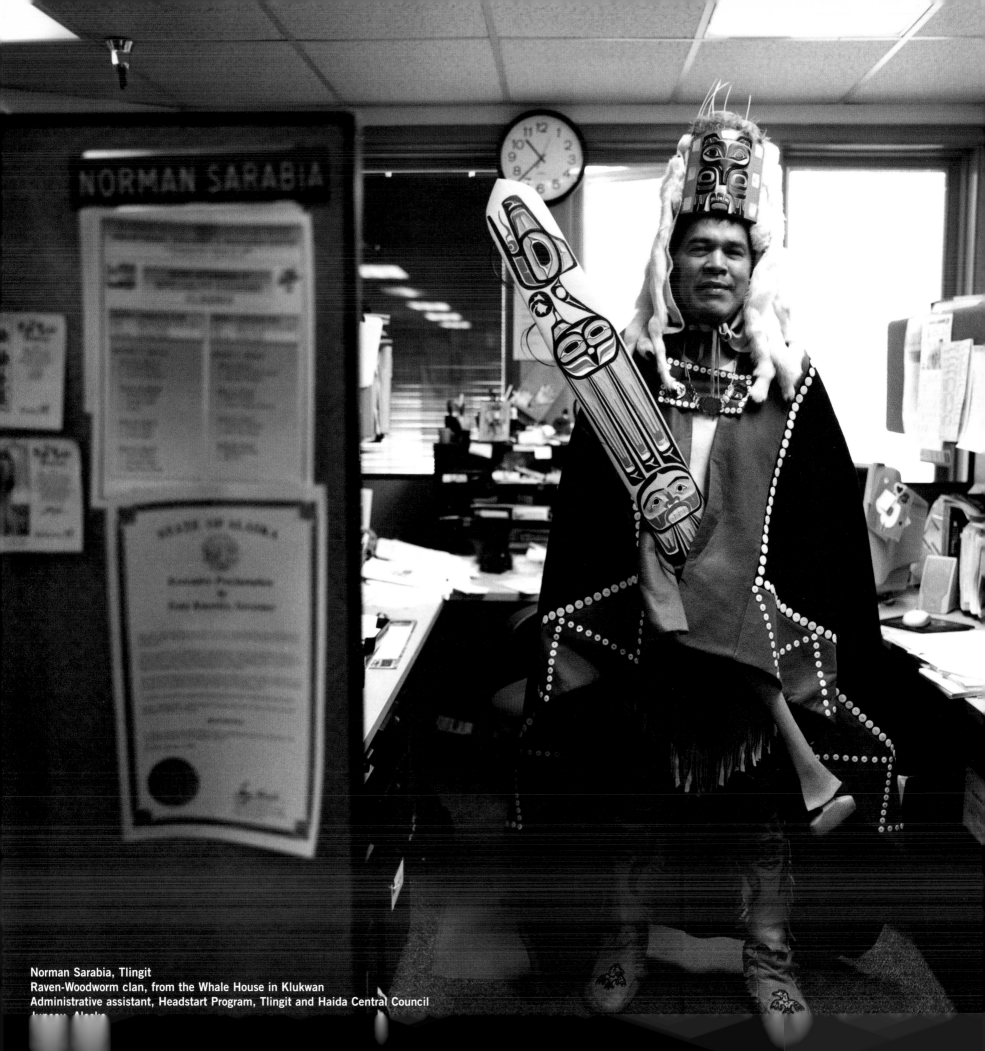

Norman Sarabia, Tlingit
Raven-Woodworm clan, from the Whale House in Klukwan
Administrative assistant, Headstart Program, Tlingit and Haida Central Council
Juneau, Alaska

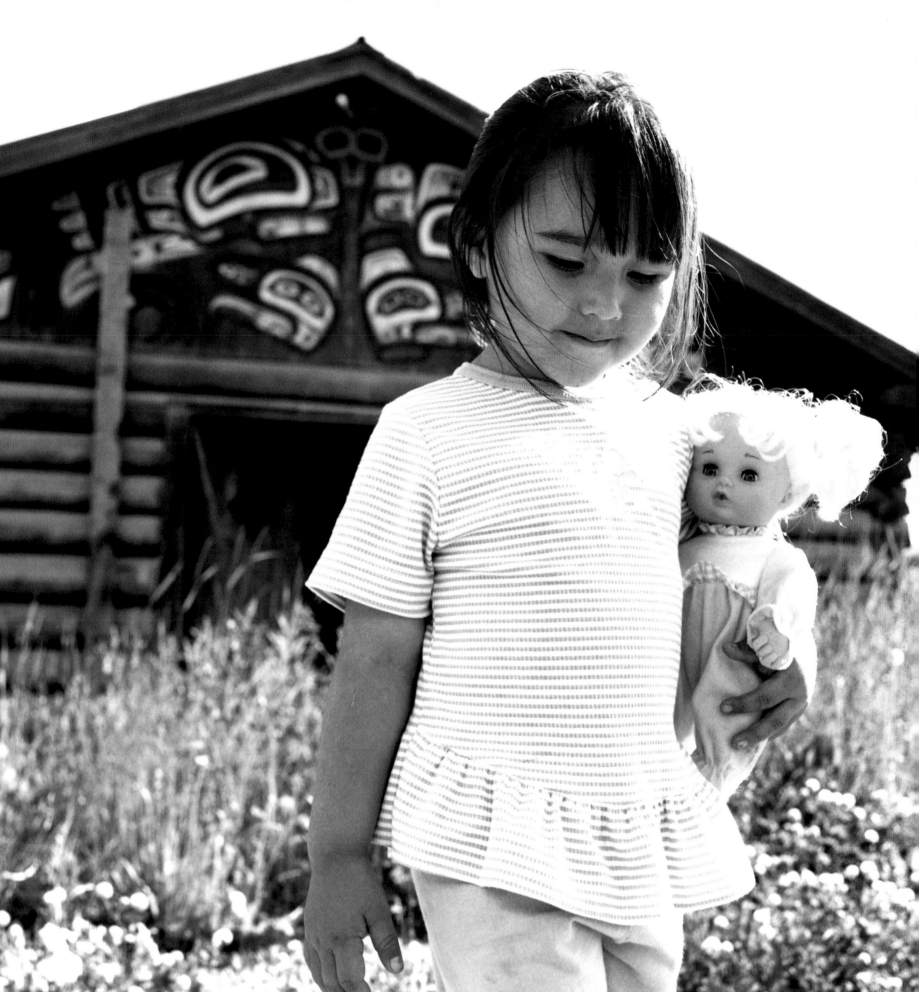

Kaitlyn Stevens, Tlingit
Klukwan, Alaska

Charlie Jimmy, Sr., Tlingit
Chilkat Dancer since 1964
Haines, Alaska

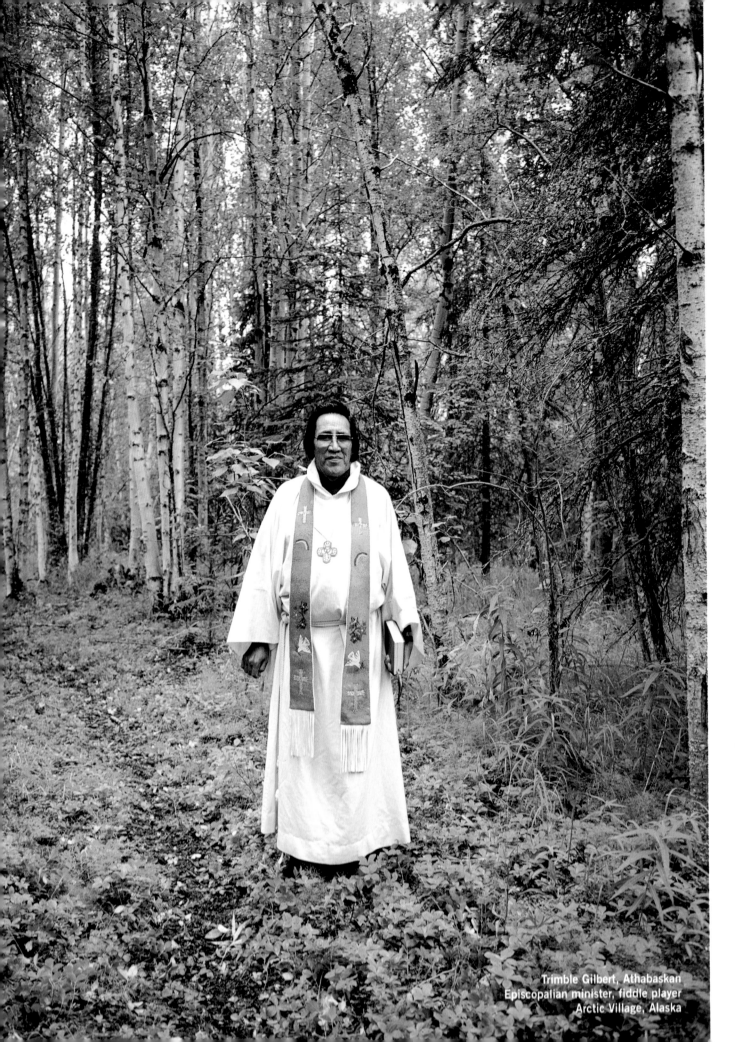

Trimble Gilbert, Athabaskan
Episcopalian minister, fiddle player
Arctic Village, Alaska

My father always talked about the tree people. The roots held together and the trees just swayed in the wind. North wind blows strong. If you don't help each other, you won't make it sometimes. We've been scattered around, it's time to get together. We all need to come together like the roots of a tree."

CHARLIE JIMMY, SR., TLINGIT

Corazon LaFern Noyola, Spokane/Colville
Spokane reservation, Washington

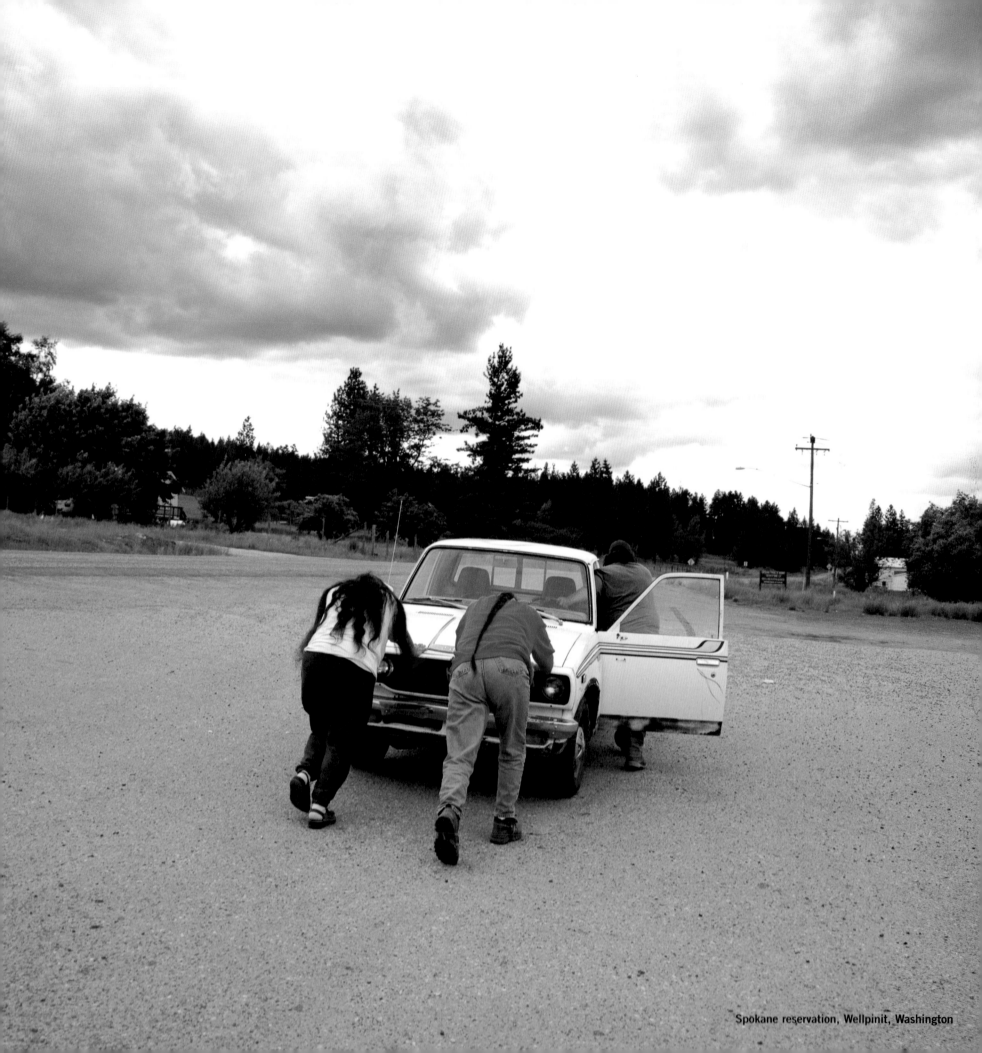

Spokane reservation, Wellpinit, Washington

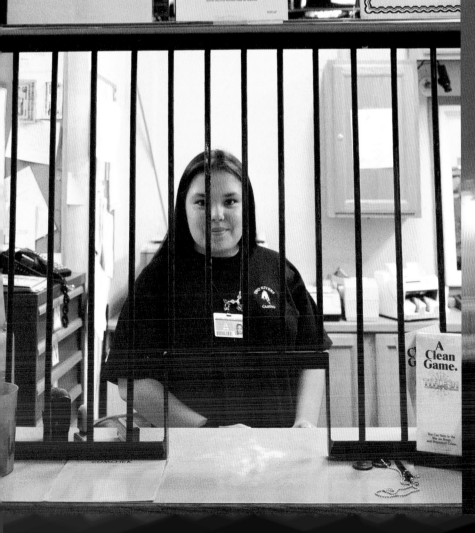

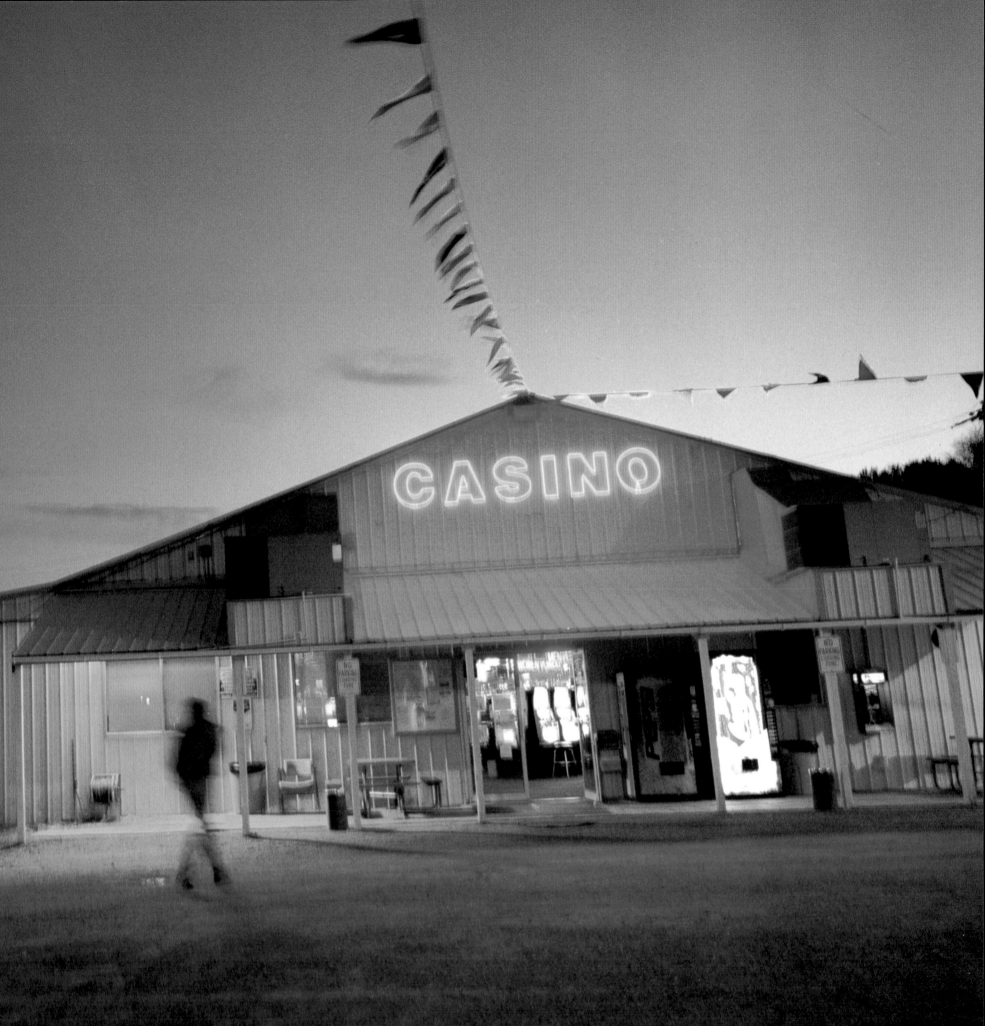

Lovinia Merson, Colville / Coeur d'Alene,
holding Sabrina Nomee, Coeur d'Alene
Coeur d'Alene reservation, Idaho

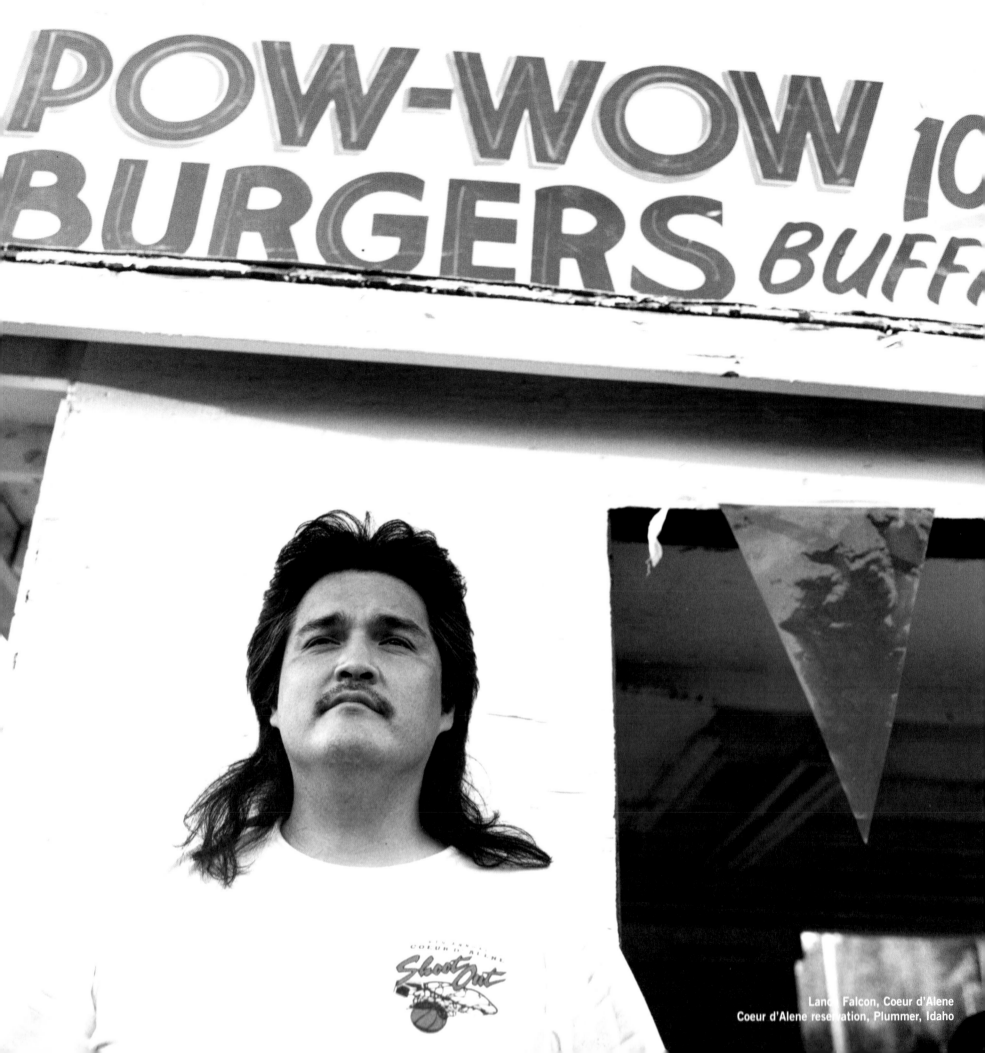

POW-WOW 10
BURGERS BUFF

Lance Falcon, Coeur d'Alene
Coeur d'Alene reservation, Plummer, Idaho

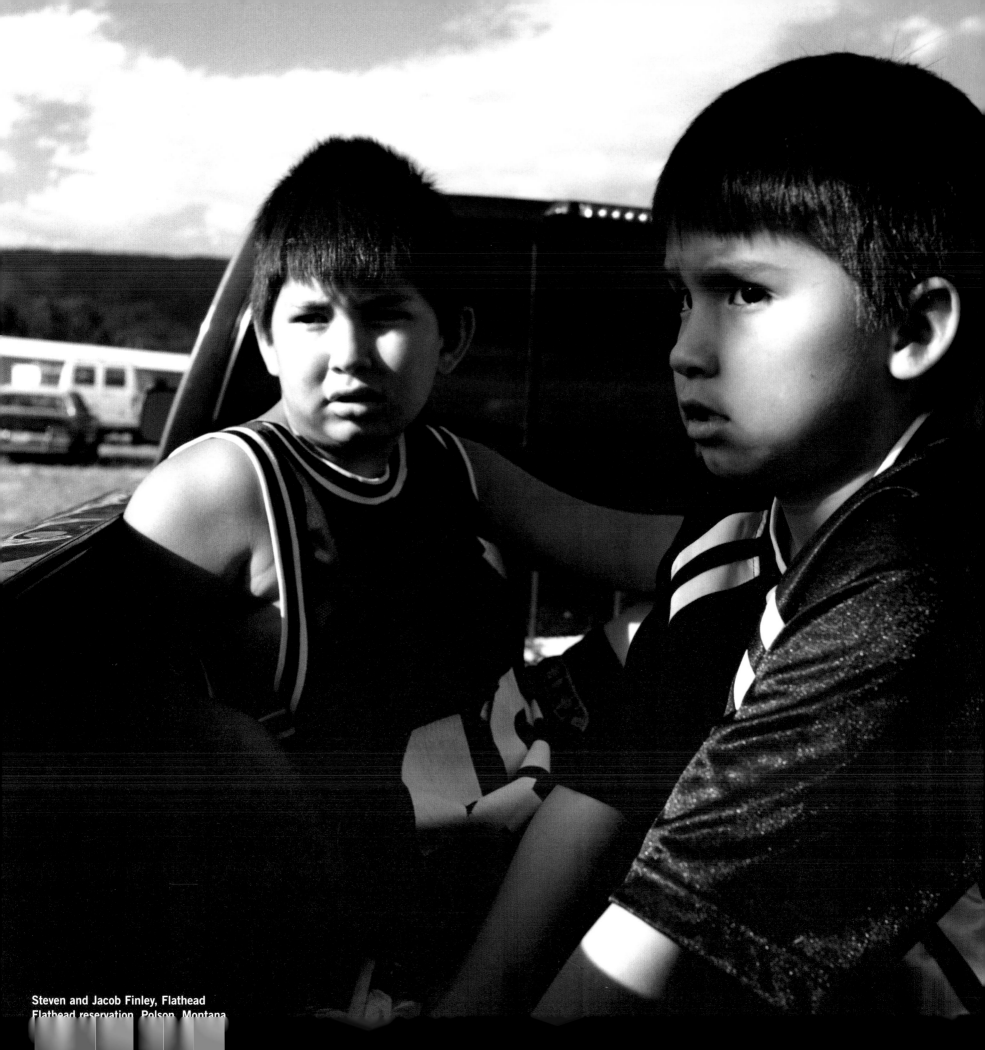

Steven and Jacob Finley, Flathead
Flathead reservation, Polson, Montana

Thomas Hewankorn (Salish/Kootani), BrandonMorigeau (Salish/Kootani),
Lance DeMarais, Kenny Charlo, Ryan Charlo, DJ Placlo, Kao Charlo, Flathead
Flathead reservation, Arlee, Montana

Wyoming

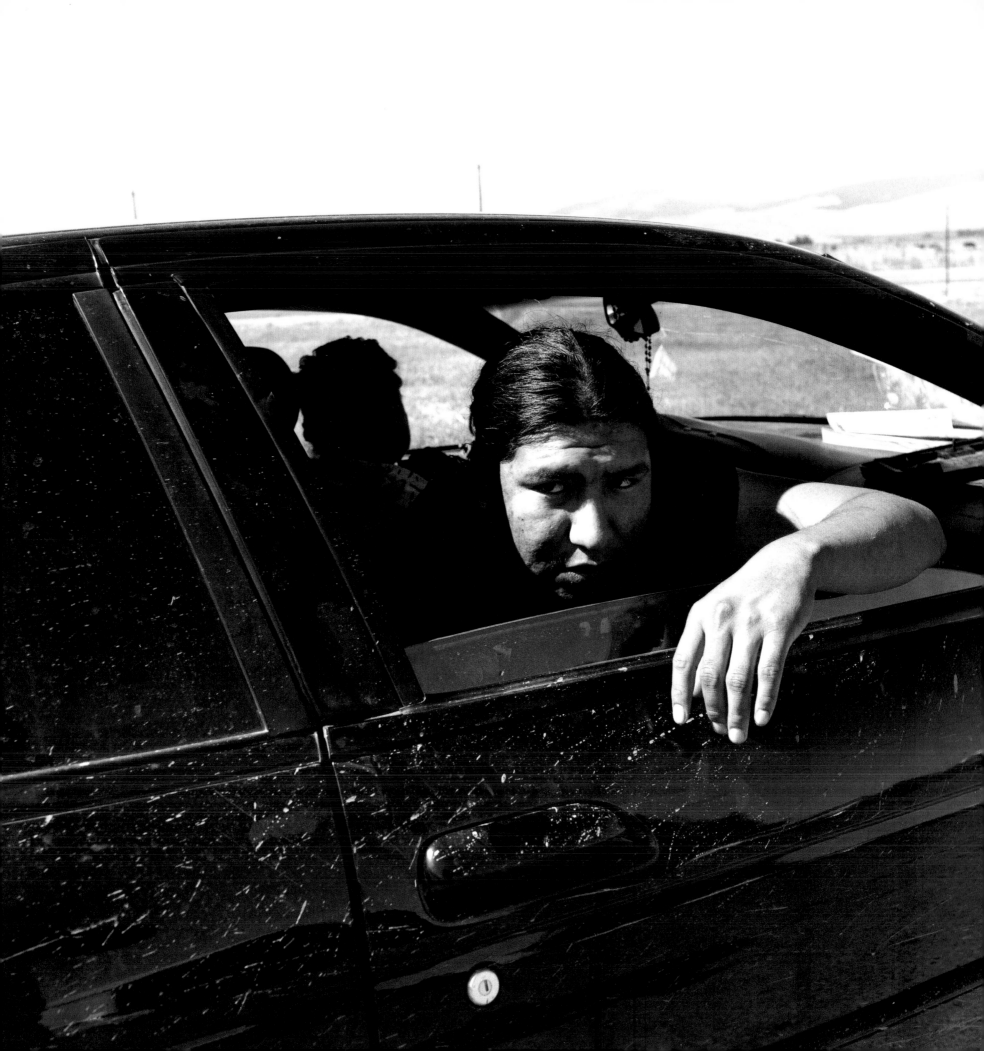

I'm not
an Indian, I'm a white guy.
I don't go to powwows. I don't speak Indian.
I do everything to the extreme."

RICHARD POGUE, SHOSHONE

Unemployed
Wind River reservation, Crowheart, Wyoming

Mary Littlelight Hudetz, Crow
Dancer, student, Alvin Ailey School, New York City

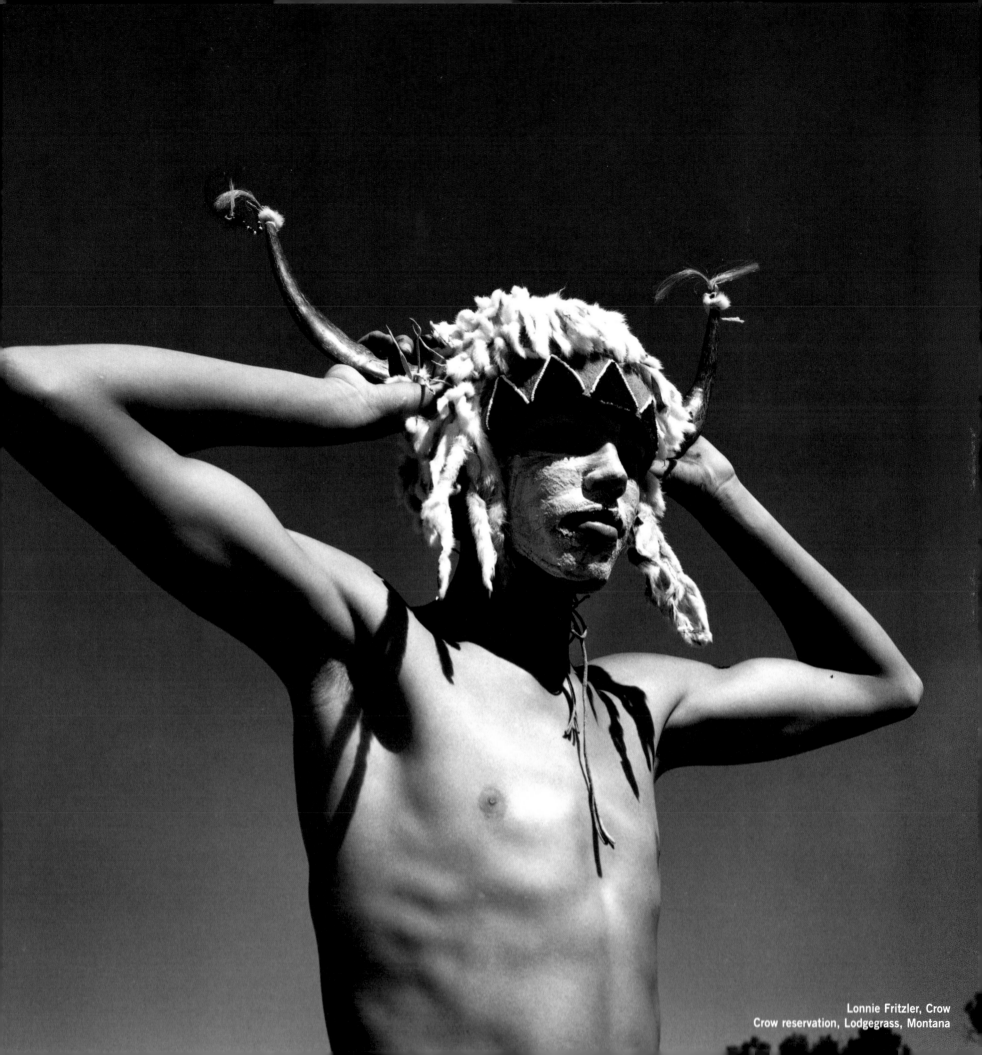

Lonnie Fritzler, Crow
Crow reservation, Lodgegrass, Montana

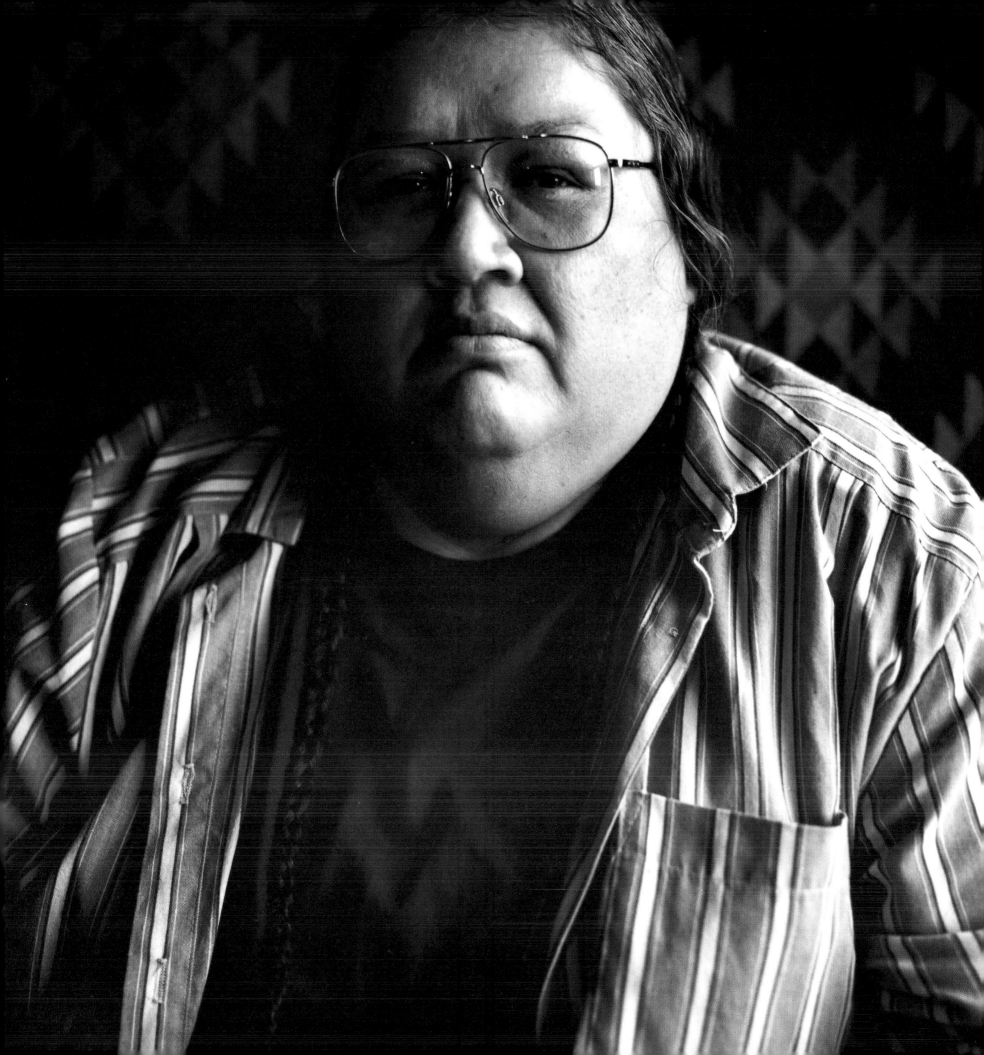

You may not believe in what we have, but you need to respect our things. Our sacred and ceremonial bundles we consider to be alive. They will all be making the long journey home when it is time for them. That's one of the longest trails the Indian people have been on, and it will continue into the future because it's a bureaucratic trail. My goal is to help return as much as possible. In the meantime, I take care of the sacred objects that are entrusted to my care and make sure they're respected the way they should be. These things are active and I'm usually the one that handles them. The others belong to men and only they can handle them. I've gone through the ceremonies and have been given the right to handle men's objects but I still don't, out of great respect. I arrange for a man to handle the men's objects. I never do anything without the tribal people's approval. That's how I learn to take care of them. If these sacred objects want water or light, we do that. We have found ways to put modern method with traditional method. I also take care of human remains. Nothing protected us from being dug up until 1990. Everybody else was protected because of consecrated ground. I've heard told that at one point there were more Indian human remains in museums than Indian people alive. I'm seen by a lot of people as a caretaker of our ancestors. It coincides with my Indian name, Baakaht-Dahsh Dehsh, One Who Cares for Children. No matter who I take care of, they were somebody's child at one point."

FAITH BAD BEAR, CROW / SIOUX

Crazy Horse clan
Assistant curator of Ethnology for the North American Indian Collection, Science Museum of Minnesota
St. Paul, Minnesota

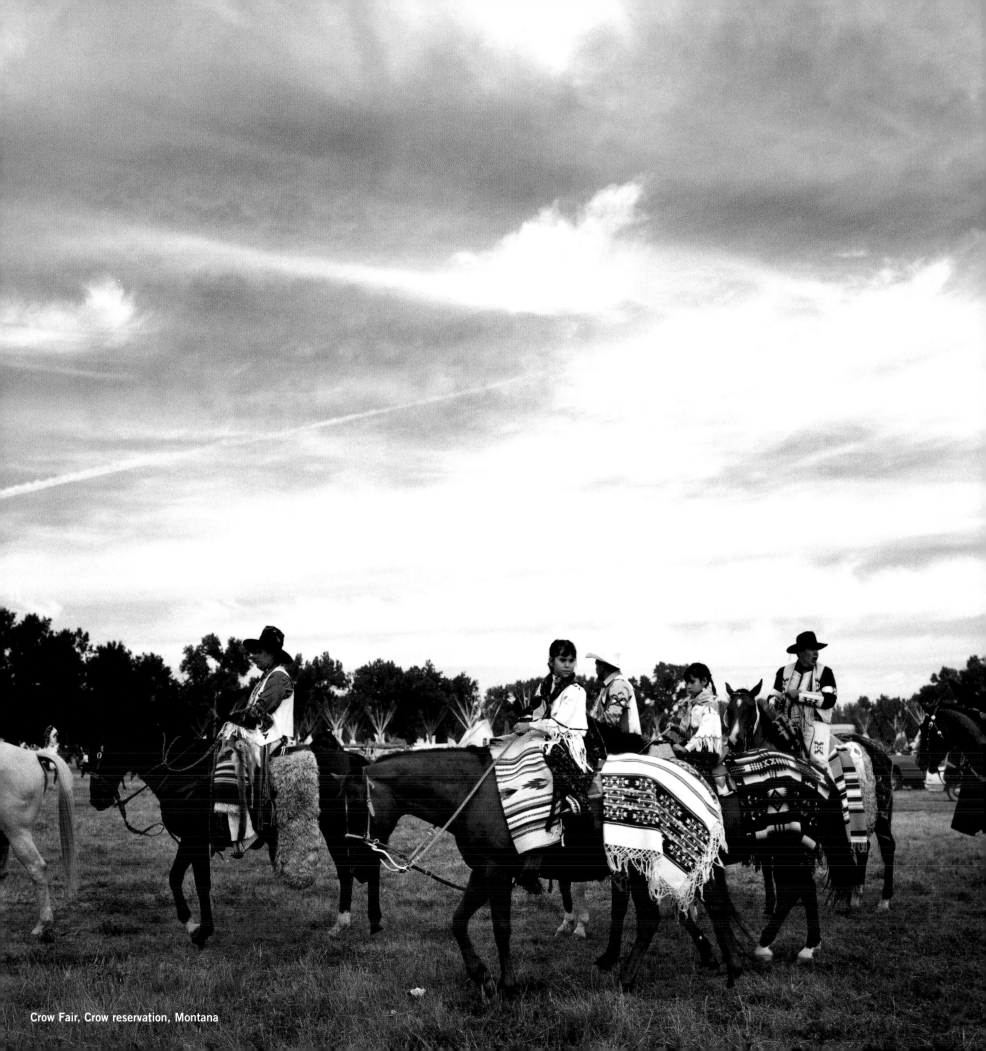

Crow Fair, Crow reservation, Montana

Tylynn and Taneisha Left Hand, Crow/Cheyenne
Crow reservation, Montana

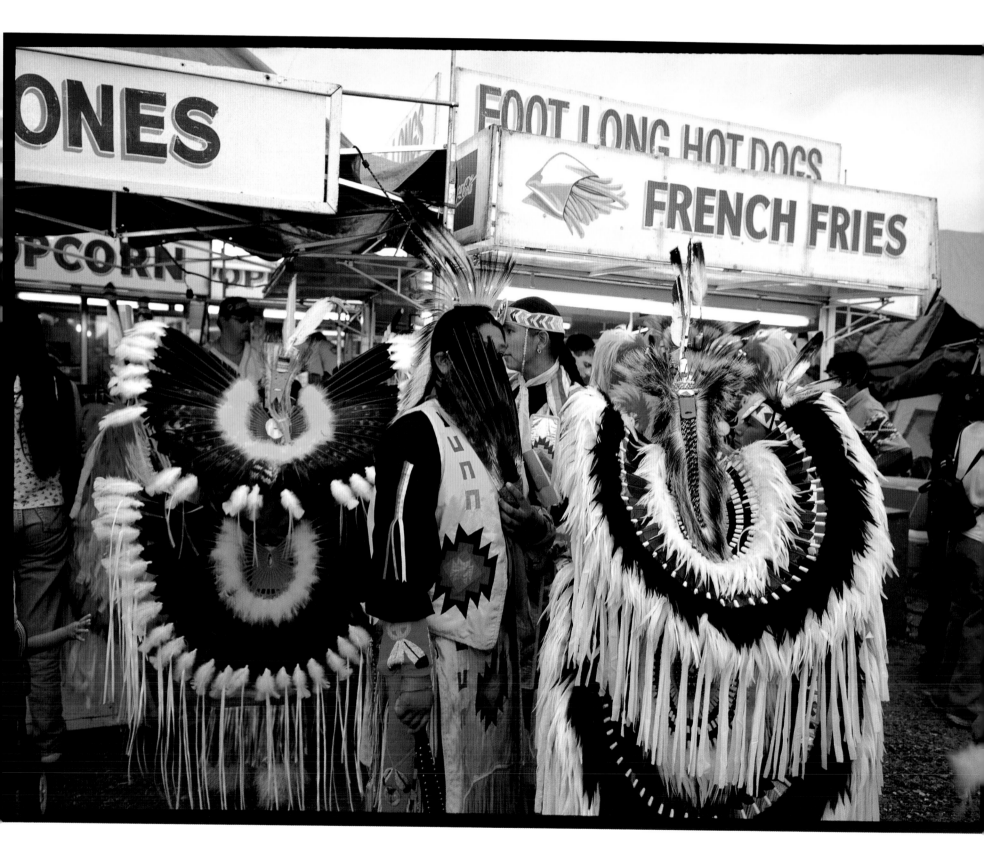

Crow Fair

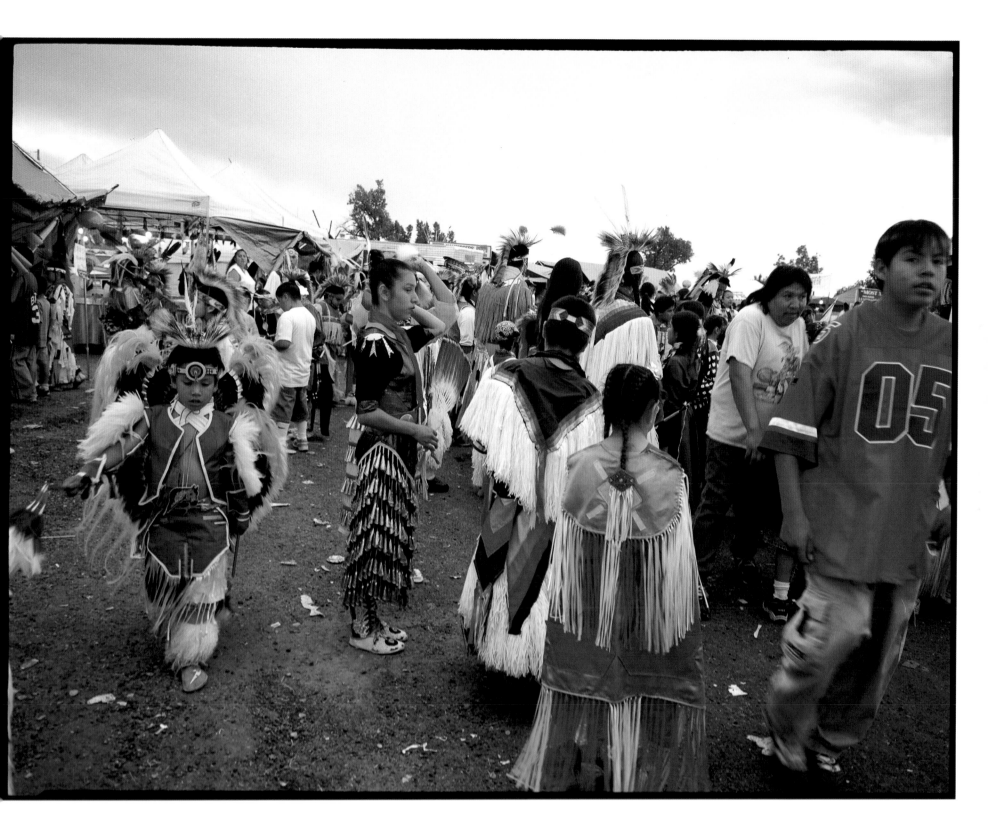

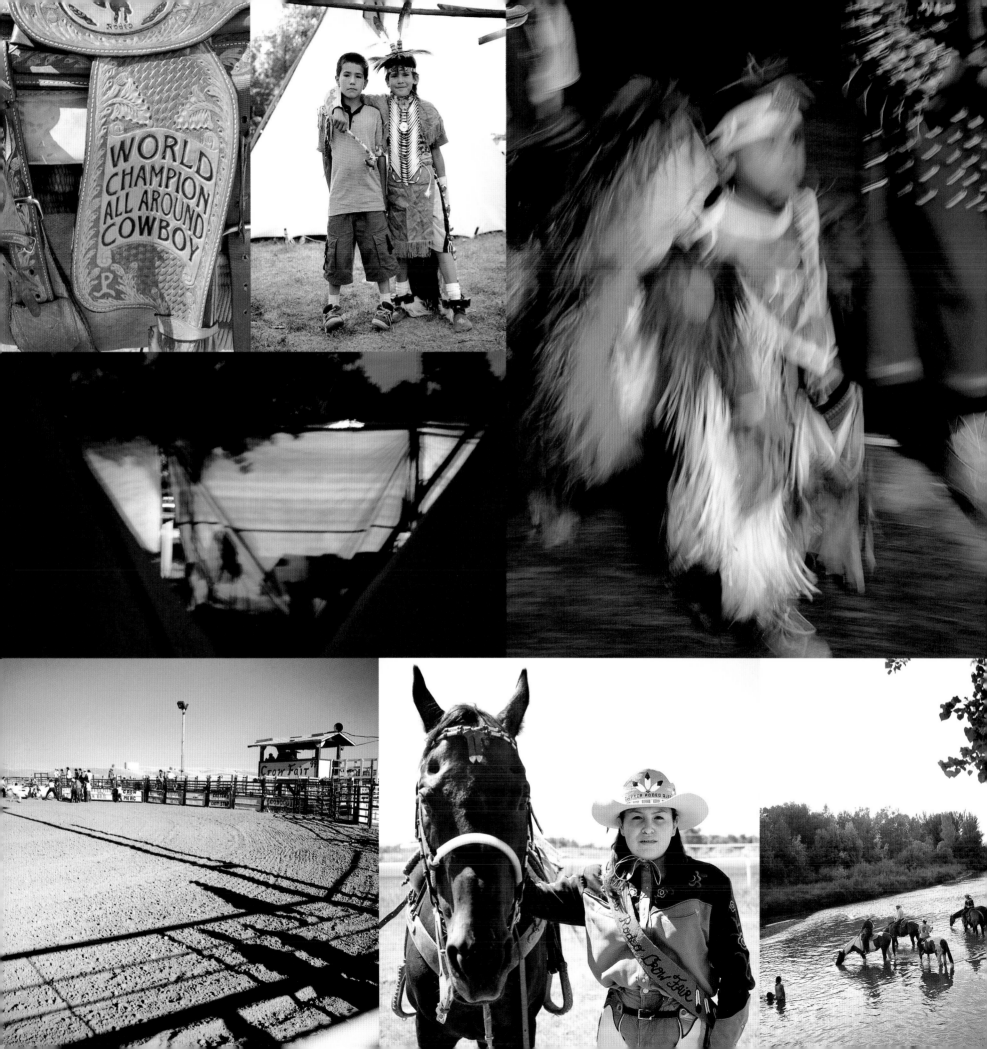

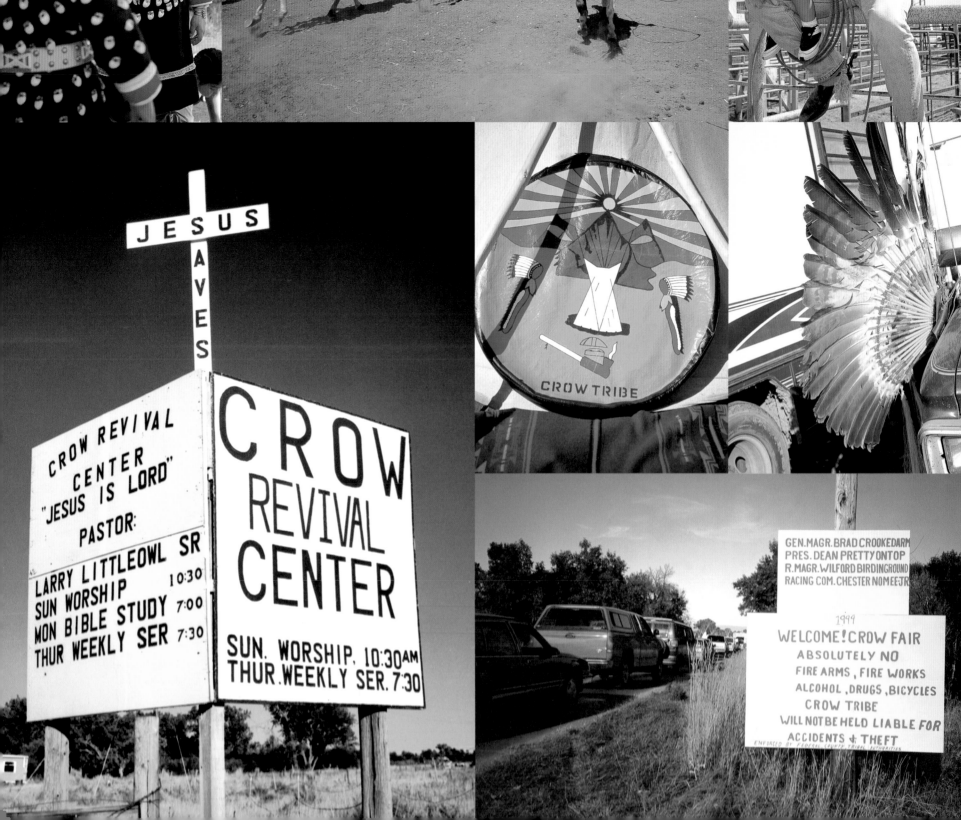

JESUS SAVES

CROW REVIVAL CENTER
"JESUS IS LORD"
PASTOR:
LARRY LITTLEOWL SR
SUN WORSHIP 10:30
MON BIBLE STUDY 7:00
THUR WEEKLY SER 7:30

CROW
REVIVAL
CENTER
SUN. WORSHIP. 10:30AM
THUR. WEEKLY SER. 7:30

CROW TRIBE

GEN. MAGR. BRAD CROOKEDARM
PRES. DEAN PRETTY ON TOP
R. MAGR. WILFORD BIRDINGROUND
RACING COM. CHESTER NOMEE JR.

1999
WELCOME! CROW FAIR
ABSOLUTELY NO
FIRE ARMS, FIRE WORKS
ALCOHOL, DRUGS, BICYCLES
CROW TRIBE
WILL NOT BE HELD LIABLE FOR
ACCIDENTS & THEFT
ENFORCED BY FEDERAL COUNTY TRIBAL AUTHORITIES

My mother was non-Indian, the daughter of Southern Baptist missionaries to China, and my father was Cheyenne. Because of my father, I believed it was possible to be thoroughly rooted in the Cheyenne way, and at the same time to engage in the world that sat beyond it. This view has characterized my life and career. As an attorney who represented Indian tribes and communities, and now as the director of the National Museum of the American Indian, I have always lived betwixt and between two worlds. This placement has allowed me to protect that from which I came, as well as to explain its value and authenticity to others."

W. RICHARD WEST, CHEYENNE

Director, Smithsonian Institution, National Museum of the American Indian
Washington, D.C.

"The world knows us as Cheyennes. We call ourselves Tsistsistas, the Human Beings. We follow our elders' instructions to 'Walk gently through life' and to 'Listen to every voice of Creation,' and to their wisdom that 'Our Nation will be strong so long as the hearts of the women are not on the ground.' The Tsistsistas are still here, in greater numbers than before and growing tall once more. And the hearts of our women are smiling."

Suzan Shown Harjo

Suzan Shown Harjo, Cheyenne/Hodulgee Muscogee
Poet, writer, curator, policy advocate,
president of the Morningstar
Institute, Washington, D.C.,
with her daughter,
Adriane Shown Harjo, Cheyenne/Hodulgee Muscogee
Performance poet, curator, artist
Washington, D.C.

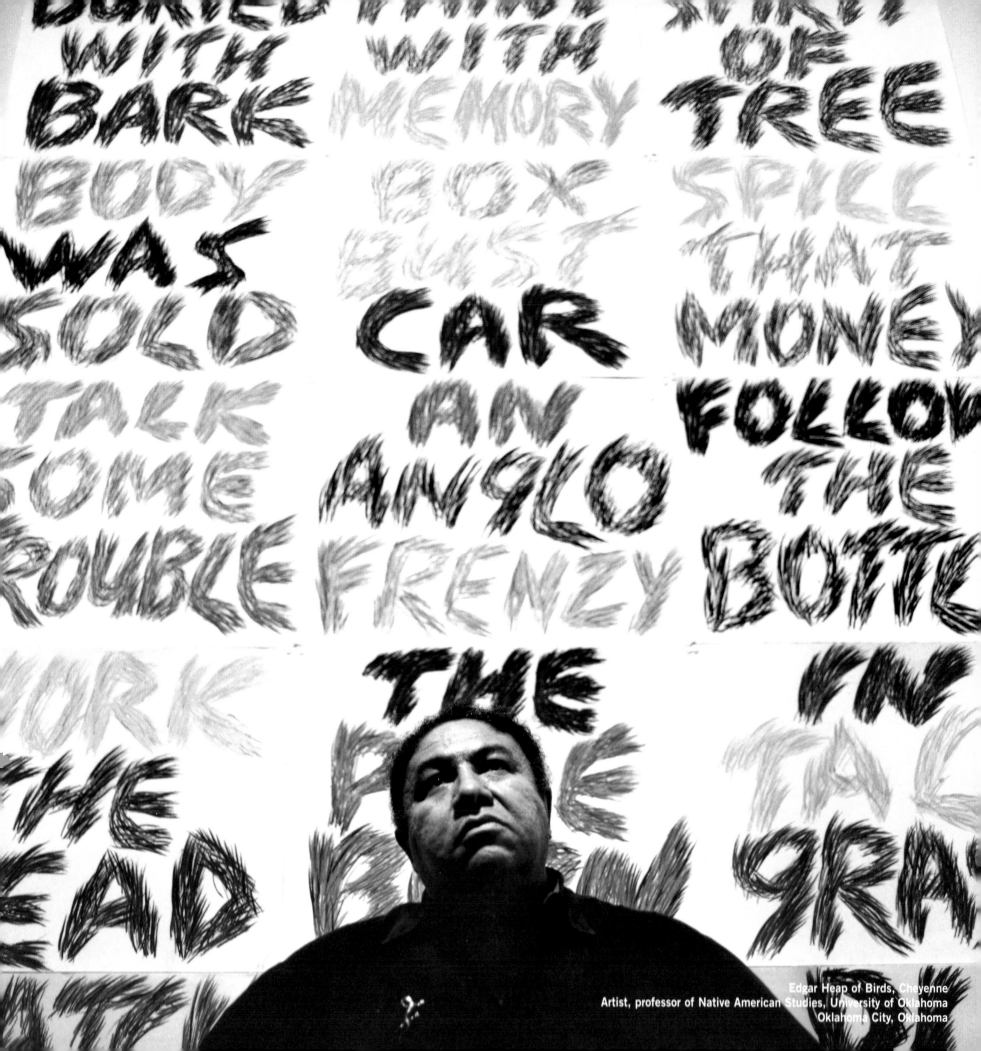

Edgar Heap of Birds, Cheyenne
Artist, professor of Native American Studies, University of Oklahoma
Oklahoma City, Oklahoma

"I'm an Indian who happens to be a filmmaker, a storyteller, whose vision is to see Indian people prosper as Indians, not just as Americans."

Chris Eyre, Cheyenne/Arapaho
Filmmaker, Rapid City, South Dakota

Darlene Miller, Canadian Delaware (Lenape)/White Earth Chippewa
Filmmaker, animator, Fort Wayne, Indiana
Annie Frazier Henry, Blackfoot/Sioux
Filmmaker, poet, child advocate, Vancouver, British Columbia
Ava Hamilton, Arapaho
Independent producer, director, Boulder, Colorado

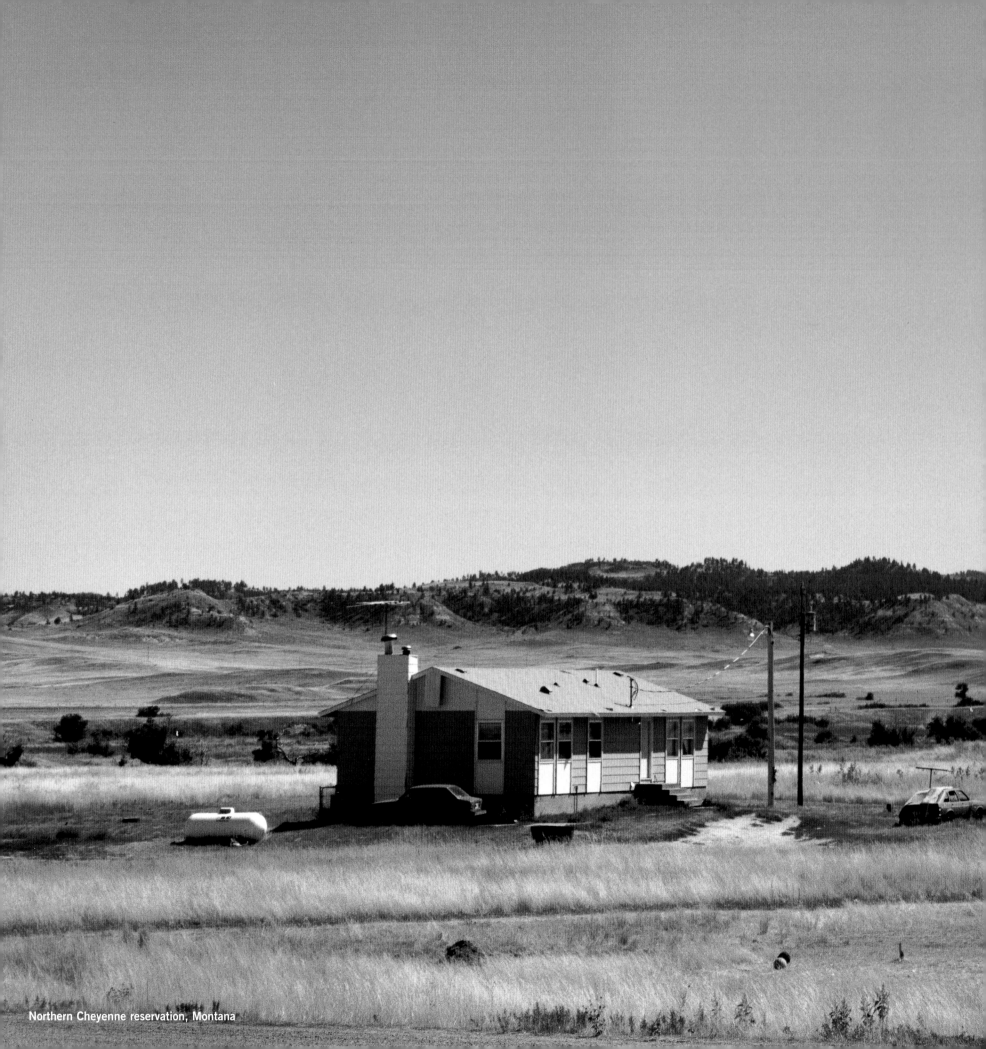

Northern Cheyenne reservation, Montana

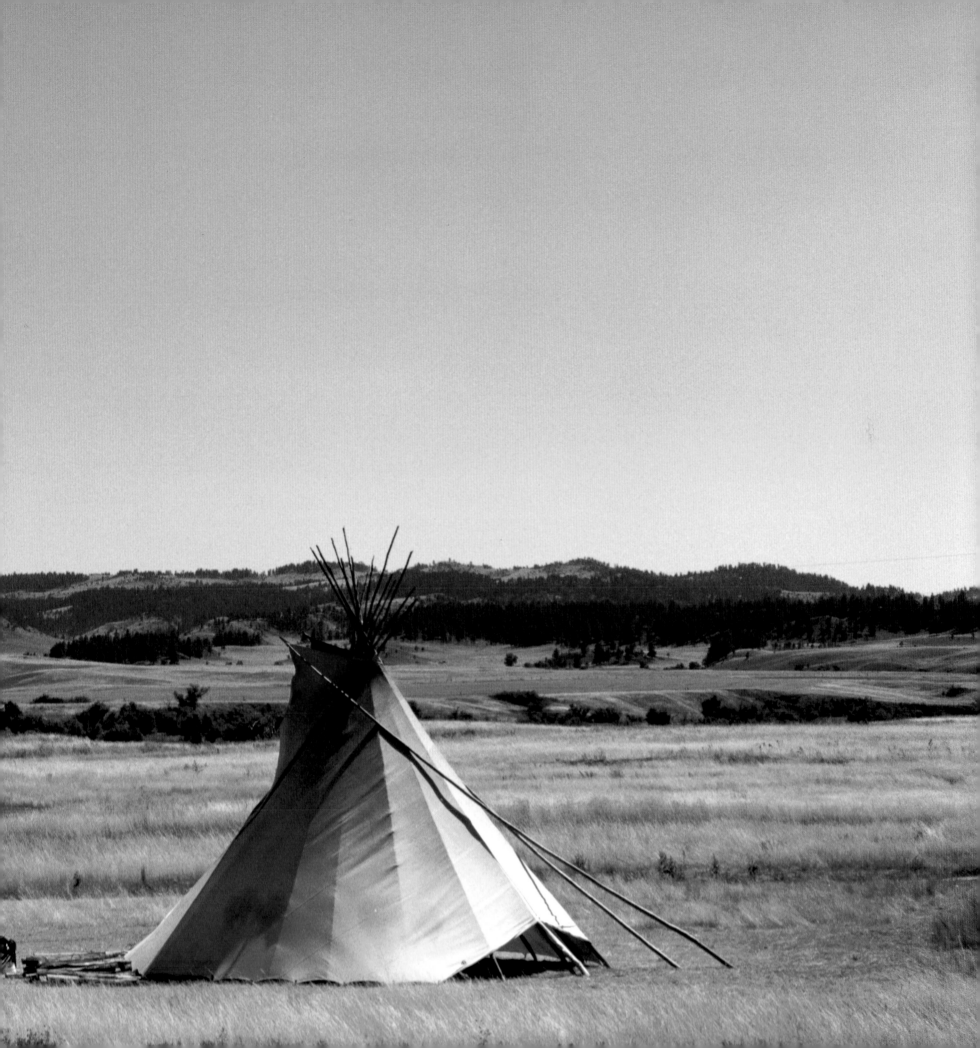

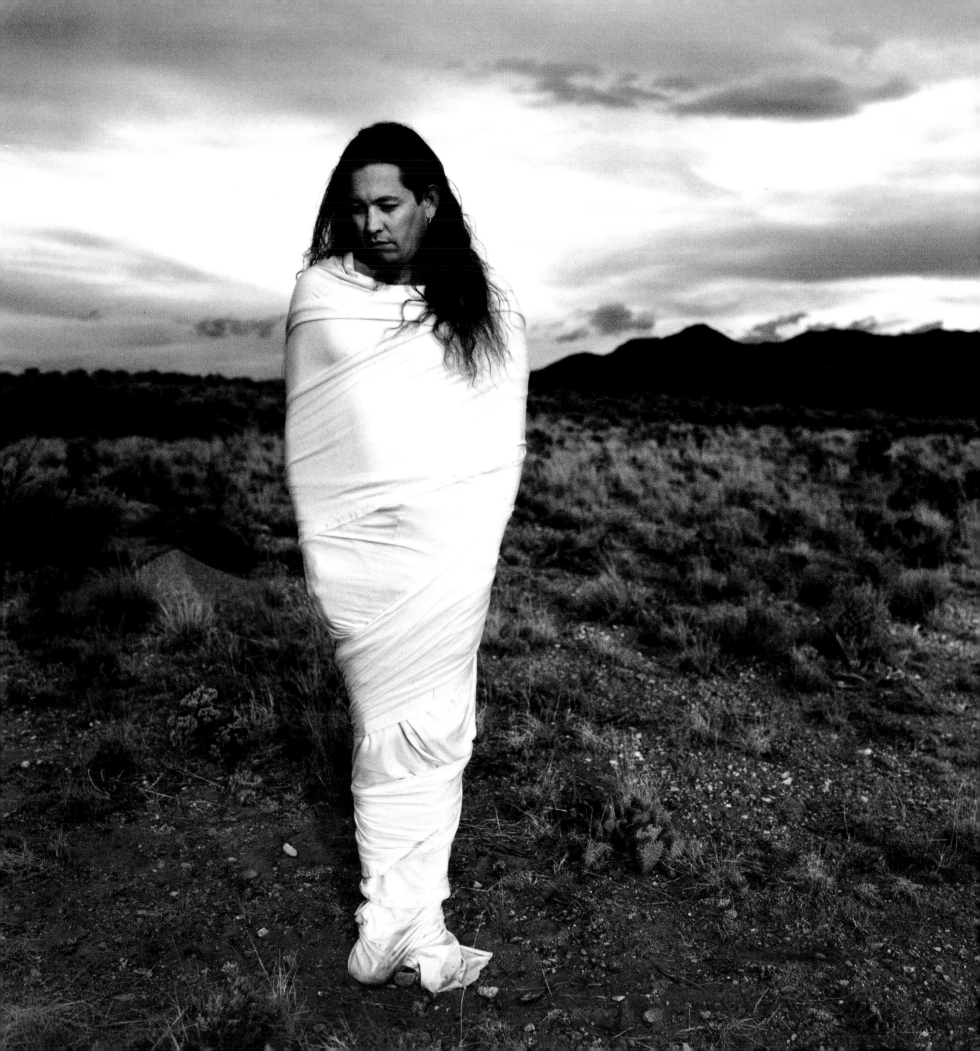

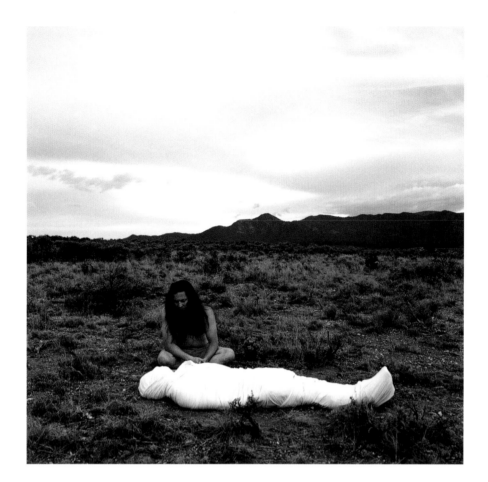

"I asked to be photographed this way because I have worked extensively with what I call the cocoon figure in my art. For me, the cocoon or chrysalis represents transformation and change, which is what my people are all about. Adaptability has been the hallmark of Indian cultures. We wouldn't be here today if it weren't for our ability to adapt without losing our identity. The dominant culture has refused to see this. They assume they have the right to define us. This right to define is embedded in Western culture. Their definition of us was established at the height of colonialism. When they tell our story, they always stop at 1900. The complete story can't be told without dealing with living Indian people. We are not a footnote to our own history."

BENTLY SPANG, NORTHERN CHEYENNE

Artist, curator
Billings, Montana

"I'm an adviser and I lead
different kinds of ceremonies;
naming, sweats, fasting, Sun Dancing,
also praying for people,
and helping the youth.
I tell the history of the Cheyenne people
so the youth will know
where they came from."

Charles Little Oldman, Northern Cheyenne
Spiritual leader of the Northern Cheyenne people, Gourd Dancer
Northern Cheyenne reservation, Lame Deer, Montana

Zane Spang, Northern Cheyenne
Service unit director, Northern Cheyenne Health Clinic, co-owner of Cheyenne Trailriders
Northern Cheyenne reservation, Ashland, Montana

When Columbus got off the boat he asked us who we were. We said we're the Human Beings, we're the People. Conceptually the Europeans didn't understand that, it was beyond their conceptual reality. They didn't see us. They couldn't see who we were. Historically speaking, we went from being Indians to pagans to savages to hostiles to militants to activists to Native Americans. It's five hundred years later and they still can't see us. We are still invisible. They don't see us as human beings, but we've been saying to them all along that's what we are. We are invisible to them because we are still the Human Beings, we're still the People, but they will never call us that. They taught us to call ourselves Indians, now they're teaching us to call ourselves Native Americans. It's not who we are. We're the People. They can't see us as human beings. But they can't see themselves as human beings. The invisibility is at every level, it's not just that we're tucked away out of sight. We're the evidence of the crime. They can't deal with the reality of who we are because then they have to deal with the reality of what they have done. If they deal with the reality of who we are, they have to deal with the reality of who they aren't. So they have to fear us, not recognize us, not like us. The very fact of calling us Indian creates a new identity for us, an identity that began with their arrival. Changing identity, creating a new perceptual reality, is another form of genocide. It's like severing a spiritual umbilical cord that reaches into the ancestral past. The history of the Indians begins with the arrival of the Europeans. The history of the People begins with the beginning of the history of the People. The history of the People is one of cooperation, collectivity, and living in balance. The history of the Indians is one of being attacked and genocide, rather than a history of peace and balance. The history of the People under attack, the Indians, in an evolutionary context is not very long, it's only five hundred years. The objective of civilizing us is to make Indian history become our permanent reality. The necessary objective of Native people is to outlast this attack, however long it takes, to keep our identity alive."

JOHN TRUDELL, SANTEE SIOUX

Poet, recording artist
National spokesman during the 1969–71 Indians of All Tribes Occupation of Alcatraz Island
National chairman of the American Indian Movement from 1973 to 1979
Los Angeles, California

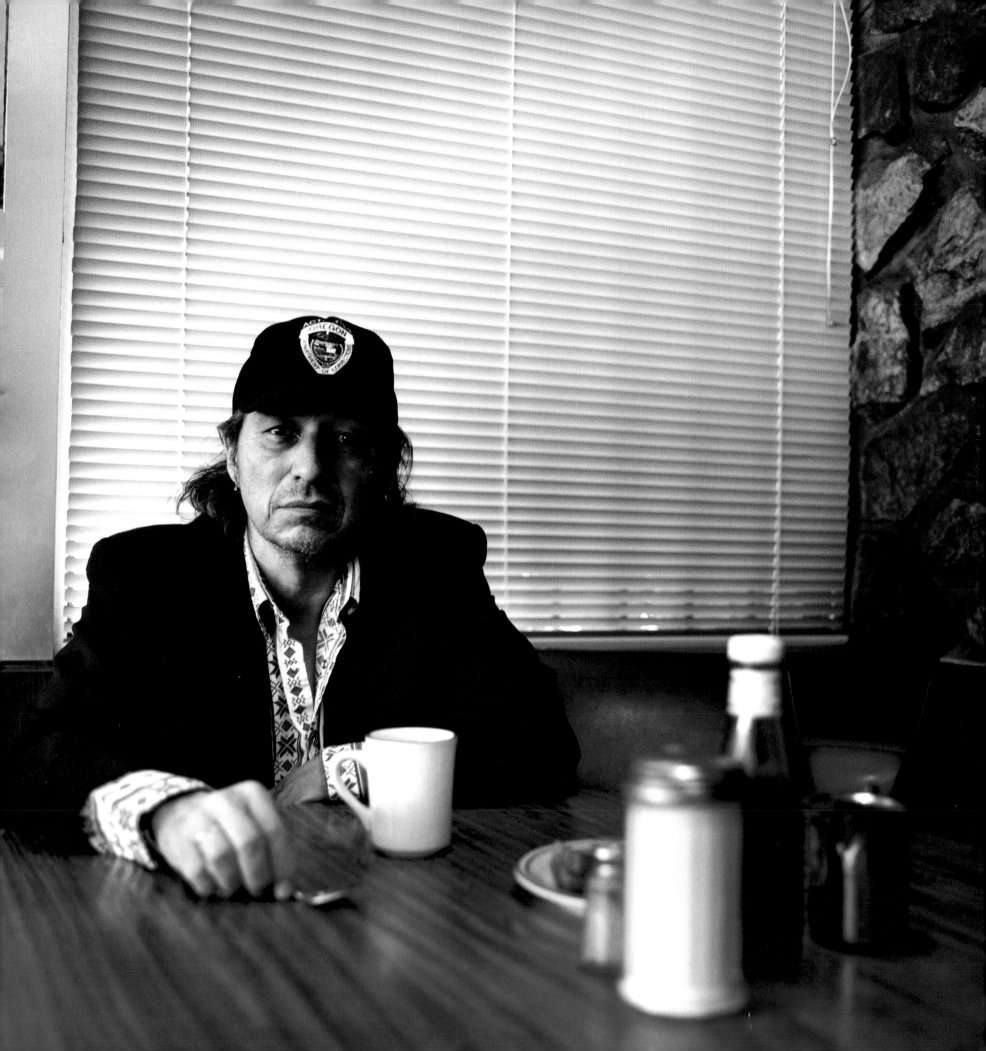

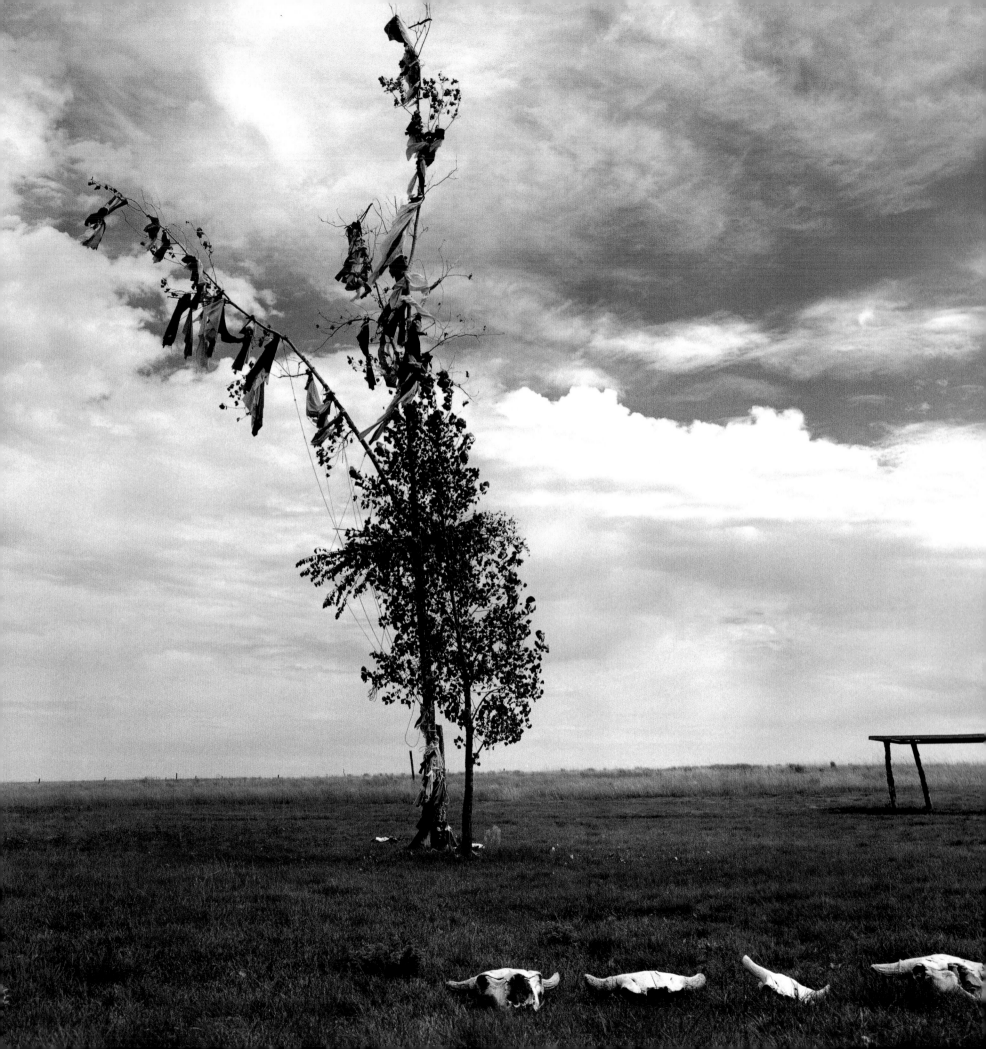

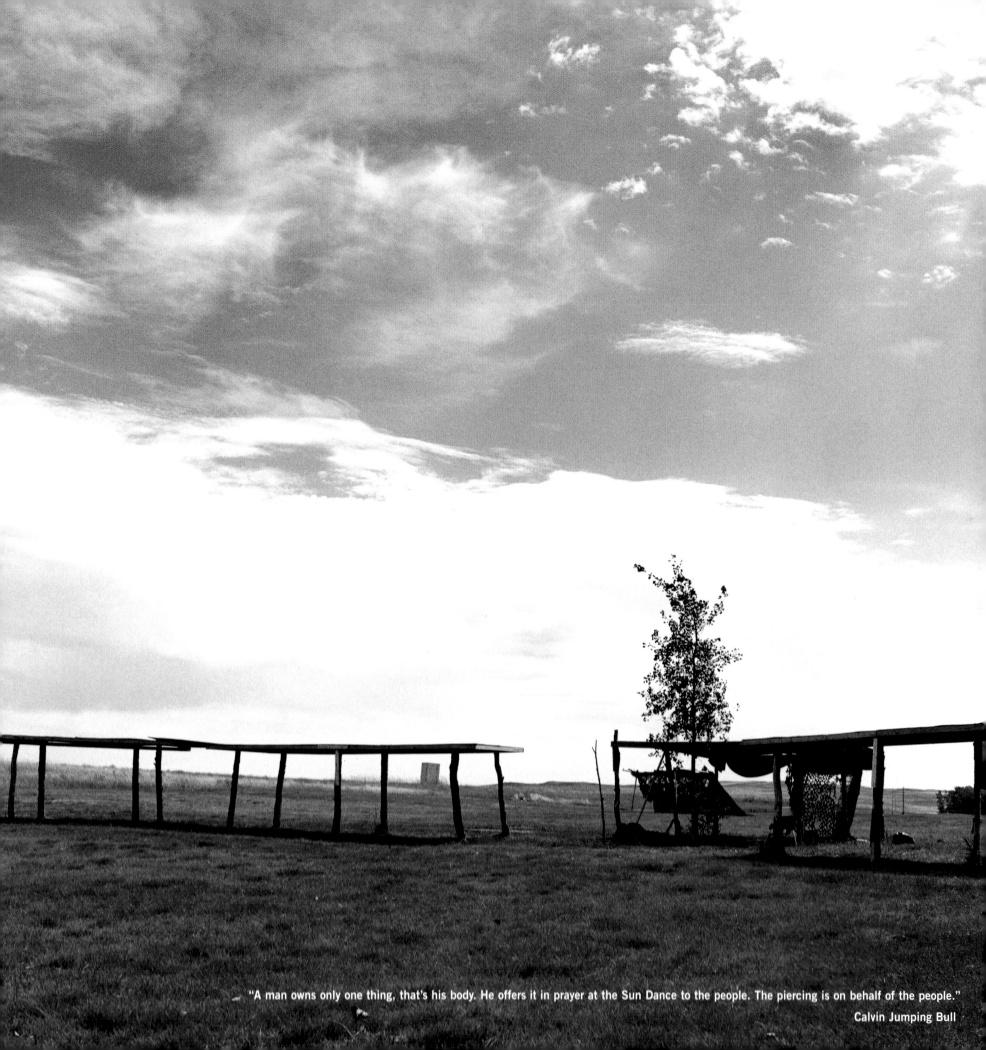

"A man owns only one thing, that's his body. He offers it in prayer at the Sun Dance to the people. The piercing is on behalf of the people."

Calvin Jumping Bull

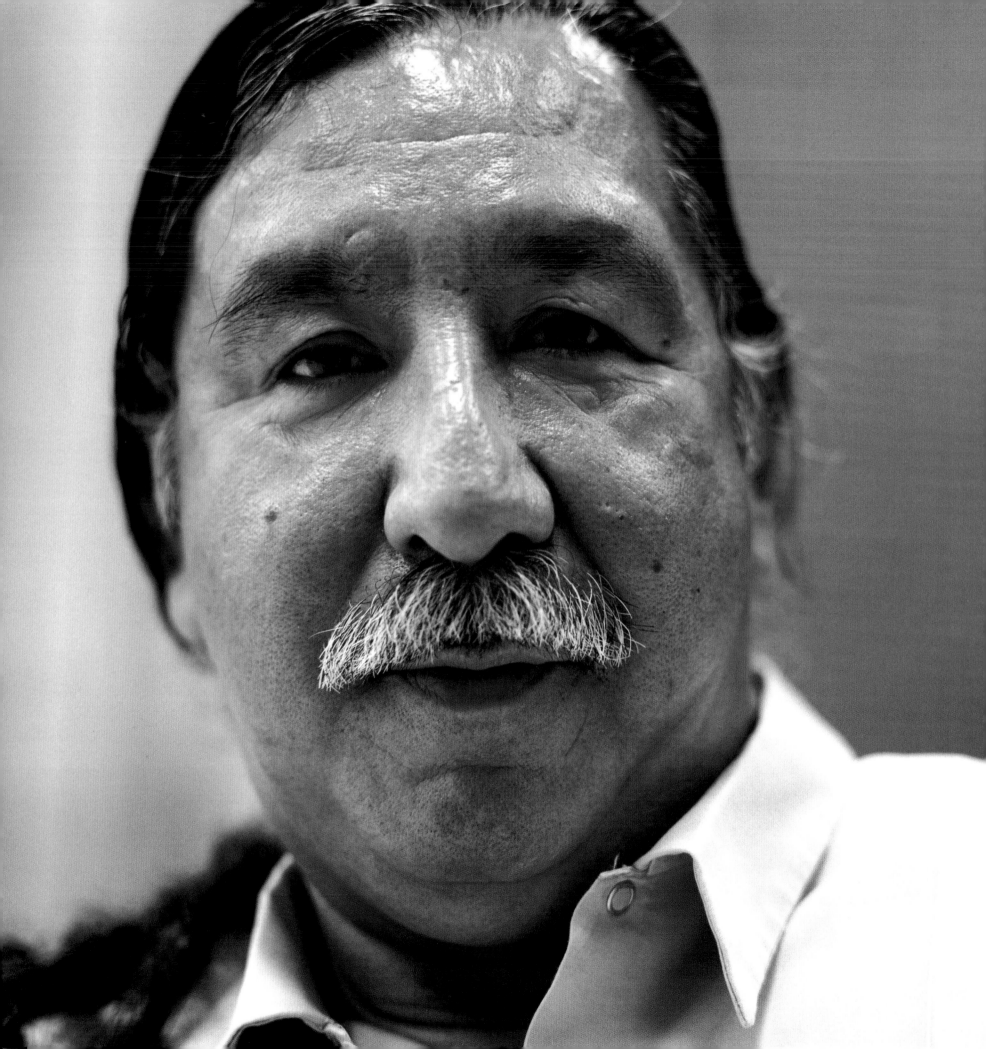

We have to continue to tell the world that we have a legitimate religion. And we have to show people that it's not barbaric. The piercing, it's painful, but it's something I wanted to do. I wanted to pierce, I wanted to sacrifice to the Creator. One reason I pledged to Sun Dance was to thank the women of the world, especially the women who bear my children. I know the pain they must go through having a child. I can't take their place, I can't share their pain. My pledge was to honor the women.

"I would like to say to the children, the young people, to learn about their people, about their culture, to be proud of who they are. The kids, I'd like to see them carry themselves with respect, to have high morals. That's the way of our people.

"They can take away my freedom, but they can't take away what I believe in."

LEONARD PELTIER, DAKOTA/TURTLE MOUNTAIN CHIPPEWA

Artist, writer, activist
United States Penitentiary, Leavenworth, Kansas

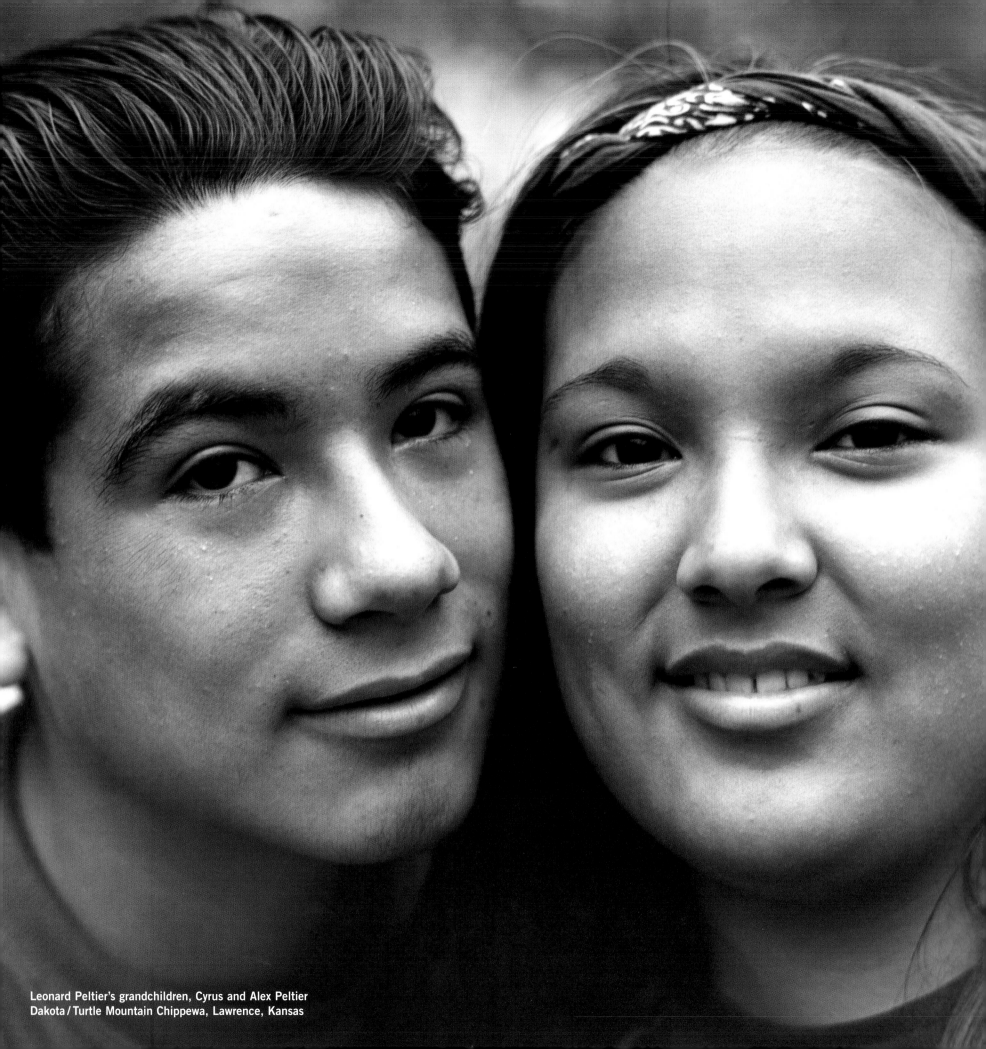

Leonard Peltier's grandchildren, Cyrus and Alex Peltier
Dakota / Turtle Mountain Chippewa, Lawrence, Kansas

Calvin Jumping Bull, Oglala Lakota
Educator since 1957, teaches Lakota language, philosophy, history, culture
Pine Ridge reservation, Oglala, South Dakota

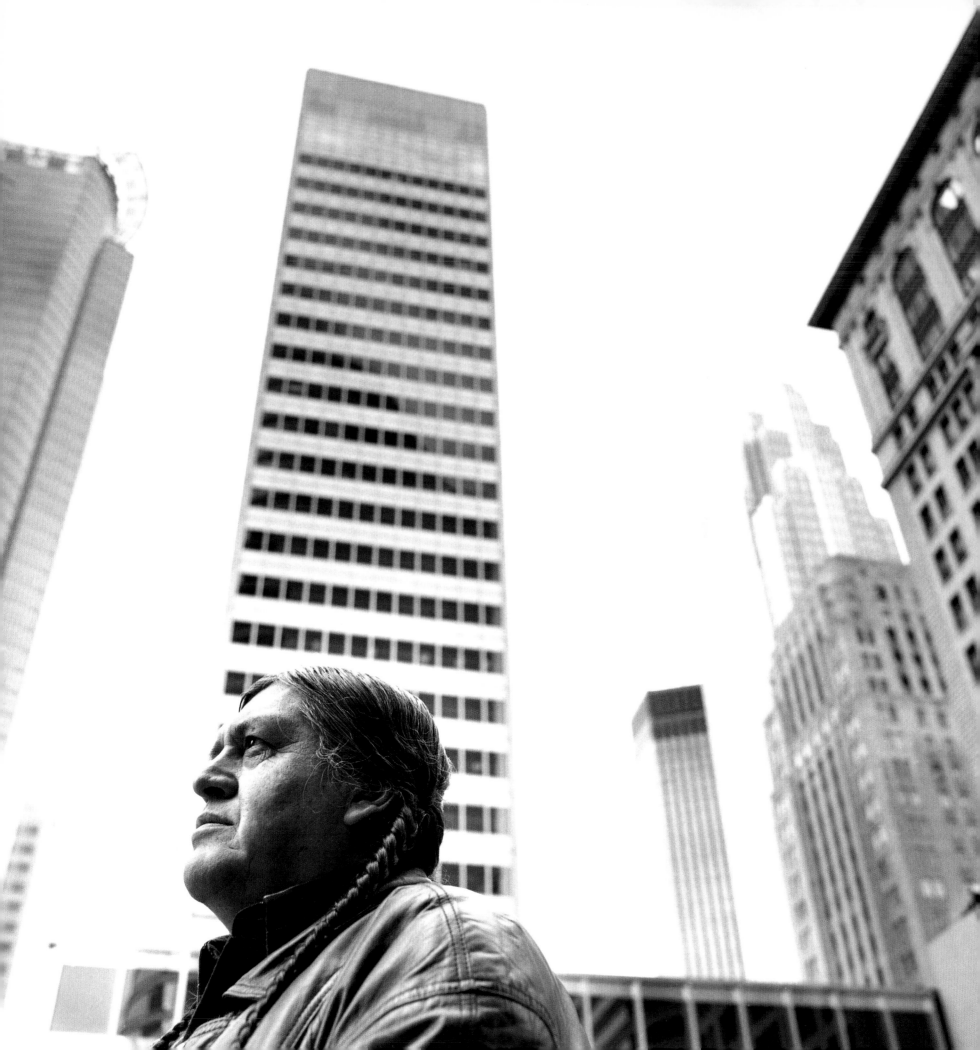

There's a border town syndrome in America. They still have that frontier mentality. It's still open season on Indians. We're the only race that's used as a mascot. We've been edited out of existence in modern education. They think about us as a romantic part of history. Before casinos, Indians weren't thought of in an economic sense, except on the nickel."

WILLIAM MEANS, OGLALA LAKOTA

Activist, director of the International Treaty Council, Vietnam veteran
Minneapolis, Minnesota

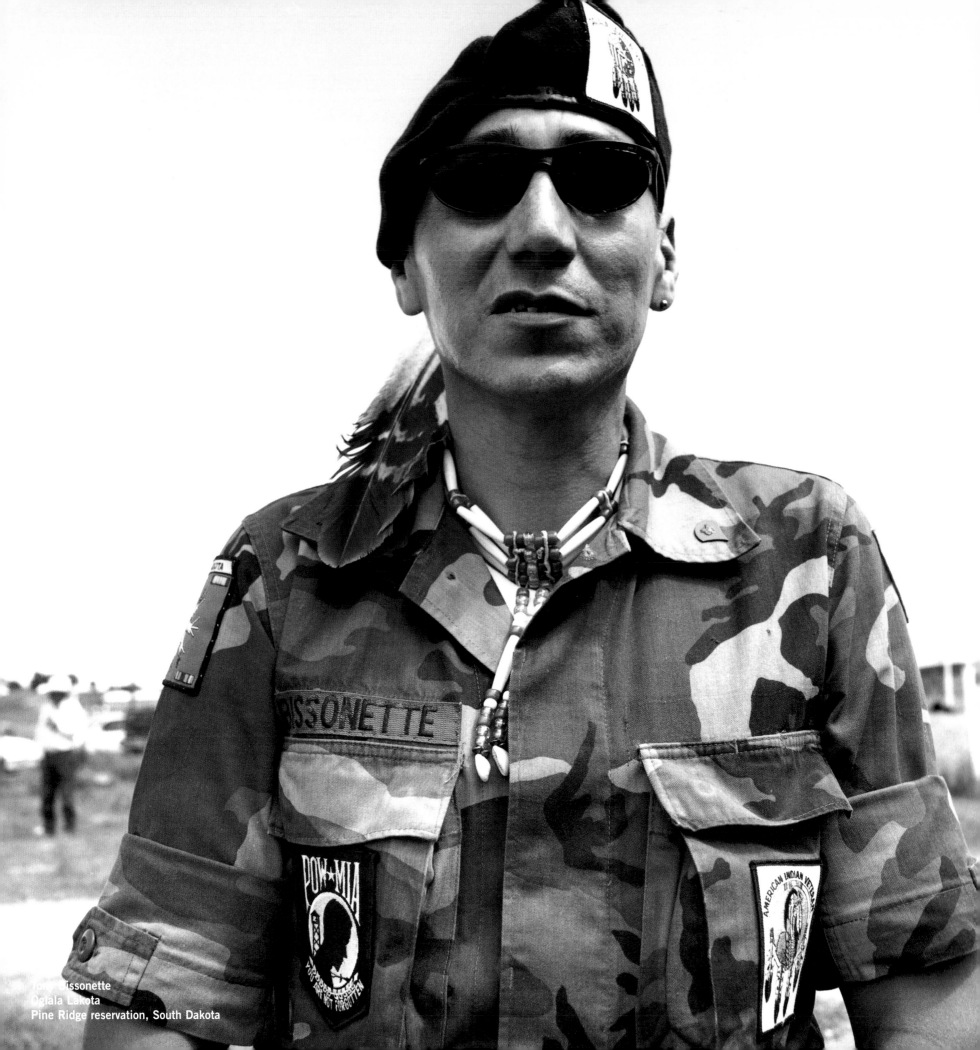

Tony Bissonette
Oglala Lakota
Pine Ridge reservation, South Dakota

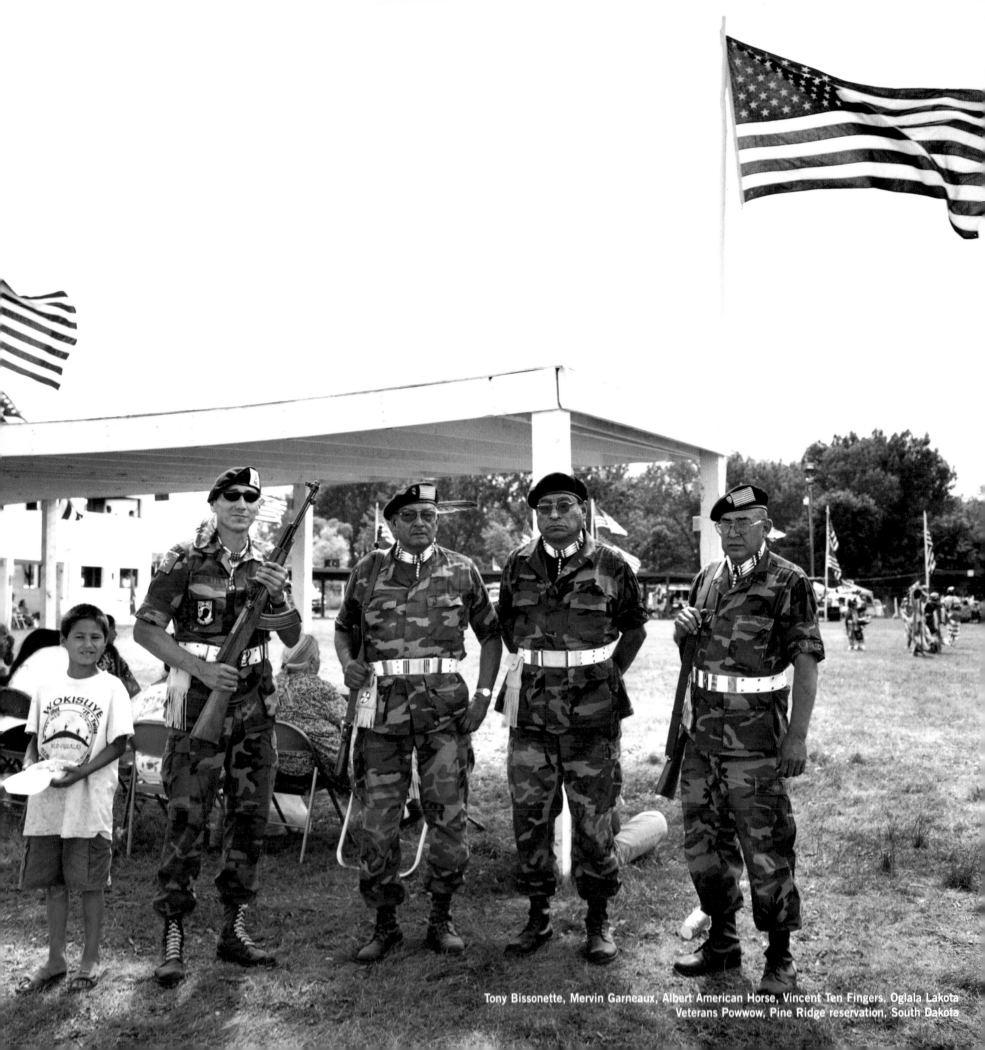

Tony Bissonette, Mervin Garneaux, Albert American Horse, Vincent Ten Fingers, Oglala Lakota
Veterans Powwow, Pine Ridge reservation, South Dakota

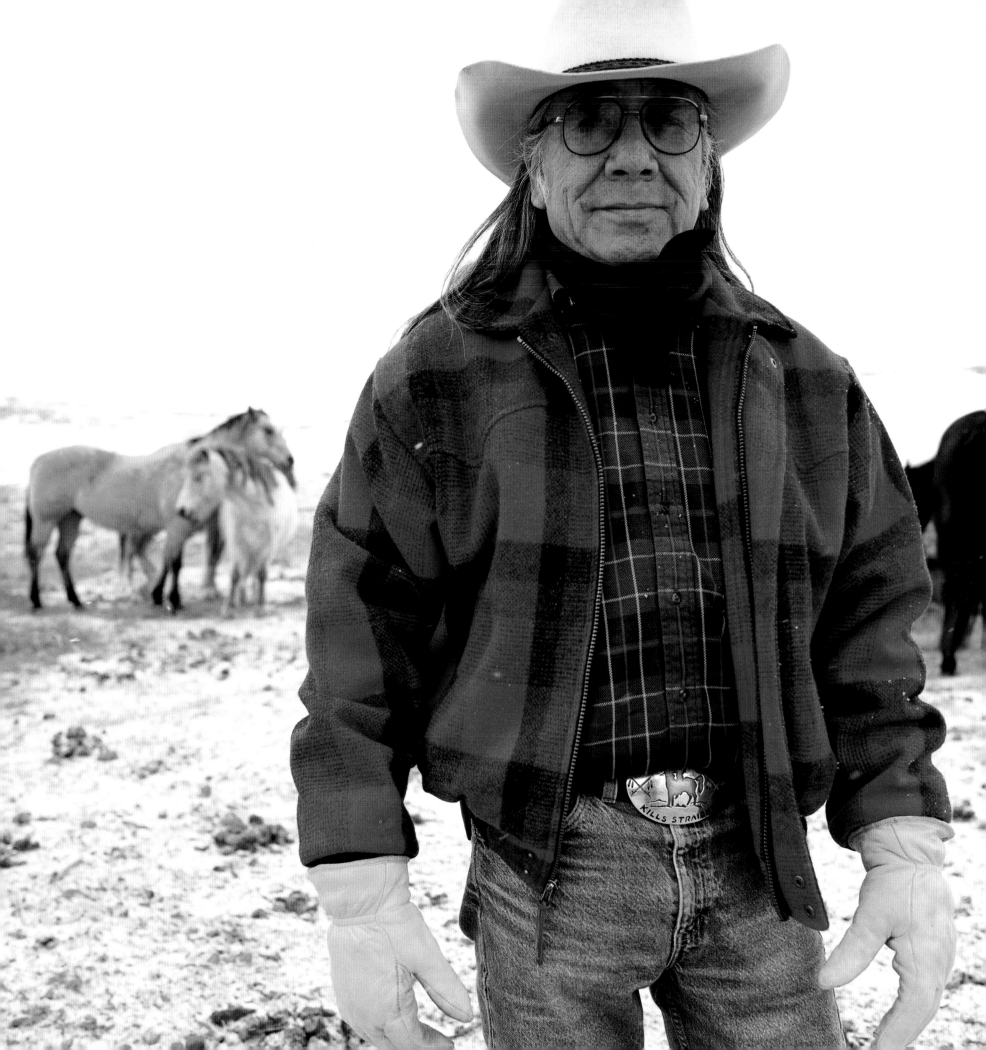

I'm the grandson of White Lance, who was one of the few survivors of Wounded Knee. In 1968 I began to have a recurring dream. I saw myself on a black horse, riding with people who were in wagons, walking, and riding. I realized it was the ride to Wounded Knee in 1890. In 1982 I went to the first of many ceremonies. The medicine man said the spirits wanted to talk to me and I should be prepared for it. I had to cleanse myself, to go to *inipi* as often as possible. The spirits liked what I was thinking about, that I wanted to retrace the ride and pray. My wife, Ethel, was a tremendous help during this time and on our journey. In 1986, Alex White Plume, Eugenio White Hawk, myself, and sixteen others went up to Bridger and began the ride. We didn't really know where we were going when we started, but then the first day we just knew where we were headed. Alex, Eugenio, and I fasted for four days and four nights as we rode. I felt and saw the presence of the people who were there in 1890 around me. We began to realize the significance of what we were doing, and thought about the spiritual instructions that we had received in the beginning and along the way. The ride was about having the knowledge of what happened then, and about the way we had been as a nation. At that time the whole Oglala nation that I am a part of was falling apart. Families were falling apart, there was so much alcoholism and suicide. There were a lot of problems on Pine Ridge as a result of colonization. Another society was dictating our lifestyle. The sacred ways were being forgotten. As we began to lose the moral aspects of our society, we were becoming brown facsimiles of the white people. During the Ride we had ceremonies all along the way, and we continue to do this. The first day we prayed for the children, that they would have a future. The second day we prayed for the elderly people who had retained their language and culture, who had held on to what they had. We prayed that they would continue to pass that on to the young people. The third day we prayed for the sick and infirm, the spiritually and emotionally weak. As a people we were spiritually weak. Many of us had become Christian, which was foreign to this land. We as Lakota had been grounded in our spirituality. On the fourth day, we prayed for the incarcerated, and for the people trapped in white society. On the fifth day we prayed for the women. The women are the sacred life-givers. We are a matriarchal and matrilineal society, except many of us have lost that understanding. The sixth day we prayed for *Wolakota*, peace and tranquillity. We prayed that there would be peace within our society, and for our neighbors, and all humans, and also between humans and nature. The seventh day we prayed for the people who were massacred at Wounded Knee, for the tragic way they were killed, and we prayed that there would be no more of this activity toward indigenous people. Today I look back to the beginning of the Rides, to when we began to confront the past. We listened and we learned and we can understand now the greatness of our nation. Since that time a lot of spiritual activity has taken place. Today we can deal with trauma, we can heal from within. The nation was falling apart, and now we are learning to heal ourselves."

BIRGIL KILLS STRAIGHT, OGLALA LAKOTA

Traditionalist, author, former educator, programs administrator, founder of the Chief Big Foot Memorial Ride

Pine Ridge reservation, Kyle, South Dakota

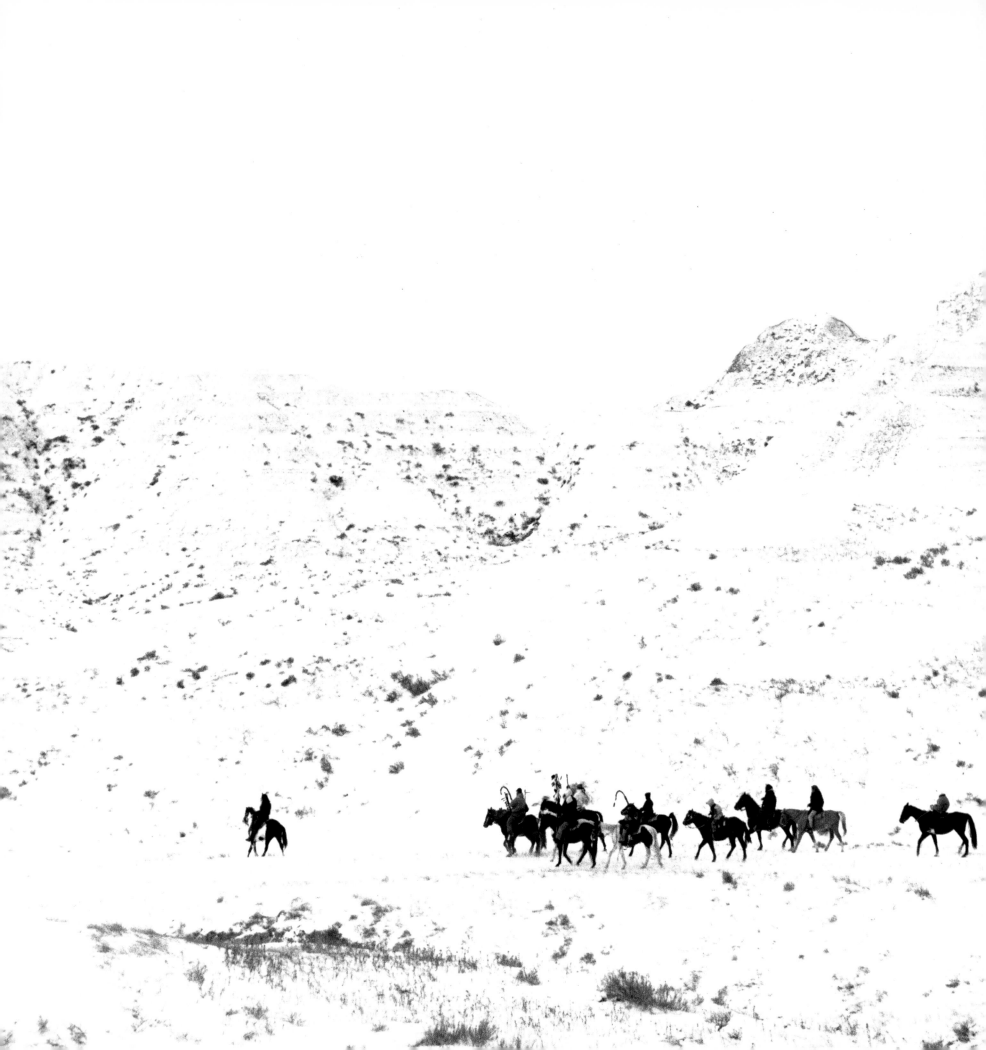

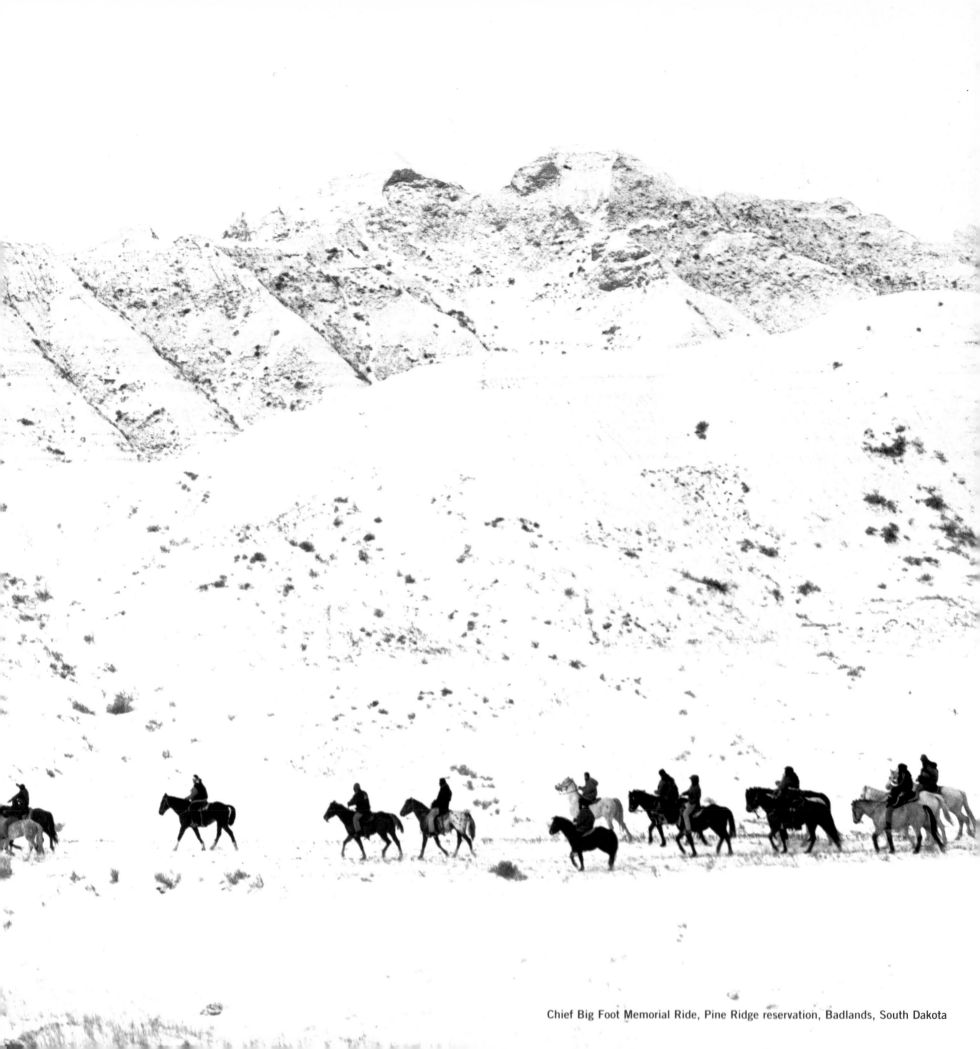

Chief Big Foot Memorial Ride, Pine Ridge reservation, Badlands, South Dakota

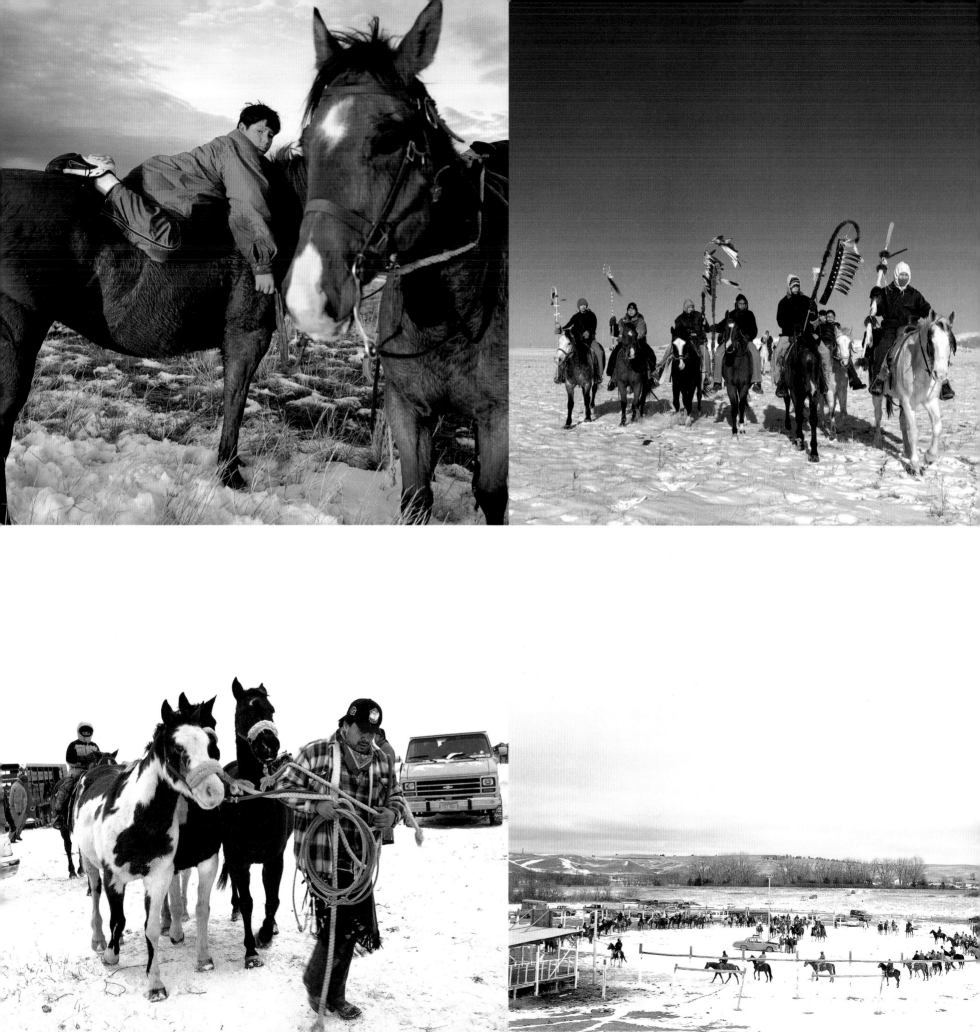

MASSACRE
(CONTINUED)
9:00 a.m. by a line of foot soldiers and cava...

On December 15, 1890, Hunkpapa Lakota Chief Sitting Bull was murdered while resisting arrest at the Standing Rock Agency. Sitting Bull and Minnecoujou Lakota Chief Big Foot had been placed on the U.S. Army's list of "fomenters of dissent," for violating the federal Indian "civilization" rules by practicing their traditional religion. After Sitting Bull was killed, some of his people fled to Big Foot's camp at Grand River.

Oglala Lakota Chief Red Cloud had sent runners to tell Big Foot of impending danger; the 7th Cavalry was gathering and threatening to take Red Cloud prisoner. Red Cloud asked Big Foot to come and help, and warned him that he should take a safe route on his way south. Big Foot was also seeking food and safety for his people. The journey to Pine Ridge began on December 15.

A large number of Lakota had gathered on Stronghold Table, a mesa in the Badlands, for a Ghost Dance. They were talked into relocating to a flat plain beside Wounded Knee Creek. The Indians had also agreed to give up their weapons. On December 28 the 7th Cavalry intercepted Big Foot's people and escorted them to this camp. Throughout the night, the Army soldiers surrounding the camp drank heavily, celebrating their success in rounding up and disarming the Indians, especially the relatives of Sitting Bull, one of the 7th Cavalry's most hated enemies from the Battle of the Little Big Horn.

A blizzard moved in on the morning of December 29. The soldiers moved into the camp and, provoked by an accidentally fired gun or perhaps a handful of dirt thrown into the air by a medicine man, began to fire on the disarmed Indians. More than 400 men, women, and children were massacred. Among them was Big Foot. Most of the nearly 150 survivors were seriously wounded and lived only for days and weeks afterward. There were 30 casualties among the cavalrymen from friendly fire. The soldiers dug a mass grave pit and packed the frozen Indians down in it. The 7th Cavalry soldiers received Medals of Honor for their heroism at the "Battle of Wounded Knee."

In 1990 the Congress of the United States formally apologized for the Wounded Knee Massacre.

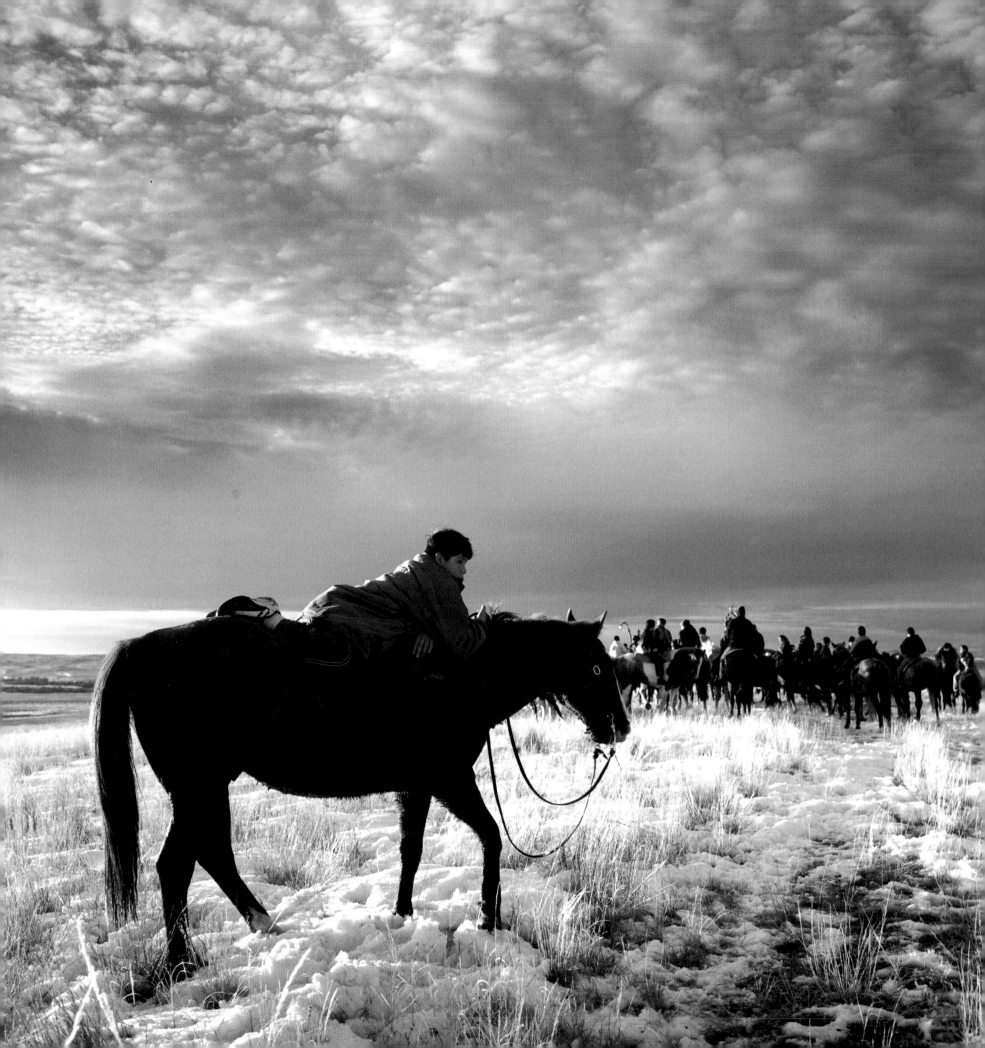

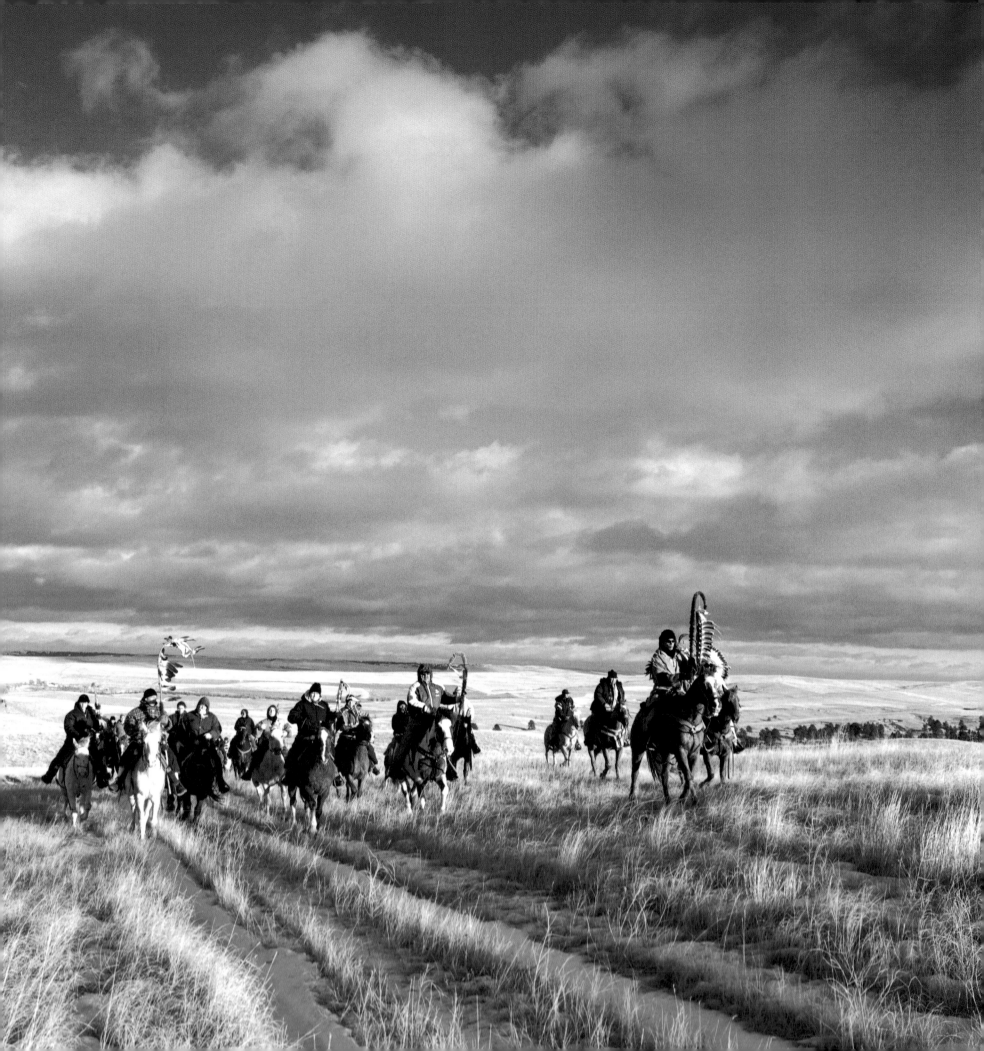

I am the sixth-generation descendant of Sitting Bull. He was my great-great-grandfather. My son is seventh generation. I'm a single parent. I received my law degree from the University of South Dakota and decided to utilize my training back home on the reservation to help my people. Since 1988 I've been participating in the Big Foot Ride as a way to honor my grandfather. I organized the first part of the Ride, which now originates on the Grand River, which is the birthplace of Sitting Bull, and also where he died. The whole thing for me is both a way to honor our ancestors who traveled the route and a way of participating and living the four main virtues of our Lakota teachings, which are wisdom, courage, generosity, and fortitude. Now that my children have become old enough to ride, I am participating in order for them likewise to learn about their history, culture, and ancestors."

RON MCNEIL, HUNKPAPA LAKOTA

Tasunka Wakinyan (His Horse Is Thunder)
President of Sitting Bull College, Standing Rock reservation
with his son

RON MCNEIL, INUNKTAYAN/HUNKPAPA LAKOTA

Inyan Hoksila (Rock Boy)
Standing Rock reservation, Fort Yates, North Dakota

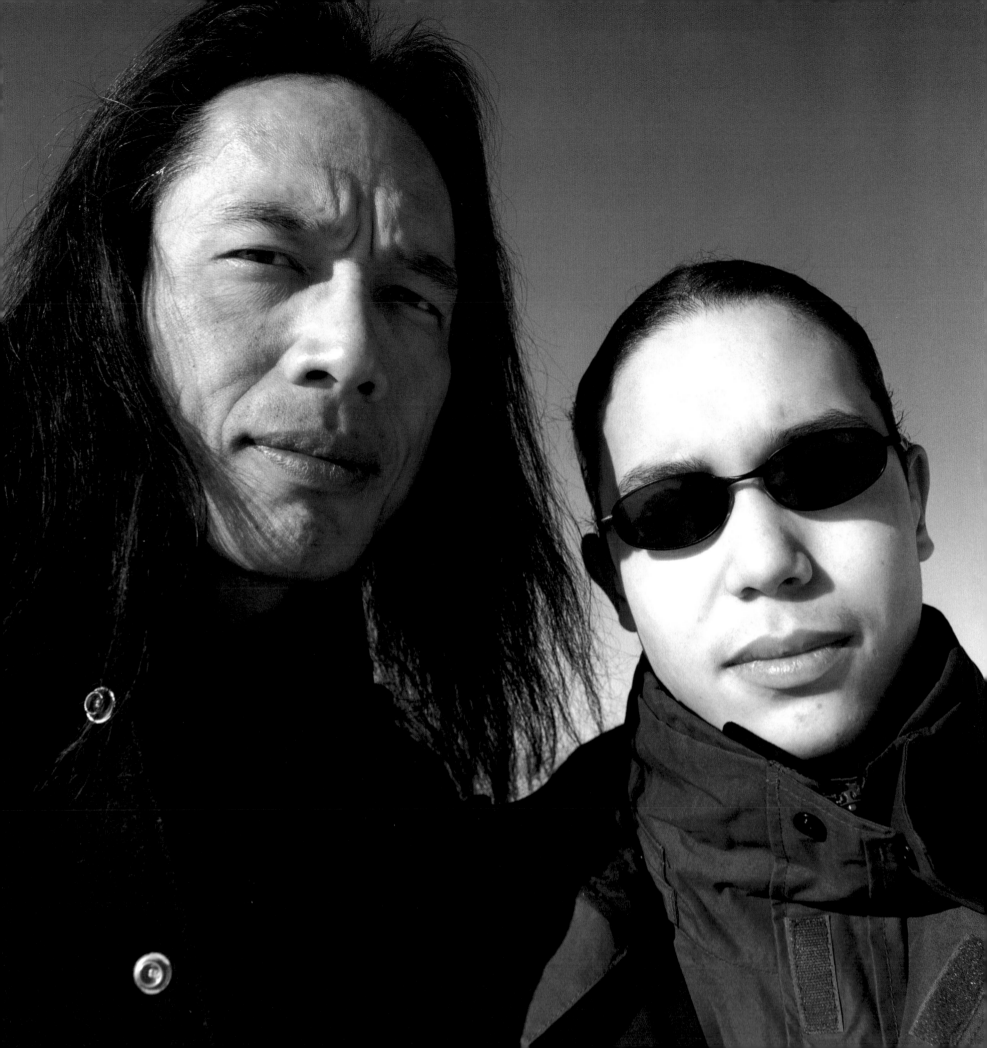

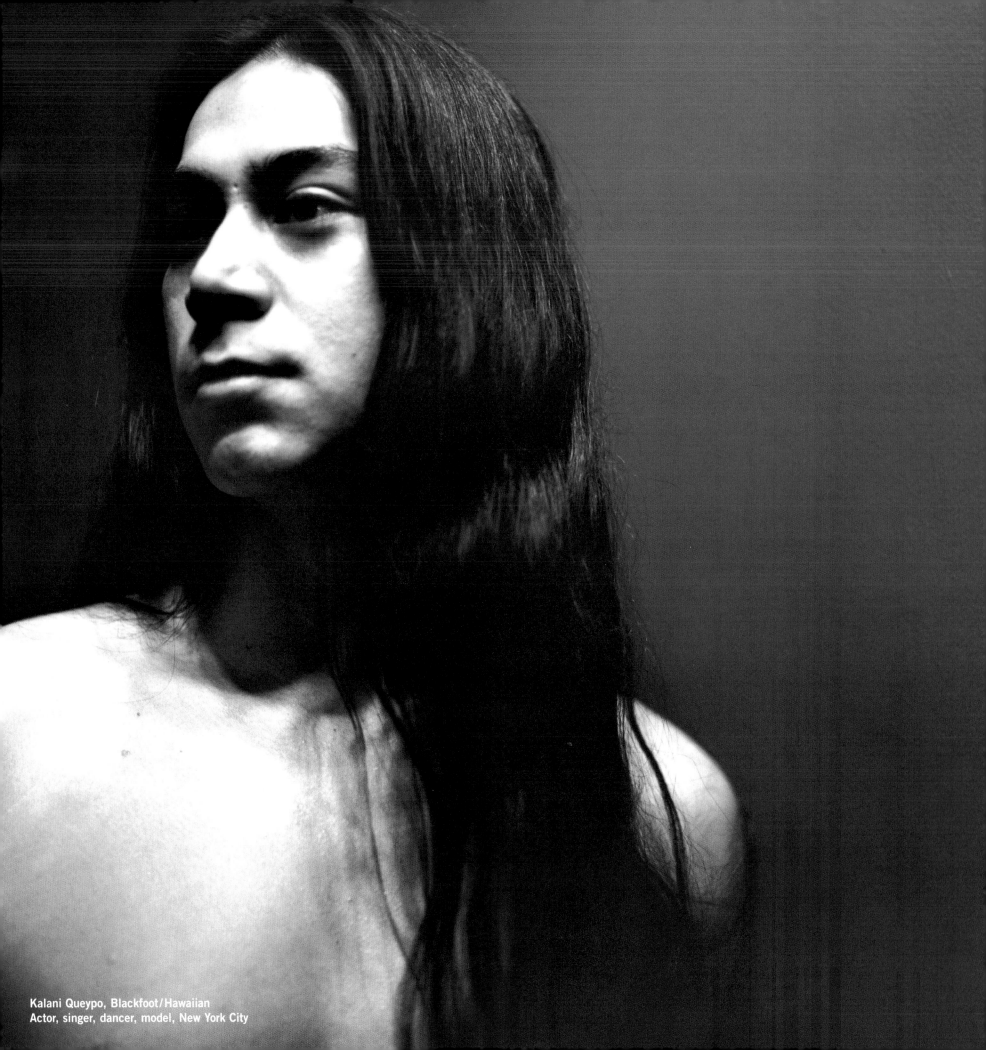

Kalani Queypo, Blackfoot / Hawaiian
Actor, singer, dancer, model, New York City

Vincent DaMallé Benson, Mandan/Oglala Lakota
Actor, website designer, Minneapolis, Minnesota

I'm not a real Indian. He's a real Indian."

MATTHEW LITTLE MAN KILLS ENEMY

Oglala Lakota

AL FAST HORSE

Oglala Lakota

Whiteclay, Nebraska

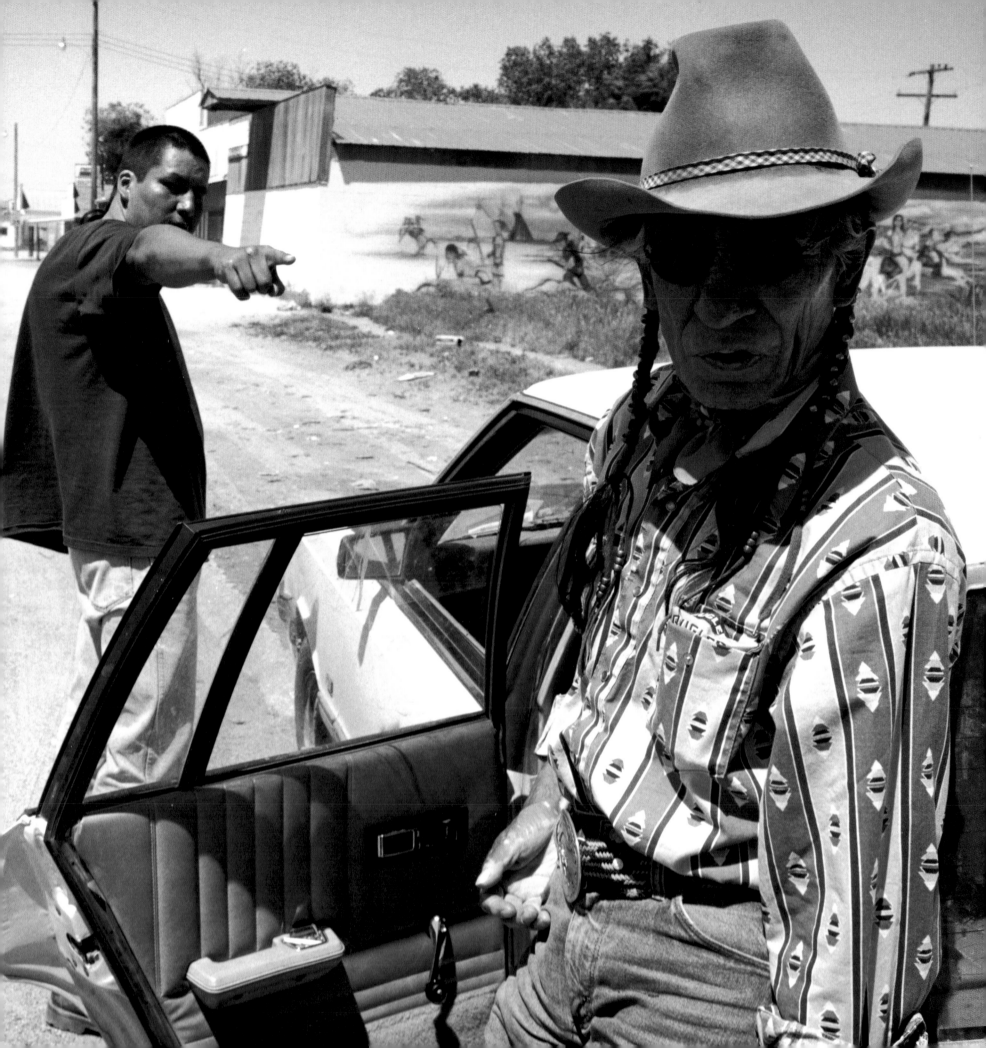

North woods

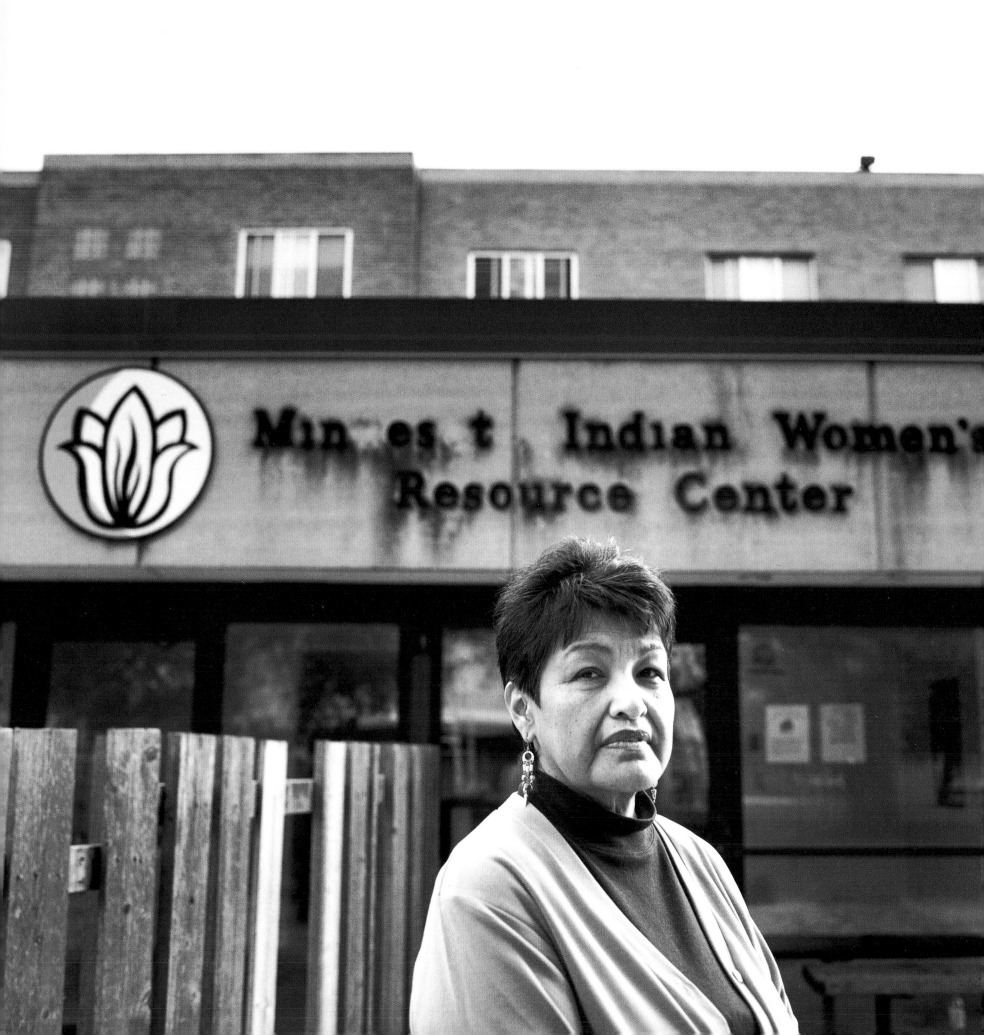

Part of my vision has always been to work for my own community. I'm truly committed to helping heal our community. We have to invest in our future by working with our children and families. Our agency advocates and facilitates family reunification and strengthening of the family. The relocation system that was in place years ago, which was set up to assimilate people, did not work, and created a lot of the problems we are dealing with in urban areas. We work with parents, especially moms, who are working on reunification with their children who were placed in foster care or juvenile detention. Many of these mothers were homeless, had no financial resources or support system, and were forced to go to emergency shelters. They may have had chemical dependency or mental health problems, and the culturally insensitive approaches that have been available just don't work. We're a culturally sensitive organization that understands the specific needs of Native people and Native families."

ROSE ROBINSON, LEECH LAKE BAND OF OJIBWE

Executive director, Minnesota Indian Women's Resource Center
Minneapolis, Minnesota

Dennis Harper, White Earth Ojibwe, with his daughters,
Leslie Harper-Liberty, Laurie Harper, Leech Lake Ojibwe
Leech Lake reservation, Cass Lake, Minnesota

Theo Harper-Liberty, Leech Lake Ojibwe
Leech Lake reservation, Cass Lake, Minnesota

Daniel Connor, Leech Lake Band of Ojibwe, barber
John Robinson, Leech Lake Band of Ojibwe
Leech Lake reservation, Cass Lake, Minnesota

"I'm picking up where Woody Guthrie left off, and applying it to Native Americana. I'm a fry bread ranter, a human activist, and a troubadour for the people."

Keith Secola, Bois Forte Ashinabe
Singer, songwriter, Tempe, Arizona

There are only ten native speakers out of the 2,000 people living on this reservation. About 3,300 are enrolled in the tribe. Assimilation works. I spoke Ojibwe when I went to boarding school in first grade, first Pipestone Federal Boarding School in Minnesota, then Brainerd Indian Training School in Hot Springs, South Dakota. I spoke English when I came back years later."

JIM NORTHRUP, ANISHINAABE

Author, poet, storyteller, Vietnam veteran
with his grandson

AARON DOW, ANISHINAABE

Fond du Lac reservation, near Sawyer, Minnesota

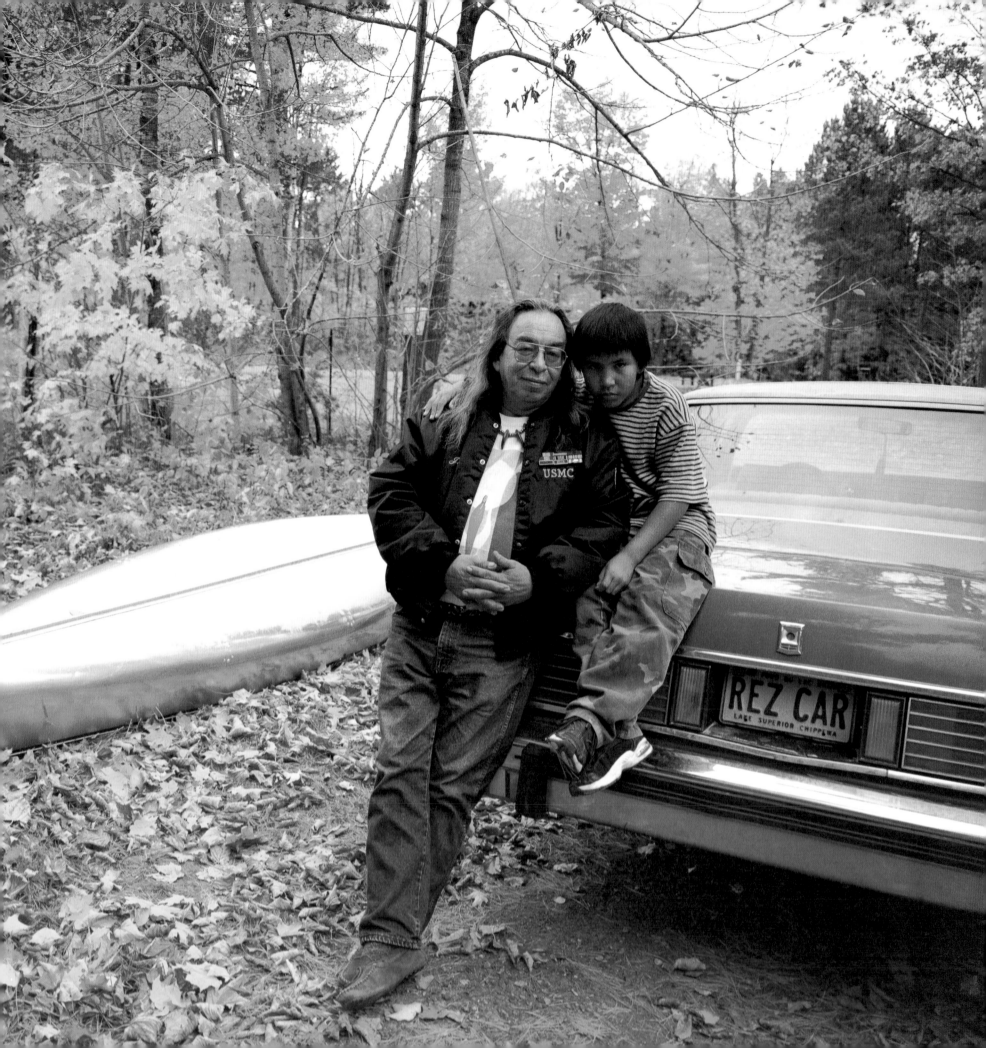

"Being an activist for
Native rights can only go
along with being a
mother and grandmother
and looking out for the future
of our children."

Jean-Ann Day, Ho-Chunk, Bear clan
Activist, Stevens Point, Wisconsin

"Someone told
me this: our children
are looking out into
society trying to find where
they belong. It's like
looking in a
mirror and not seeing
your reflection."

Annie Humphrey, Leech Lake Ashinabe
Singer, songwriter, former Marine
Leech Lake reservation, Cass Lake, Minnesota

"If it was the last deer, I would die too. I would die with that deer."

MARVIN DAFOE, LAKE SUPERIOR BAND OF
RED CLIFF CHIPPEWA

Fish clan

Canoe and wigwam maker, singer, dancer, spiritual leader

Red Cliff reservation, Red Cliff, Wisconsin

"We have to follow written laws,
but there are also natural laws, sacred laws.
The earth is changing. The trees are different.
Even the water's different. I spend at least
two hundred days a year in the woods.
One day I was in the woods,
and I looked up and saw this big tree was dead,
no leaves, it was summertime.
Something just hit me. I cried for two hours."

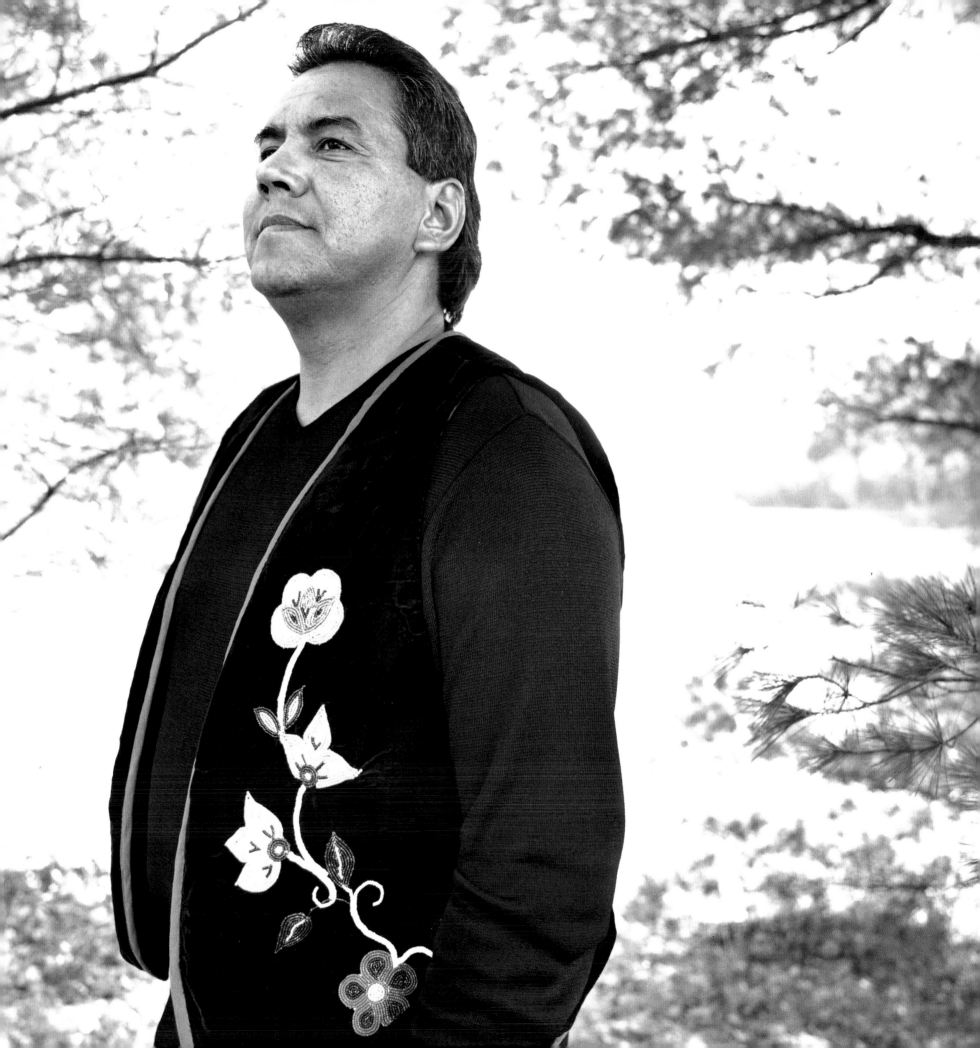

M y name
means cutter. My spirit name is Ozawa-Binnes, Brown Eagle.
Gitchi Monido gave me a gift to speak on behalf of the Lac Courte Oreilles people.
The Great Spirit moves through me. I try to live according to the Great Laws,
to respect all things and all peoples. Time is so short.
I want to accomplish so much before I leave, fighting for our rights."

GAIASHKIBOS, LAC COURTE OREILLES CHIPPEWA

Fish clan
Tribal chairman, Vietnam veteran
Lac Courte Oreilles reservation, near Hayward, Wisconsin

I've been
working in public radio since 1987.
I'm one of three Native women managing
tribal radio stations. Native radio
empowers communities, individuals, and women.
It's an empowerment tool. As young people
we are taught by our elders to listen and
remember and carry on the oral
tradition to our younger family members and to
the community. Radio is a new form
of carrying on oral tradition."

CAMILLE LACAPA, LAC COURTE OREILLES OJIBWE/HOPI/TEWA

General manager, WOJB-FM radio station
Lac Courte Oreilles reservation, near Hayward, Wisconsin

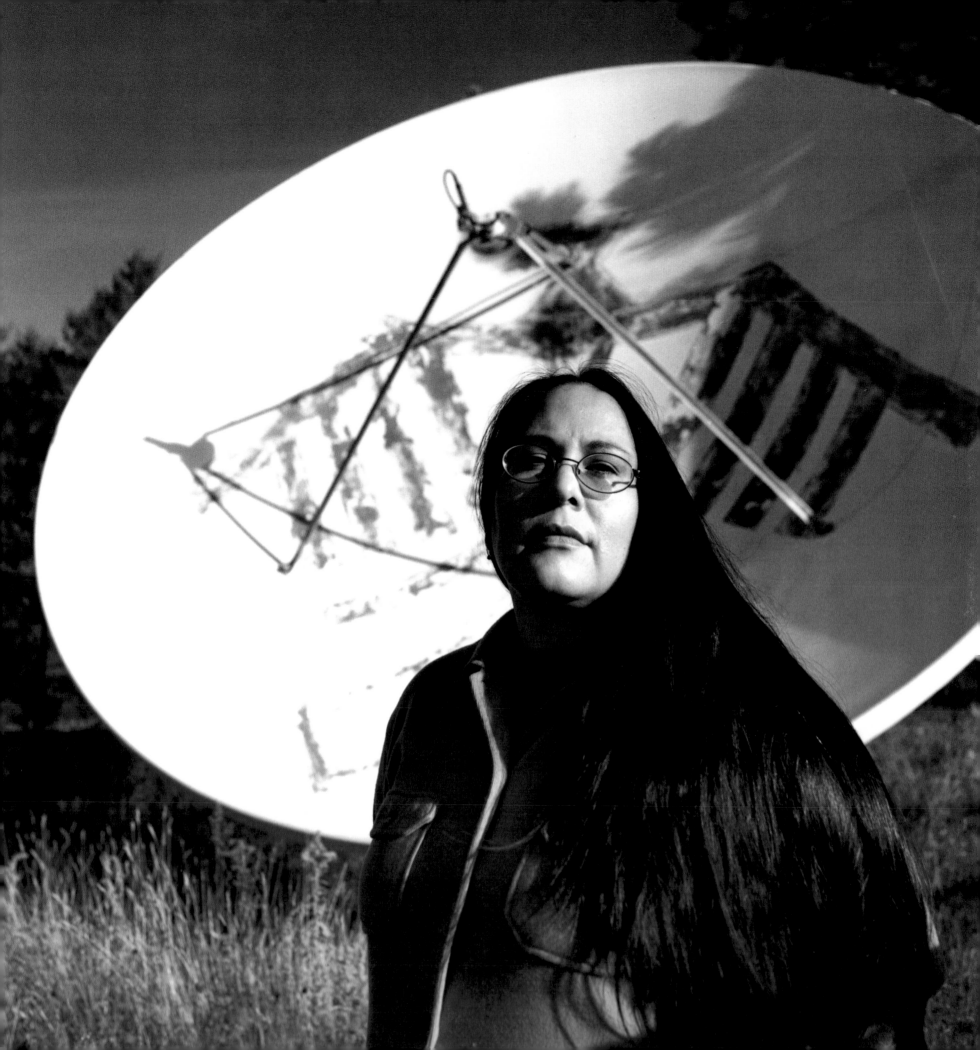

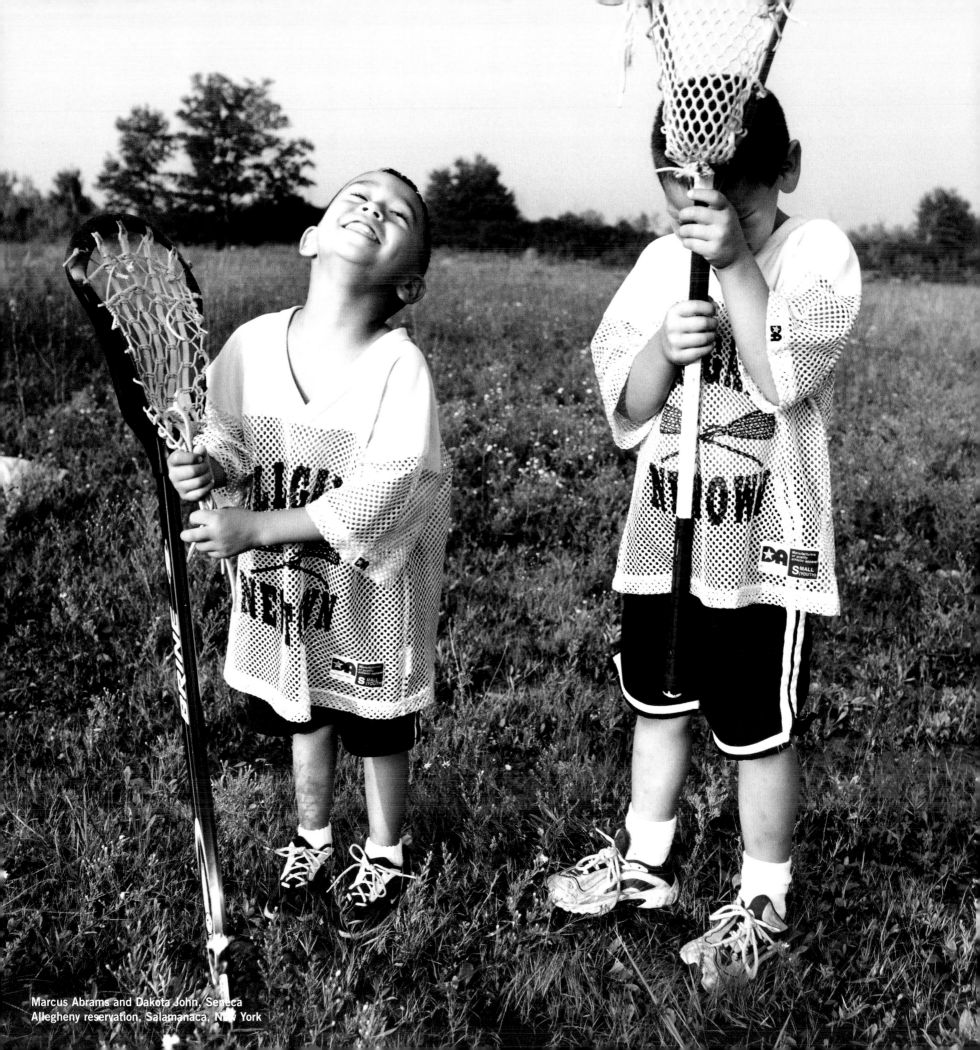

Marcus Abrams and Dakota John, Seneca
Allegheny reservation, Salamanaca, New York

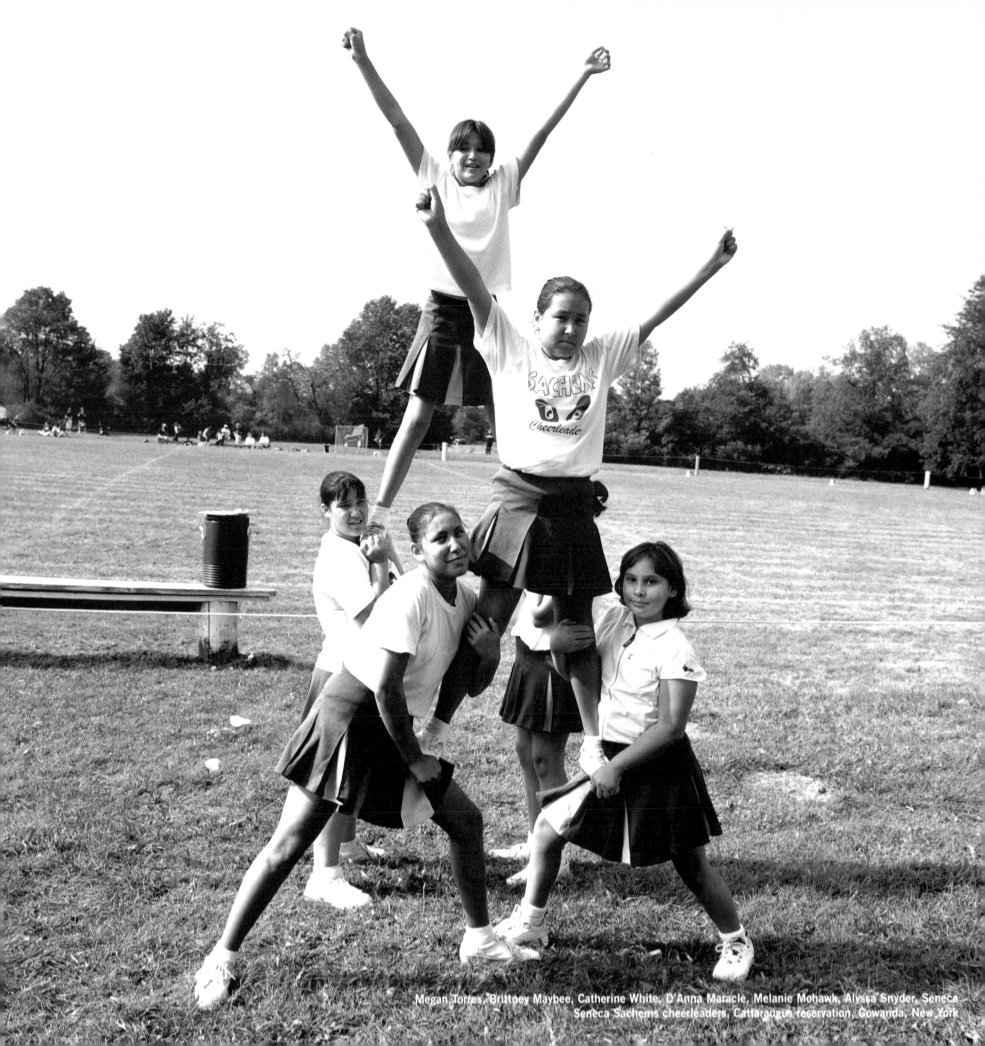

Megan Torres, Brittney Maybee, Catherine White, D'Anna Maracle, Melanie Mohawk, Alyssa Snyder, Seneca Seneca Sachems cheerleaders, Cattaraugus reservation, Gowanda, New York

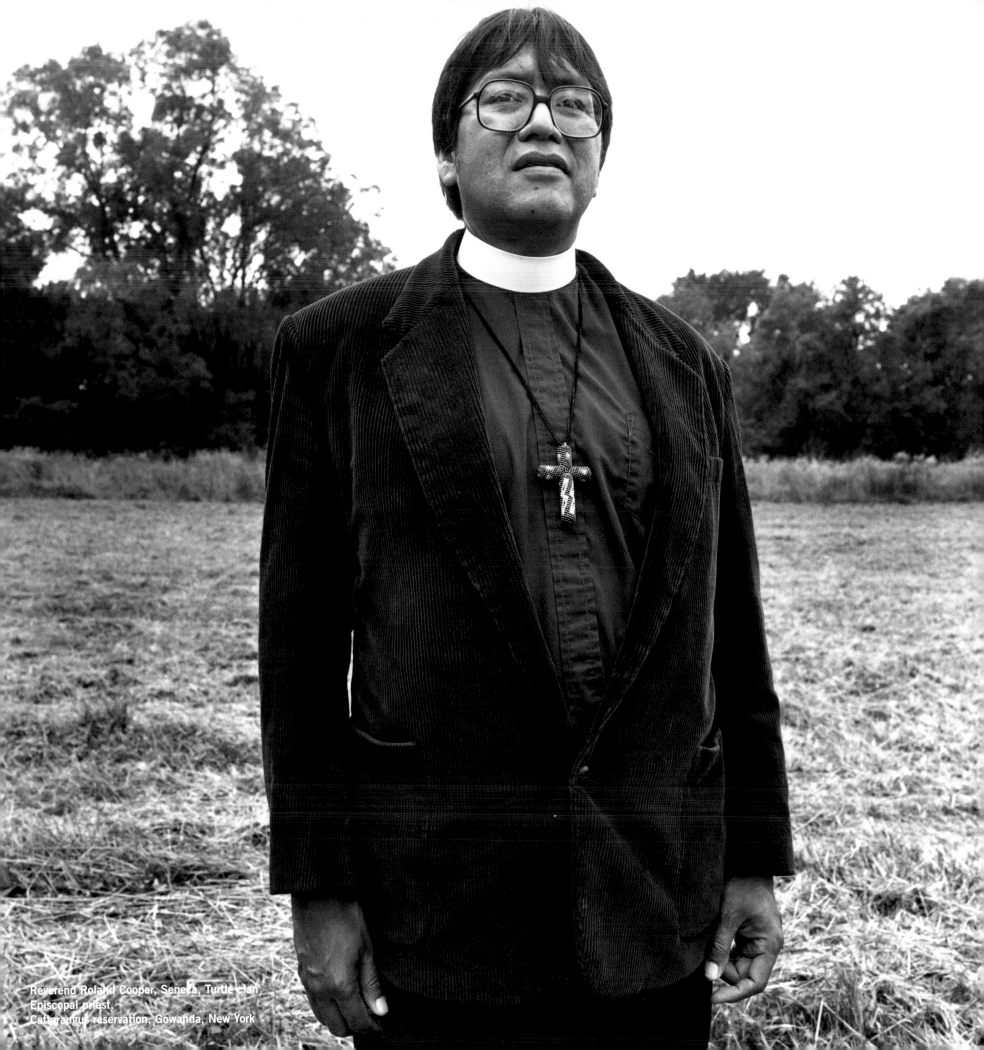

Reverend Roland Cooper, Seneca, Turtle clan
Episcopal priest,
Cattaraugus reservation, Gowanda, New York

Dorothy Webster, Onondaga, Eel clan, Clanmother,
with her daughter Karen Webster, Onondaga, in front of the Longhouse
Onondaga Nation Territory, Nedrow, New York

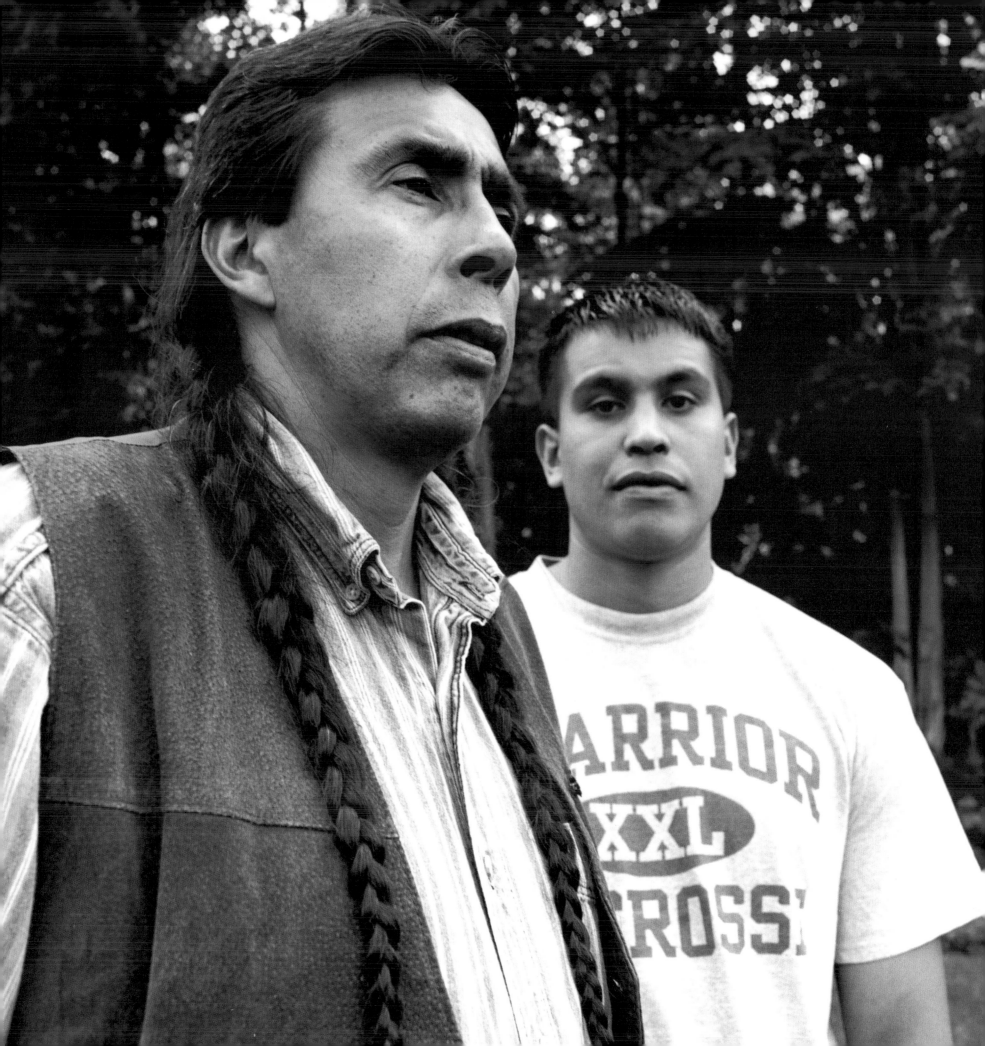

M y title is the only one that is picked by the chiefs. The Todadaho doesn't have a clan because he belongs to everybody. The Todadaho is always from Onondaga because it's the capital of the Confederacy. We've been given three messages from the Creator. The first was about our ways, how to run our ceremonies. Then the Peacemaker came with his message of the Great Law. That's when our Confederacy was formed. Then Handsome Lake brought his message. He was a Seneca chief who preached for sixteen years and passed away at Onondaga. Two hundred years ago he came out of a coma and prophesied the way of surviving between the two cultures. It takes four days to recite his preachings and prophecies at each nation. The Tonawanda women brought his preachings back, that's why we honor the Tonawanda and always start at their reserve. I think that's why we're still here, because he allowed us to adapt. Some of the things he prophesied were a cart with nothing pulling it, old people having children, diseases with no cure, trees dying from the top down because of things in the air, and burning rivers."

SIDNEY HILL, ONONDAGA

Todadaho (traditional spiritual and political leader) of the Haudenosaunee (Six Nations Iroquois Confederacy) with his nephew

MARSHALL ABRAMS, ONONDAGA

Captain of the Syracuse University lacrosse team, collegiate national champions, three-time All-American
Onondaga Nation Territory, Nedrow, New York

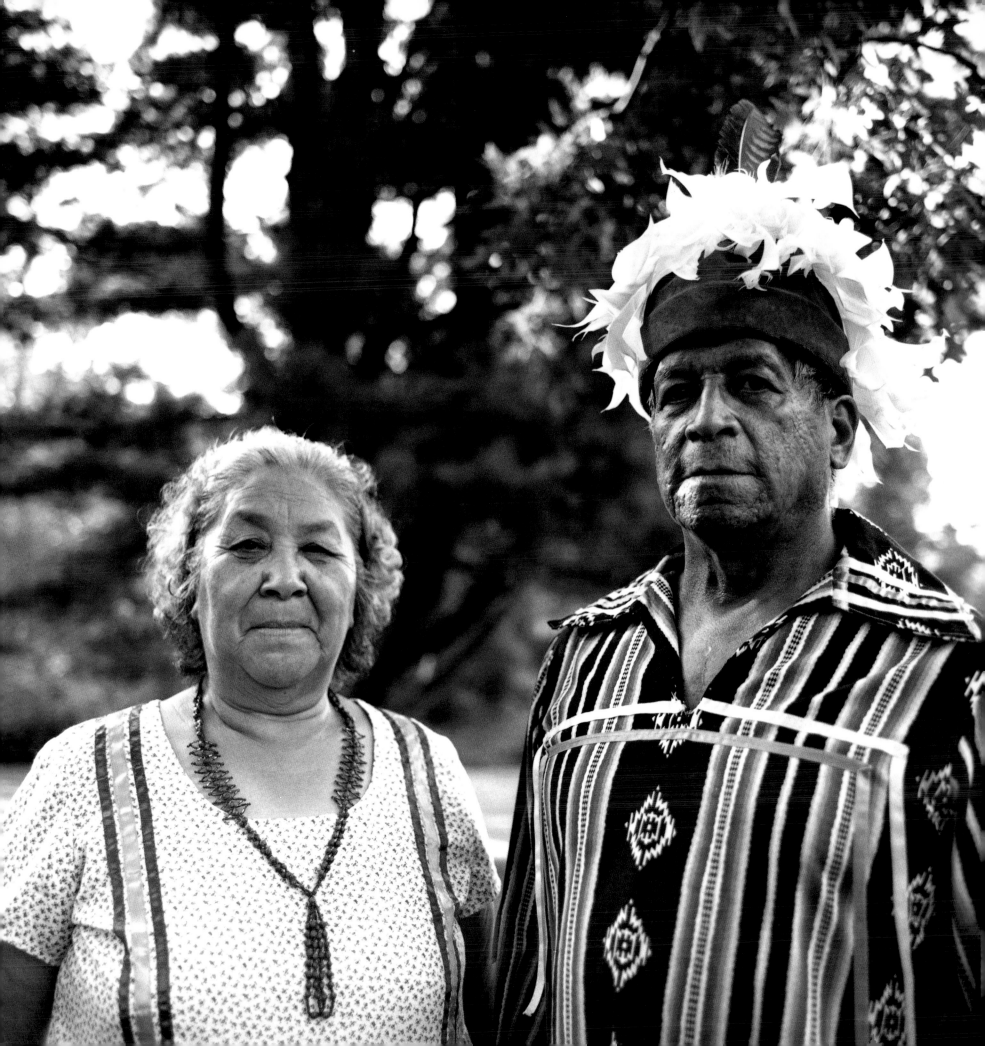

I have been a Sachem Chief since 1982. There are supposed to be eight sachem chiefs and eight subchiefs, but now we have three sachem chiefs and no subchiefs. The Sachem Chief is chosen by the clan. The clanmother talks to the clan, and she suggests who she would like to see, who is capable of doing the duties of a chief."

KERVIN JONATHAN, TONAWANDA

Sachem Chief, Turtle clan, Korean war veteran
with his wife

"I used to be the eyes and ears of my Clanmother before she died. I was put up as a Faithkeeper in 1986. One of the duties of the clanmother is putting up the Indian names of babies and adults. We teach how to cook ceremonial food, we work with our clan chief. The duty of the Faithkeeper is to keep ceremonies and our culture going in our Longhouse. I am also a Seneca language teacher. I've been doing that ever since I can remember."

EVELYN JONATHAN, TONAWANDA

Clanmother, Wolf clan
Tonawanda Seneca Nation Territory, Basom, New York

"Everyone has a song

God gave us each a song

That's how we know who we are."

ROBBIE ROBERTSON, MOHAWK

Musician, songwriter, Los Angeles, California

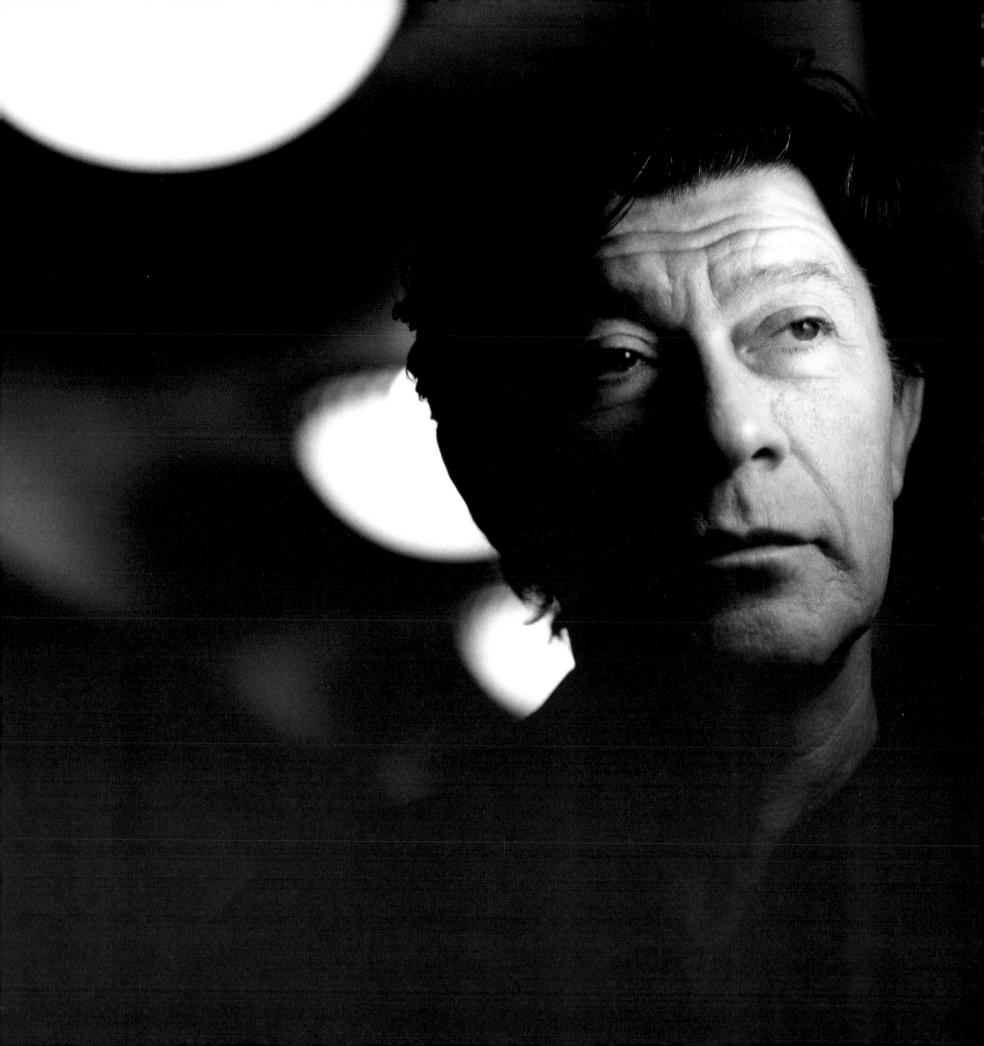

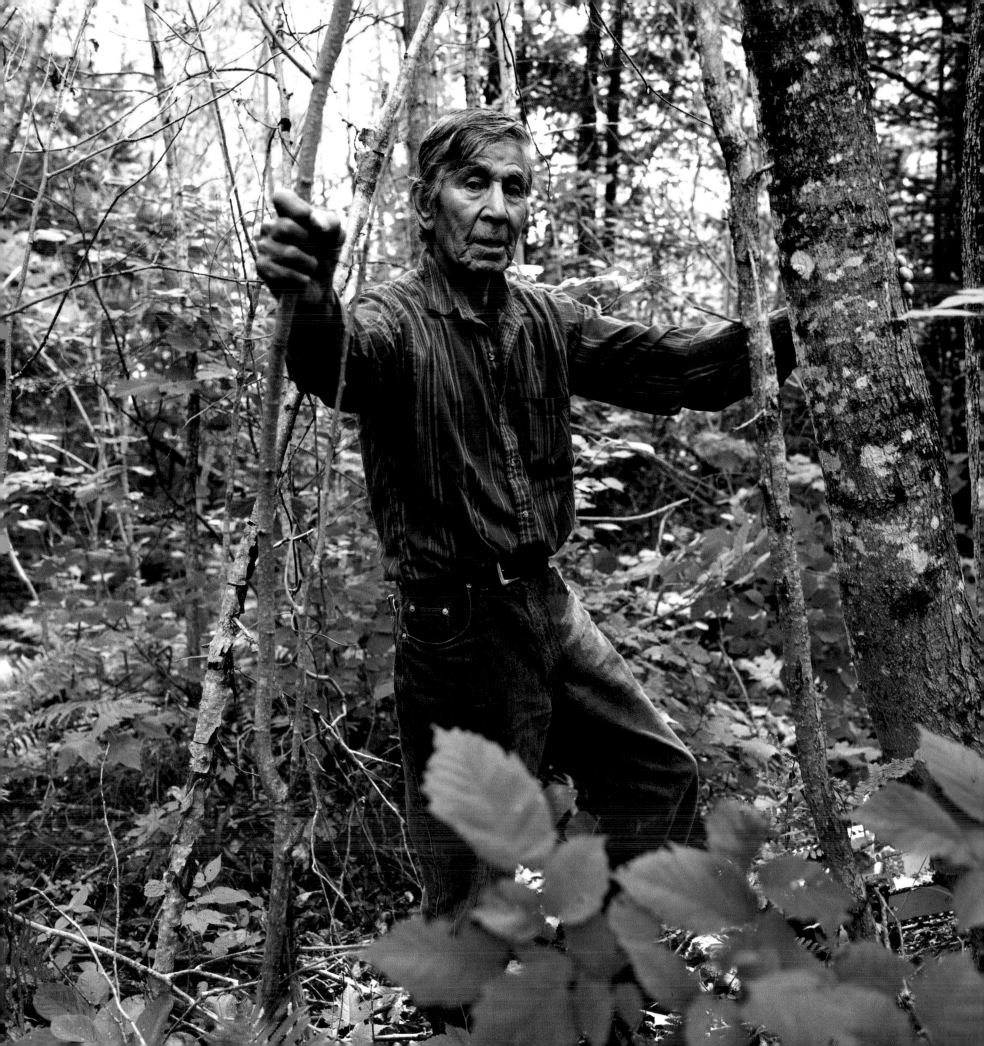

Gathering ash wood for basket-making
Donald Sanipass and his grandson Jerich Morey, Mikmaq
Presque Isle, Maine

We still have treaties with England. We never made a treaty with the United States. In 1621 we signed a treaty with the colonists that we would protect them from their enemies, and they would protect us from our enemies. That was the only reason we allowed them to settle, because of their military power, because we felt we needed protection from the Narragansett. We had fifty years of peace with the English. There were an average of one hundred and fifty ships a year that arrived. We finally went to war with them.

"We are First Encounter people. We've always been the experiment for how to change the Indian. During the seventeenth century, missionaries protected us from extermination. We were called the Praying Indians. The experiment was to see if they could implant souls so we would no longer be savages, to make us human beings. The colonial attitude was that we were not really human beings. We were in the way, that was the basis of westward colonization. We were also the experiment for the Allotment Act, to break down the communal tribal ownership of land. Not only have we survived, but we are culturally and spiritually strong.

"It's because of the treaties that our people made with England that this country was colonized. It's a heavy, heavy burden. It's our burden. The National Day of Mourning was a way to express that. It was a way to let other tribes know that we were in mourning for them as well as for us."

RAMONA PETERS, MASHPEE WAMPANOAG

Activist, artist, chief's councillor
Mashpee, Massachusetts

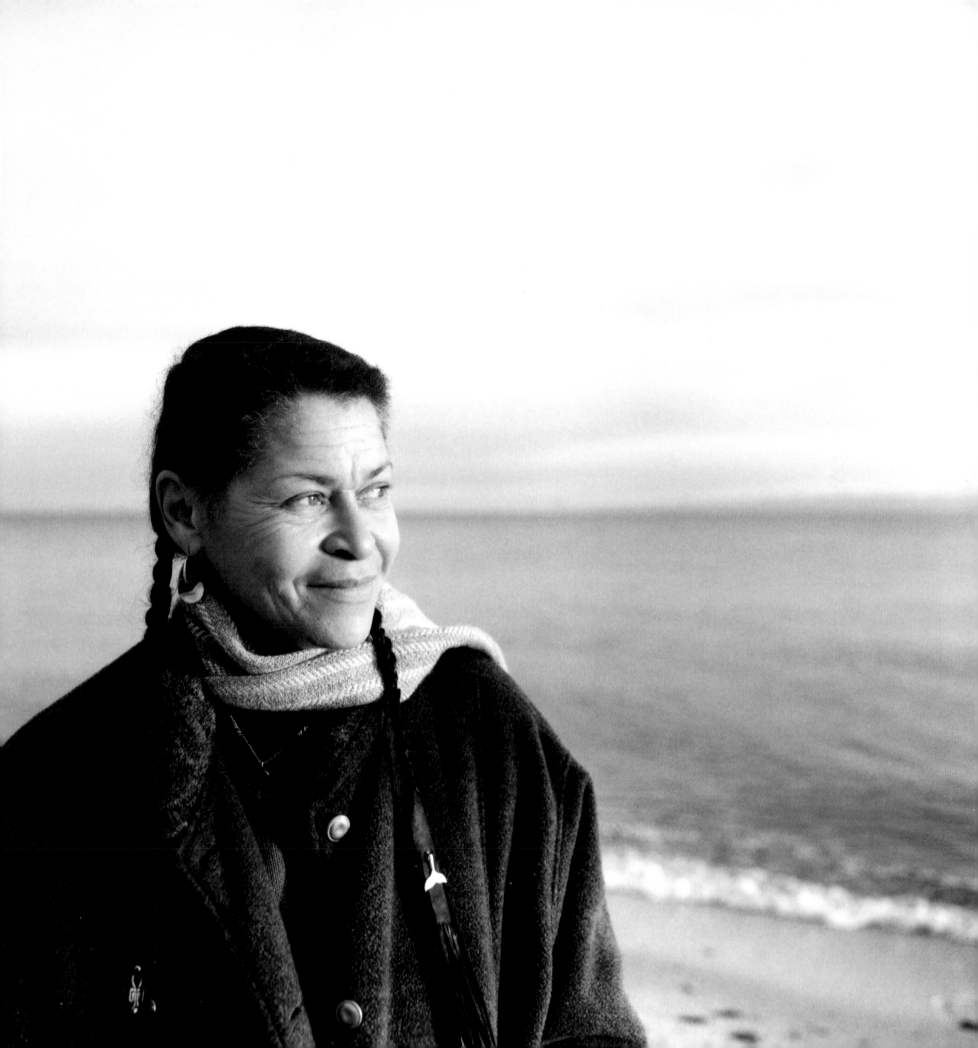

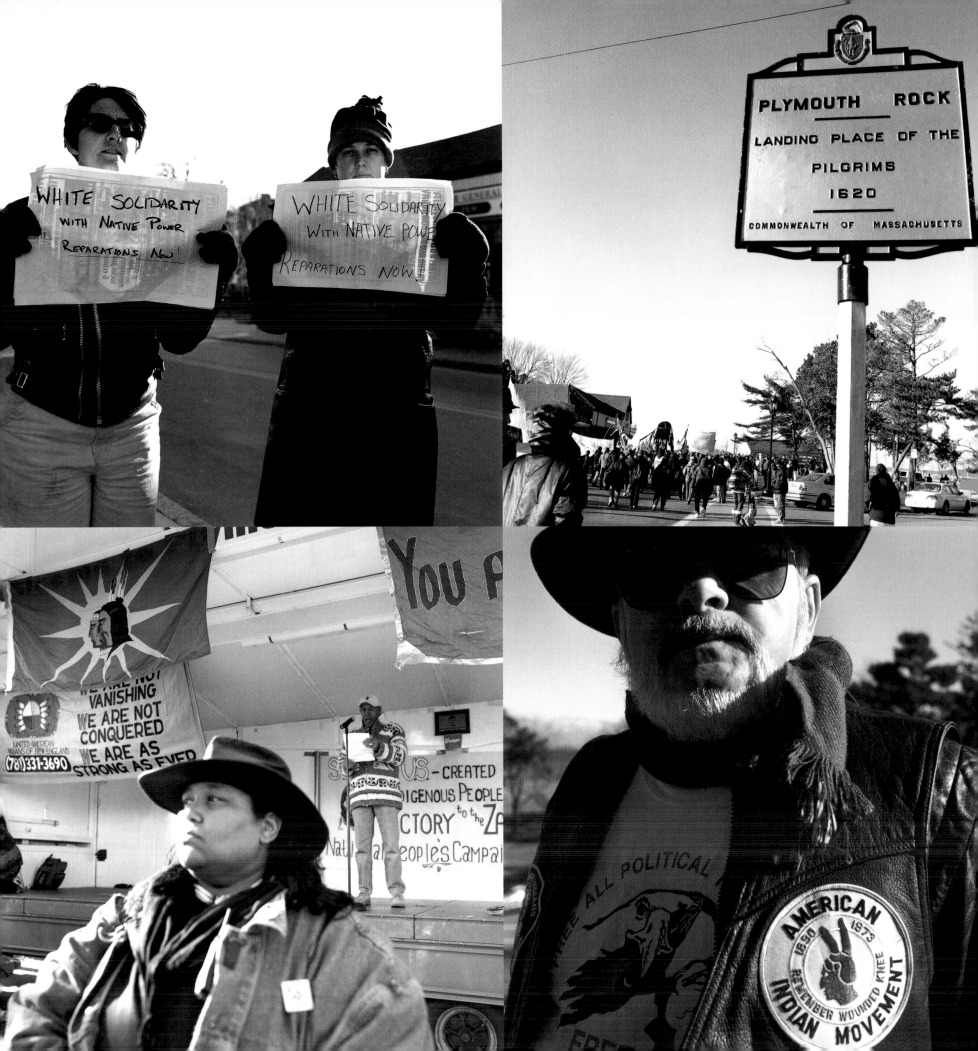

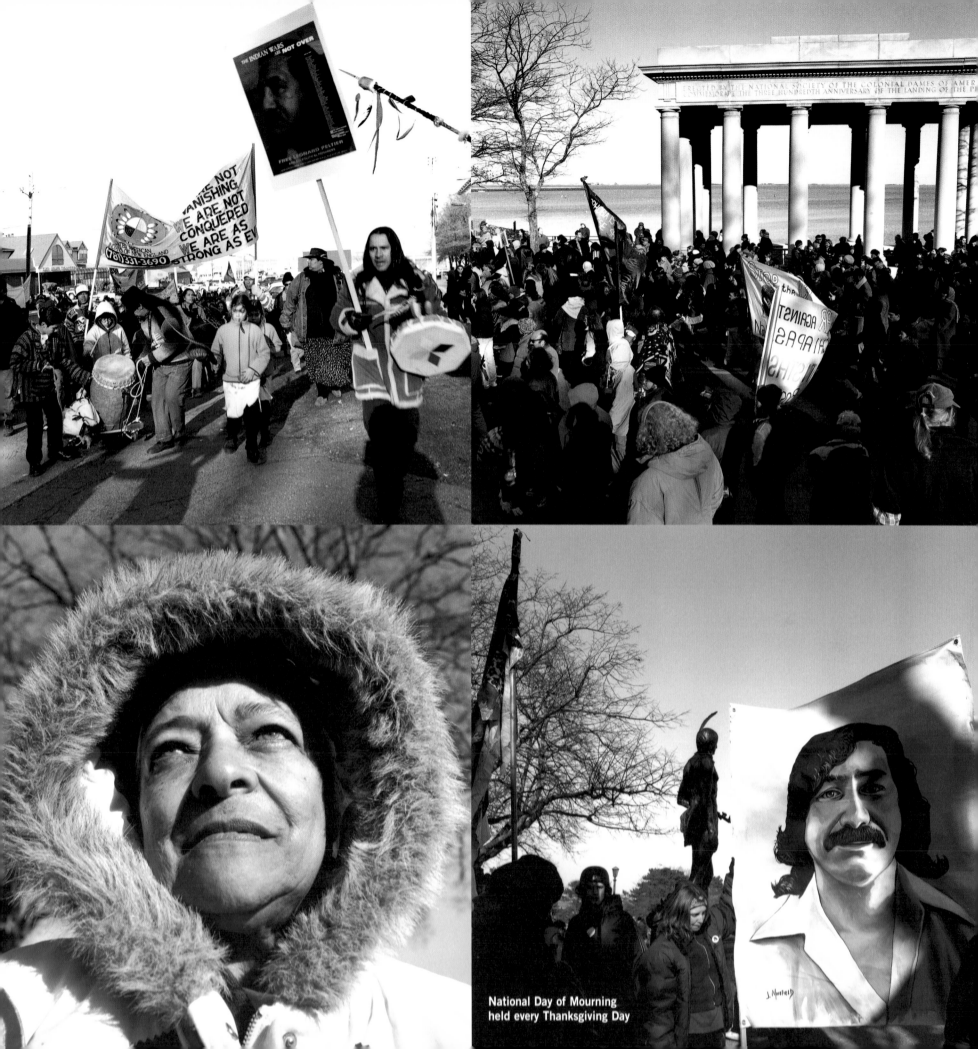

National Day of Mourning
held every Thanksgiving Day

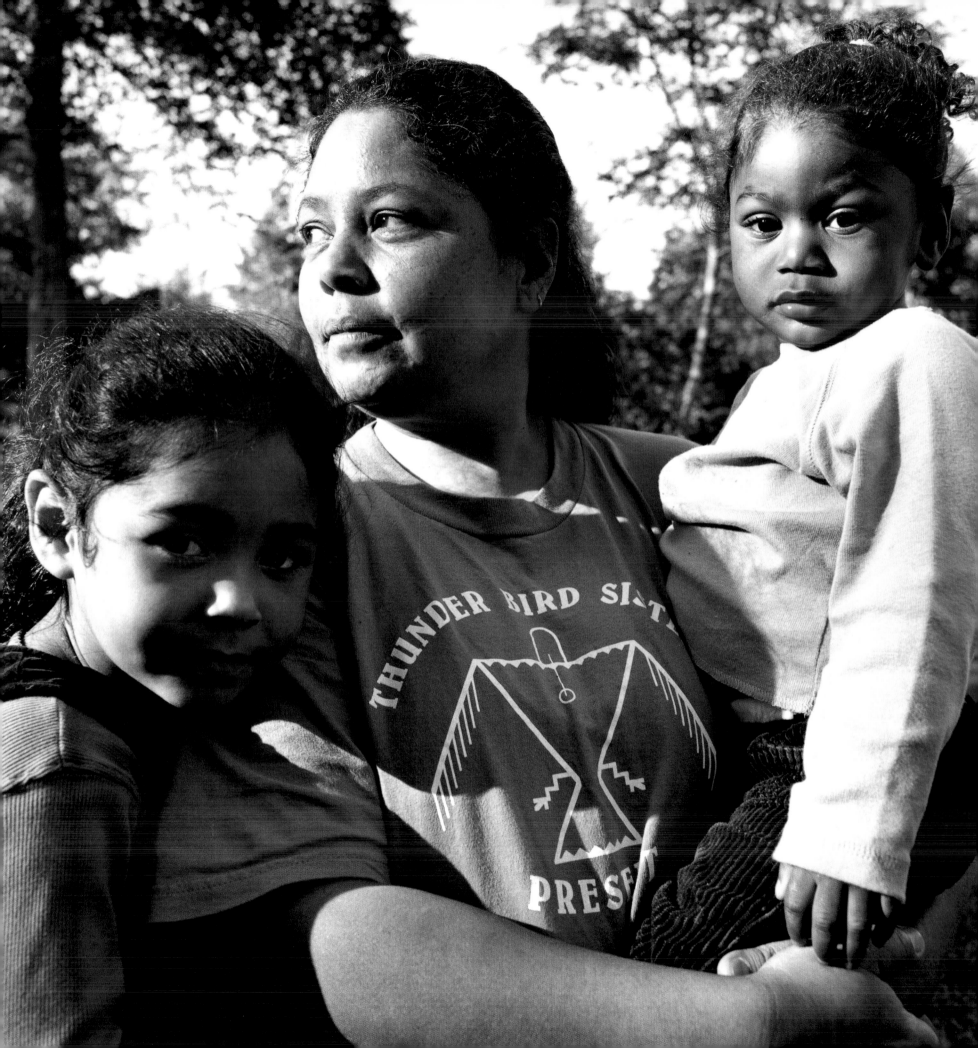

T hey
bought our land with our own corn.
We didn't know we were being
swindled because that concept didn't
exist in our society.
Now they're golfing on our cemeteries
while we live in shacks."

BECKY GENIA, SHINNECOCK

Activist, lead singer of the Thunder Bird Sisters
with her granddaughters

NASHA HILL AND MEQUANTASH EVANS, SHINNECOCK

Shinnecock reservation, Southampton, New York

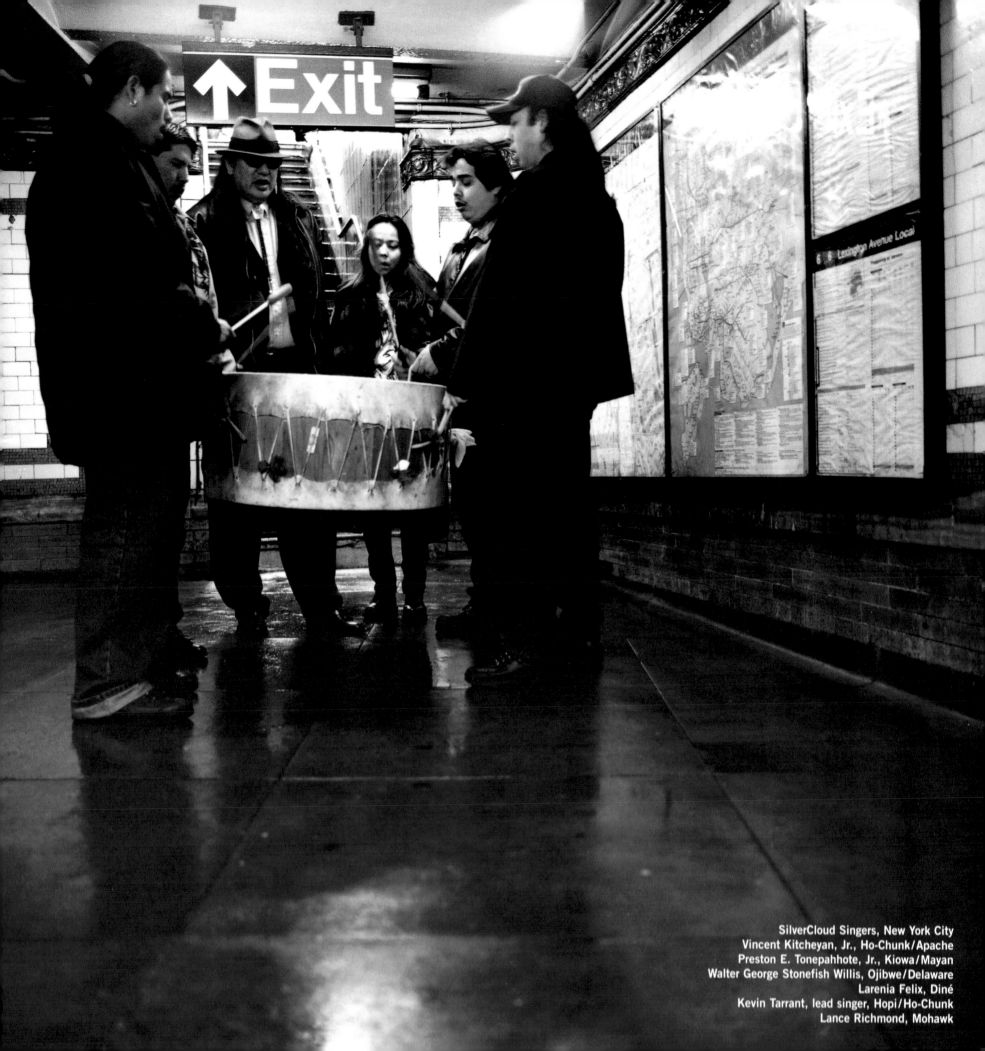

SilverCloud Singers, New York City
Vincent Kitcheyan, Jr., Ho-Chunk/Apache
Preston E. Tonepahhote, Jr., Kiowa/Mayan
Walter George Stonefish Willis, Ojibwe/Delaware
Larenia Felix, Diné
Kevin Tarrant, lead singer, Hopi/Ho-Chunk
Lance Richmond, Mohawk

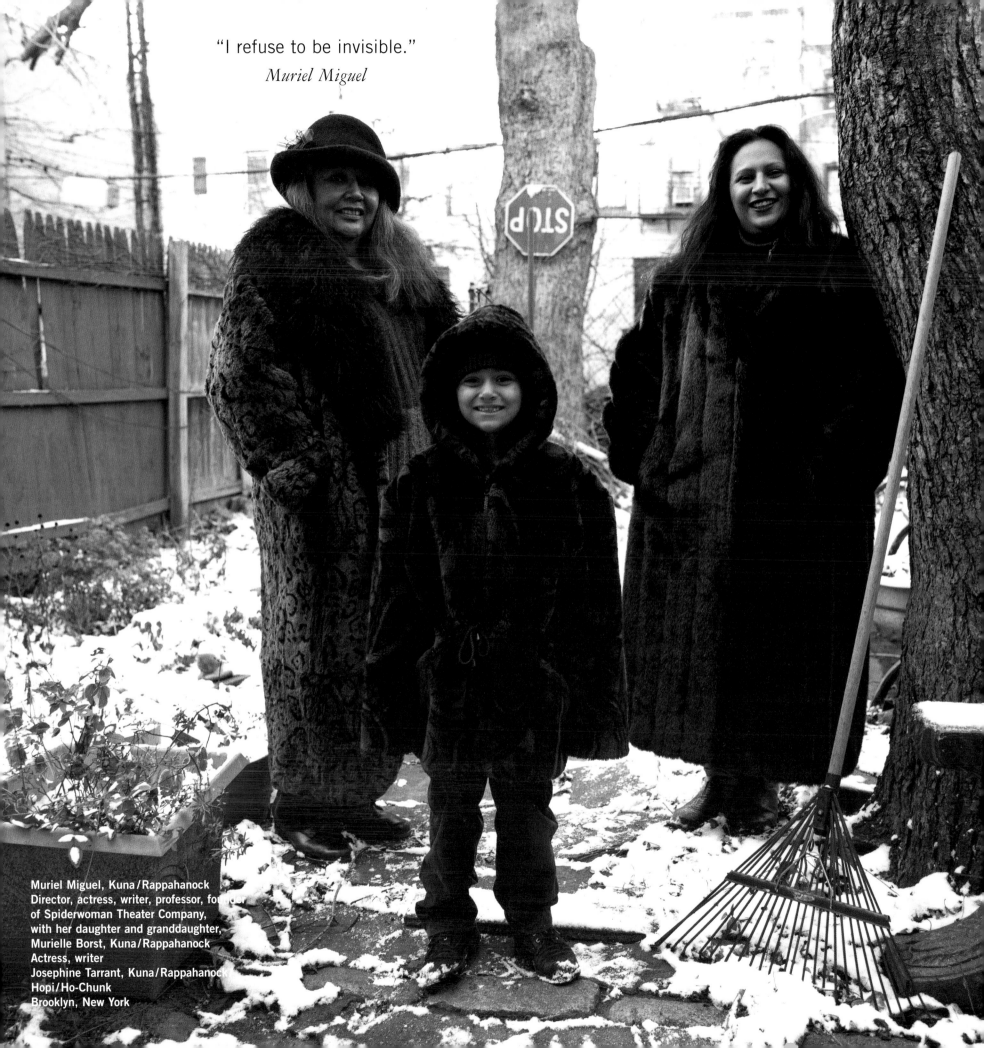

"I refuse to be invisible."
Muriel Miguel

Muriel Miguel, Kuna/Rappahanock
Director, actress, writer, professor, founder
of Spiderwoman Theater Company,
with her daughter and granddaughter,
Murielle Borst, Kuna/Rappahanock
Actress, writer
Josephine Tarrant, Kuna/Rappahanock/
Hopi/Ho-Chunk
Brooklyn, New York

"My maternal grandmother,
Laura, was the storyteller.
We learned the history of our family
through her poems and stories.
She really taught me to hear.
My paternal grandmother, Bessie,
taught me to see. She made
beauty out of everything."

Rita Coolidge, Eastern Cherokee
Singer, songwriter
Fallbrook, California

MICCOSUKEE TRIBE OF INDIANS OF FLORIDA

EMERGENCY EXIT

Miccosukee preschoolers
Miccosukee reservation, Tamiami Trail, Florida

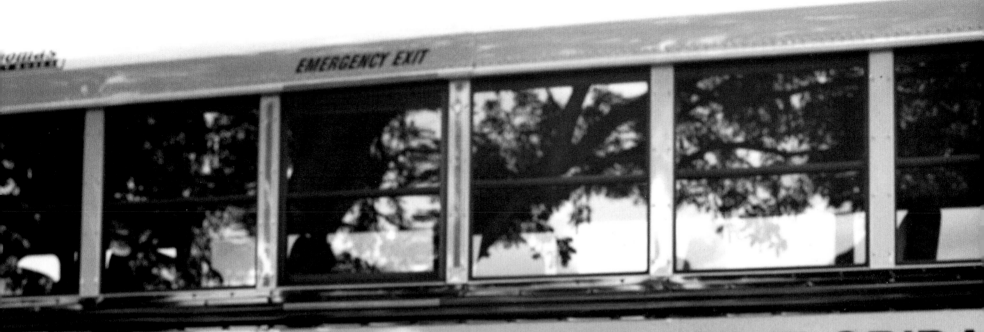

MICCOSUKEE TRIBE OF INDIANS OF FLORIDA

EMERGENCY EXIT

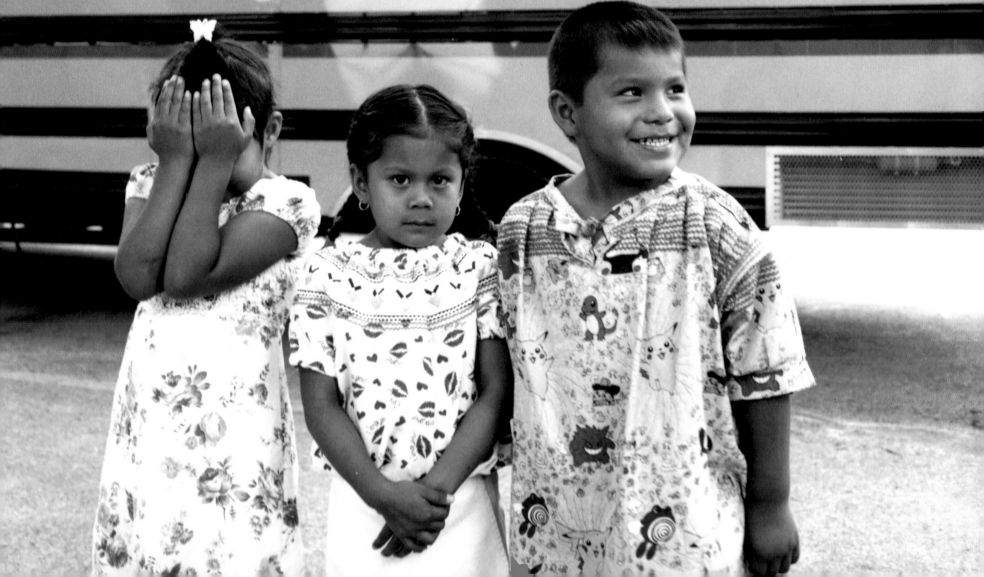

The earth we live on, it's part of us. If we don't love nature and the earth, don't respect it, it will be destroyed. I grew up in a traditional life. We love nature, we try to protect nature, trees, water, all of it. It's a beautiful way of thinking, to love nature. When I was a Miccosukee boy, we didn't care about money. We loved everything and everyone around us. We lived in camps, we visited back and forth. Modern life is fast, growing all around us. We know who we are. We kept who we are. We kept the traditional way, but we also have to recognize modern life."

BUFFALO TIGER, MICCOSUKEE

Former tribal chief from 1952 to 1985
Miccosukee reservation, Tamiami Trail, Florida

Donald King, Mark Petty, David Hickman, Mississippi Choctaw
Mississippi Choctaw reservation, Pearl River, Mississippi, near Philadelphia, Mississippi

"We are always
looking out for our children
and our elders."

Doris Potts, Potawatomi, Fish clan
Journalist, Potawatomi reservation, Mayetta, Kansas

"I don't need
beads and feathers
to be Indian."

"Native prisoners do
more time for the same
crime. Their religious beliefs
are viewed differently
than the mainstream religions.
When they're in the sweat,
that's one of the few times
they're at home.
There's no walls, no prison,
they're at home."
Eddie Joe Mitchell

Eddie Joe Mitchell with his daughter, Wabenokwe (Morning Woman), Potawatomi
Spiritual leader, leads sweats at Leavenworth and other area prisons
Potawatomi reservation, Mayetta, Kansas

"BIA [Bureau of Indian Affairs] agents would just show up and take the kids from their homes, or they threatened the family with starvation. They say Haskell's free but that's nowhere near true. The cemetery shows that. A lot of people had to die. One grave is a six-month-old baby. The male and female students weren't allowed to be together, so where did those babies come from?"

LORENE BRANT, SISSETON/WAHPETON

"We've seen the BIA slowly sell off Haskell land, and we are now fighting to keep what little we still have. There are a lot of former students who are unaccounted for from Haskell's boarding-school days. A lot of those students are still here in spirit, and that's what I'm trying to protect."

MIKE CONTRERAS, TORRES MARTINEZ BAND OF DESERT CAHUILLA

Haskell Indian Nations University, Lawrence, Kansas

MALEIGH PERRY
CHIPPEWA
1882—190[?]

Mike Contreras, Torres Martinez Band of Desert Cahuilla
Lorene Brant, Sisseton/Wahpeton
Billie Galindo, Kiowa/Sac and Fox/Shawnee/Oneida/Blackfeet
Aaron Eustace Fields, Sioux
Students, Haskell Indian Nations University

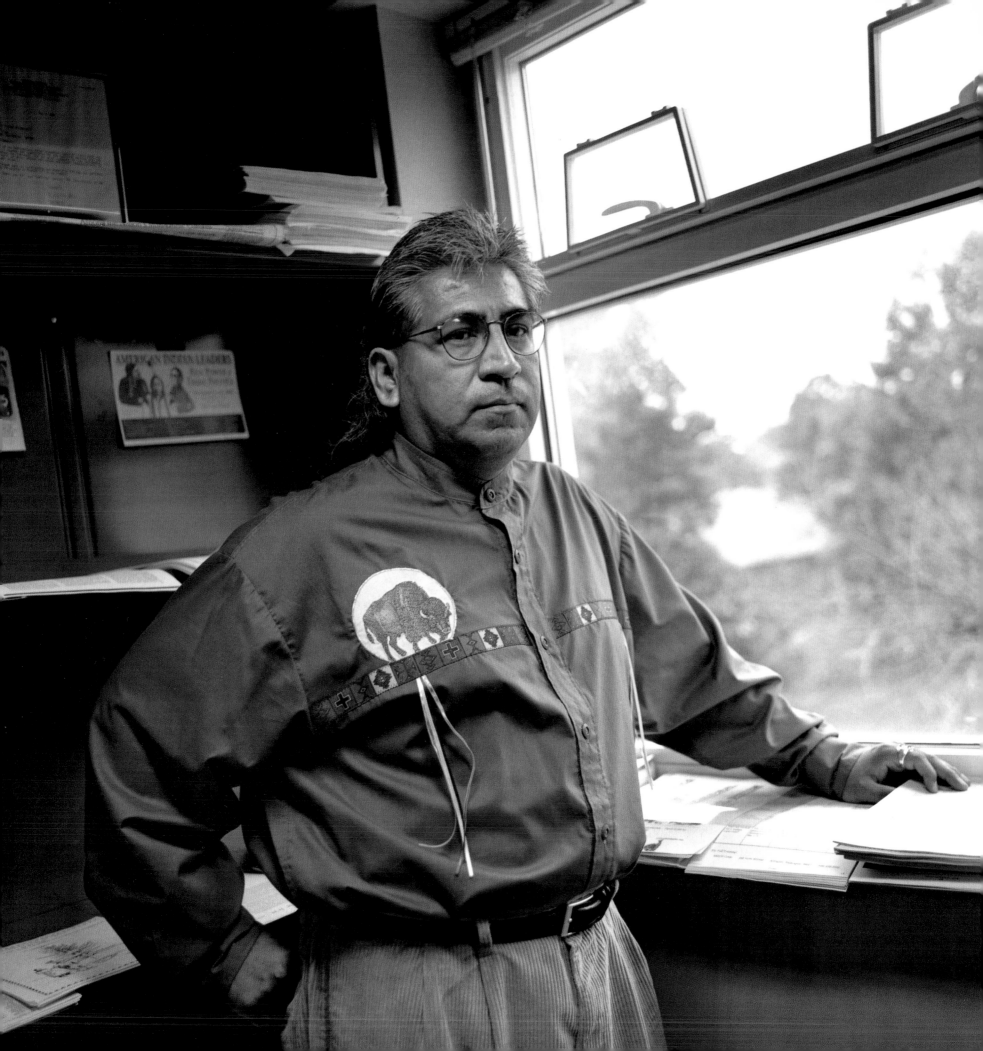

If you can make a people believe that your truth is the absolute truth, and they are convinced of that, then you have absolute power control over them, because you created their worldview. When Americans look at indigenous peoples, they believe that what they see is real, but it's a virtual reality that's manufactured. The better we know who we are as tribal people the more difficult it will be for people outside our tribal communities to oppress us. Probably the worst thing you could do to a people besides extermination is to assimilate them. We were intentionally miseducated. Education is a form of termination. I'm using that double-edged sword. I'm using the power of education to deconstruct a system that miseducated us. I'm using my sovereignty through the rhetoric of what I say."

CORNEL PEWEWARDY, COMANCHE

Professor, University of Kansas

Lawrence, Kansas

Raymond Bighead, Muscogee Creek
Seminole, Oklahoma

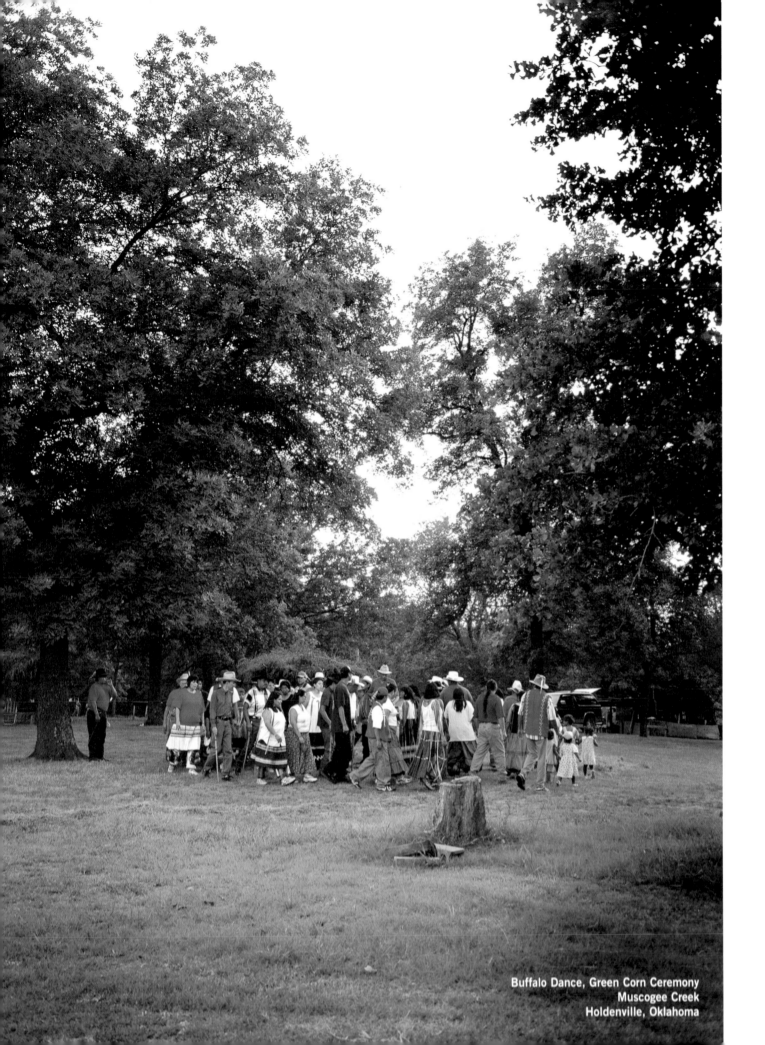

Buffalo Dance, Green Corn Ceremony
Muscogee Creek
Holdenville, Oklahoma

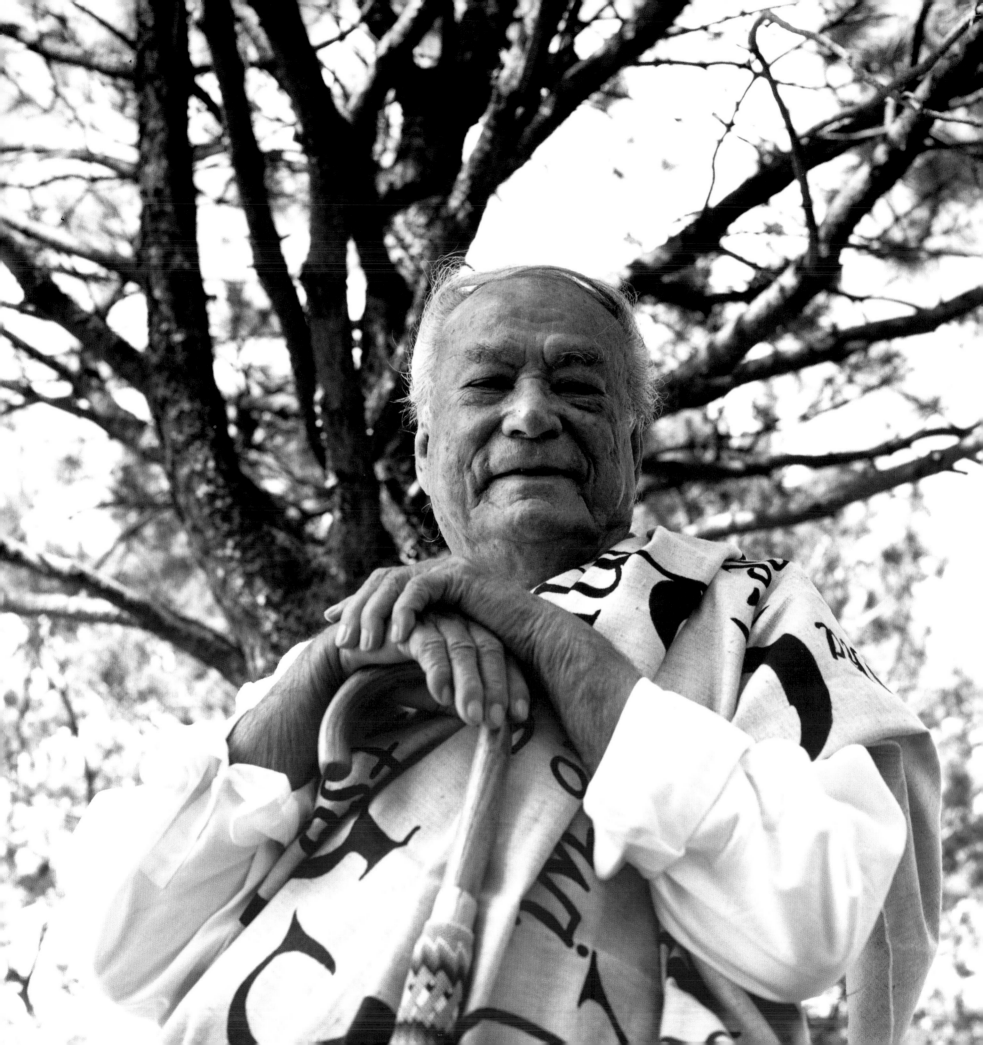

We must not fear change, rather bend it to benefit. Native Americans stand on a chasm of change greater than at any time in history. I strongly believe that it will fall to the arts, more than ever before, to define and refine the changes in Indian cultural symbols that will surely accelerate as we move into the new millennium. The task of Native American artists, as I see it, is to sift through thousands of years of traditions for those everlasting truths that can be used to temper the brute forces of a scientifically driven majority culture in a way that will guarantee the ongoingness of Native American identity and spirituality. An evolving, distinctive Indian culture will live into the future, as it has in the past, commensurate to the contributions of its creative artists to the meaning of life, through dance, music, the use of visual symbols, colors, design, oral literature, and ceremonial theater. A culture takes its most understandable shape through the arts . . . no arts, no culture."

LLOYD KIVA NEW, CHEROKEE

Artist, president emeritus, The Institute of American Indian Arts
Santa Fe, New Mexico

The Indian experience is like this episode of *Divorce Court* I saw. A couple gets married. He moves into her place and starts leaving his stuff around and not sharing in the housework. She feels that she's being taken advantage of and that her needs aren't being met. So he slaughters her entire people."

MARCUS AMERMAN, CHOCTAW

Master beadworker, multimedia artist
Santa Fe, New Mexico

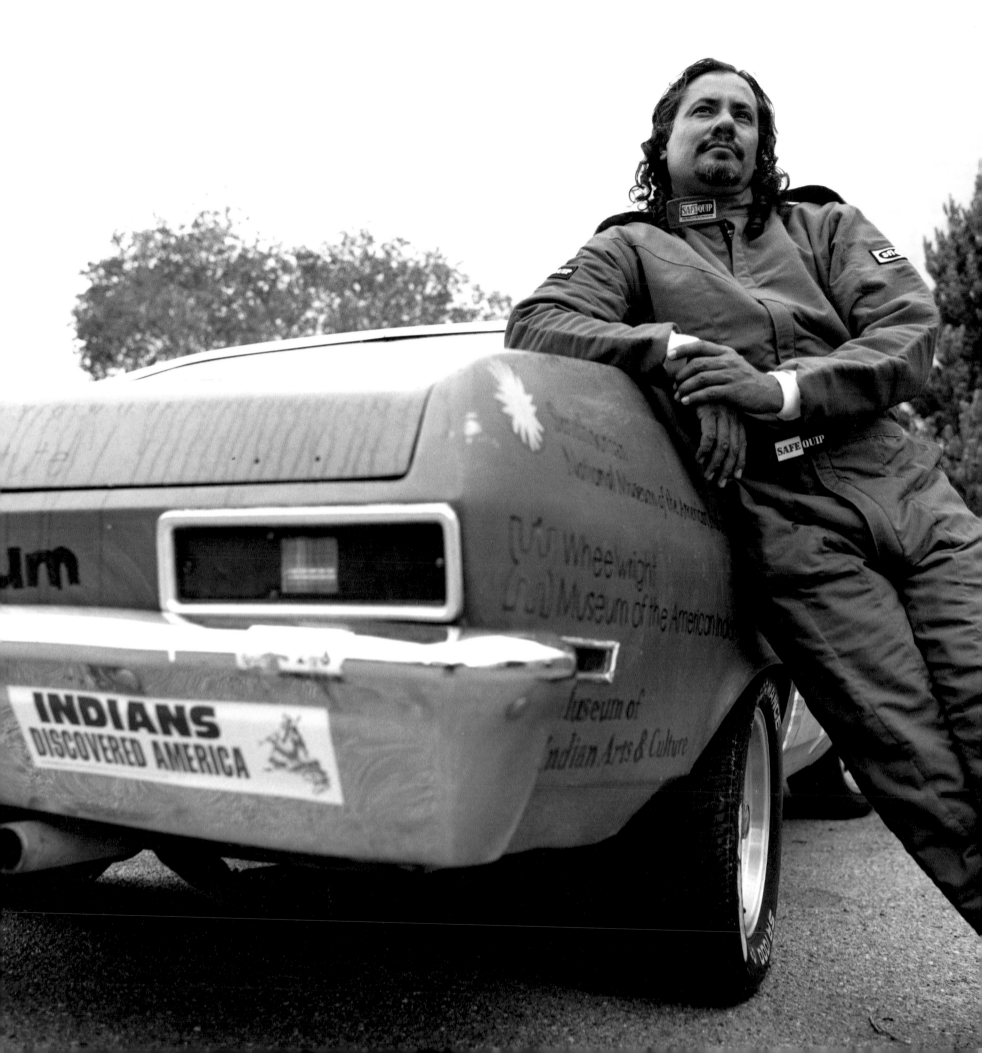

Wendy Ponca, Osage
Artist, fashion designer, Fairfax, Oklahoma

Parker Boyiddle, Kiowa/Delaware
Artist, Los Angeles, California

"It's about being a contemporary Native woman, and having a voice. The woman's voice is hardly ever heard. The men are always in the forefront. I come from a long line of warriors. When people think of warriors, they always think of men, but many of the warriors in my family have been and are women."

Jill Momaday, Kiowa, Gourd Dance clan
Actor, model
Santa Fe, New Mexico

"Native people represent a kind of fearlessness. Forgot your parka, the car died, it's 80 below, but you're gonna be all right, because nature is not an enemy, it's a challenge."

Val Kilmer, Cherokee
Actor
Pecos, New Mexico

American Indians are members of the human family. Therefore they are distinguished by those things that distinguish all human beings—language, self-awareness, and cognition among other things. But beyond that, I believe that they are distinguished within the human family by three things in particular. First, American Indians have a highly developed sense of language. Their oral traditions are among the richest in the world. They believe in the power and magic of words. Second, their aesthetic sense is extraordinary. They are artists, and the expression of their artistry pervades every aspect of their lives. And third, they are innately spiritual. Their understanding of the world, in all its dimensions, is based upon a recognition of the sacred. Every step they take and every breath they draw are the making of a prayer."

N. SCOTT MOMADAY, KIOWA

Writer, painter
Jemez Springs, New Mexico

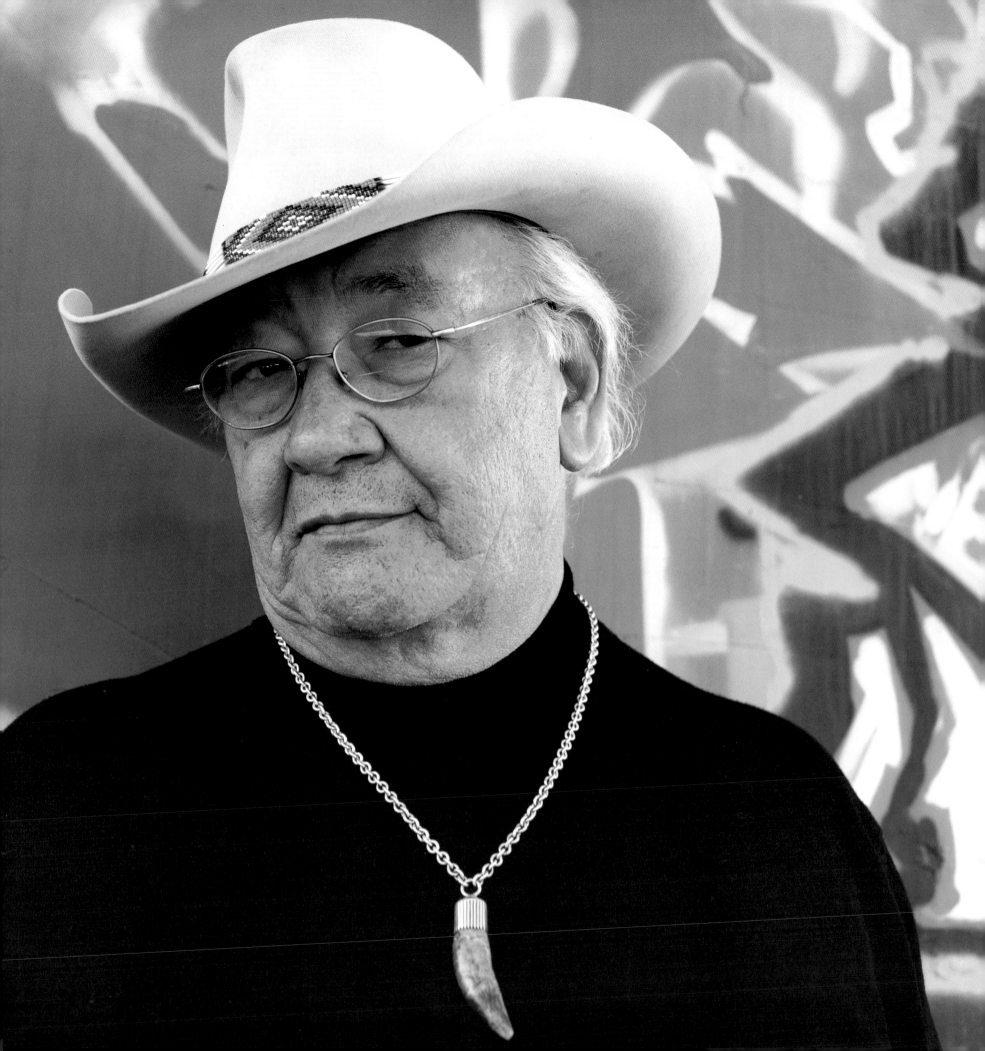

Edmund Wash-Begay, White Mountain Apache
Construction worker
Uintah and Ouray reservation, Fort Duchesne, Utah

GREAT ★ SEAL ★
WHITE MOUNTAIN ★ APACHE TRIBE

Billie Colorow with her children,
Persephani Colorow and Ephraim Colorow, Jr., Northern Ute
Uintah and Ouray reservation, Fort Duchesne, Utah

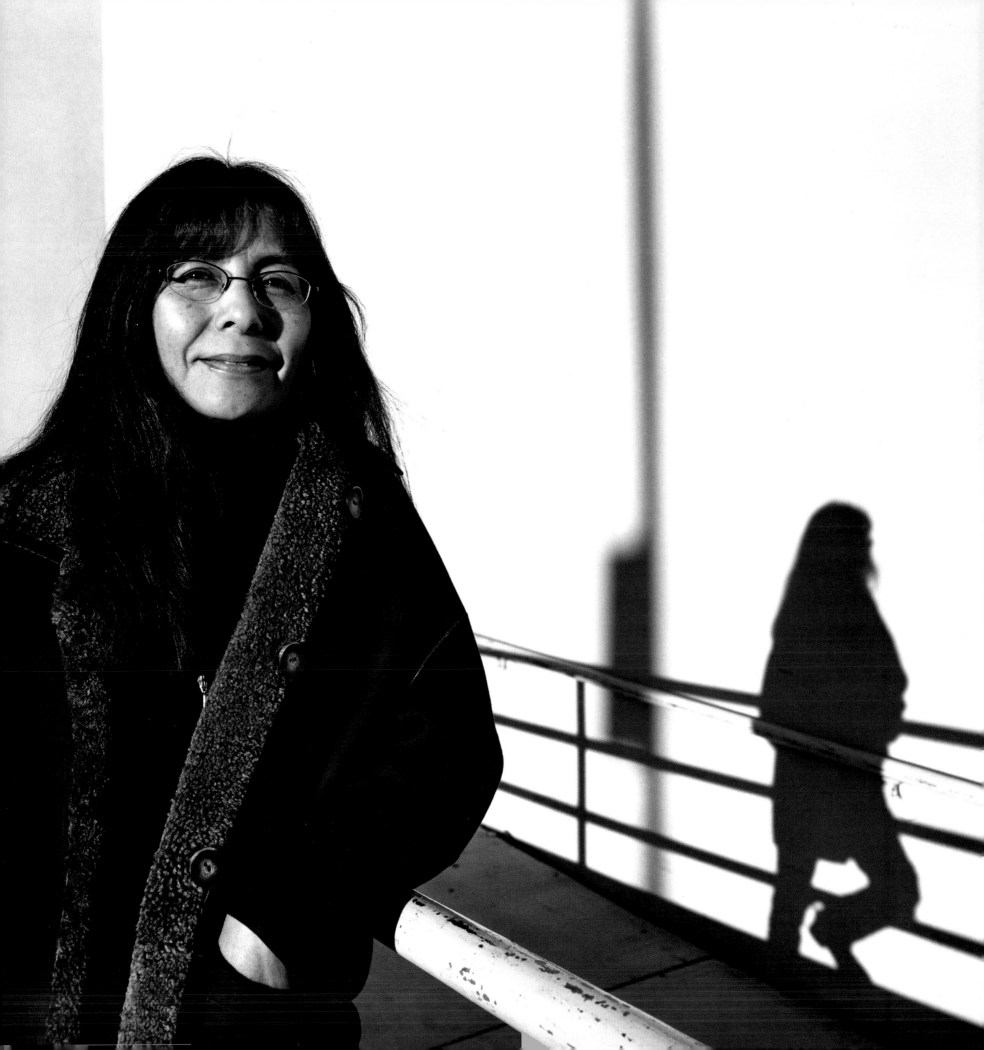

W_e

have to look inside of ourselves to see what

the cultural memory is."

BEVERLY SINGER, SANTA CLARA PUEBLO/NAVAJO

Filmmaker, author, professor, University of New Mexico

Albuquerque, New Mexico

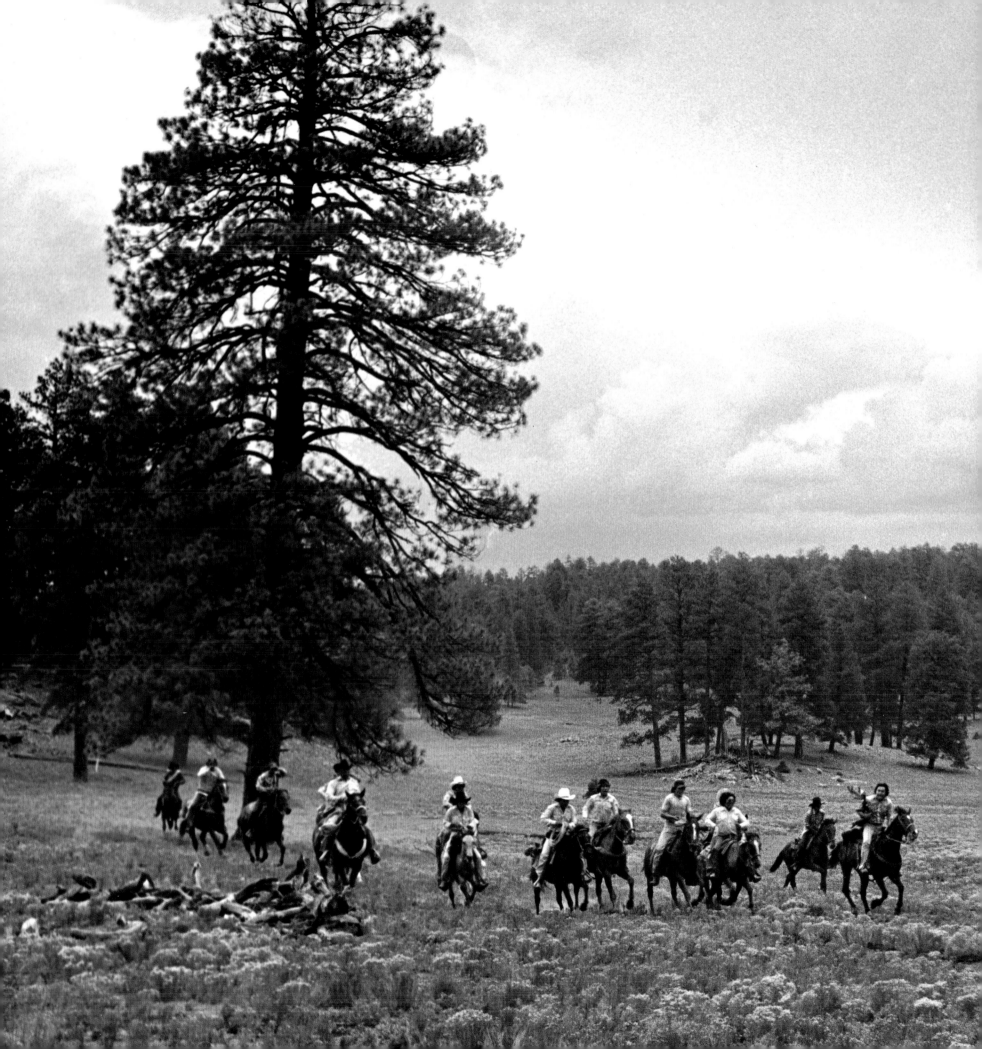

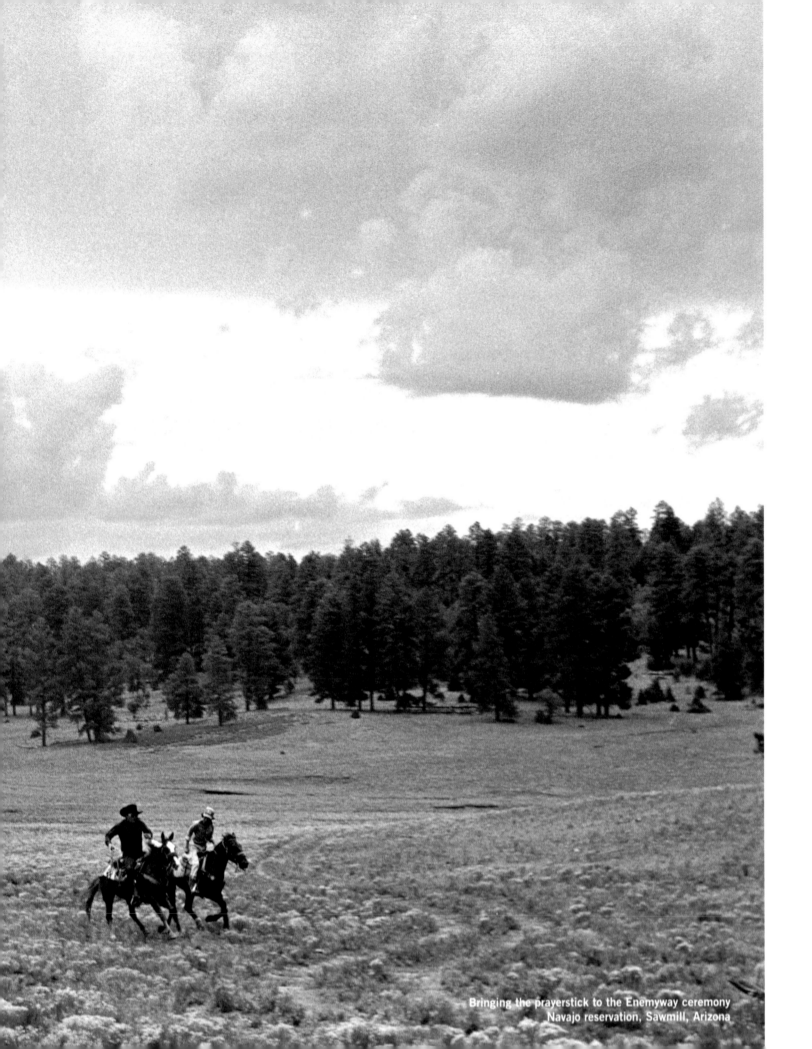

Bringing the prayerstick to the Enemyway ceremony
Navajo reservation, Sawmill, Arizona

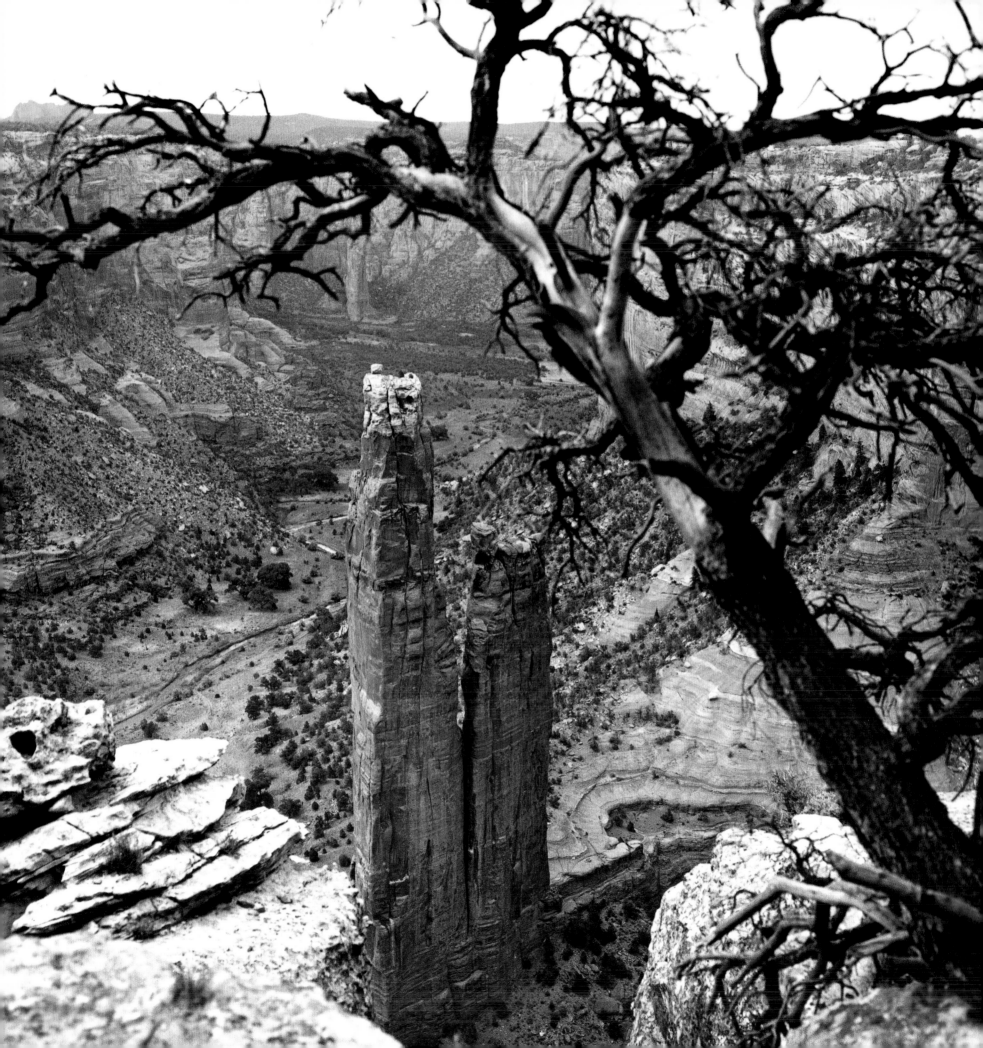

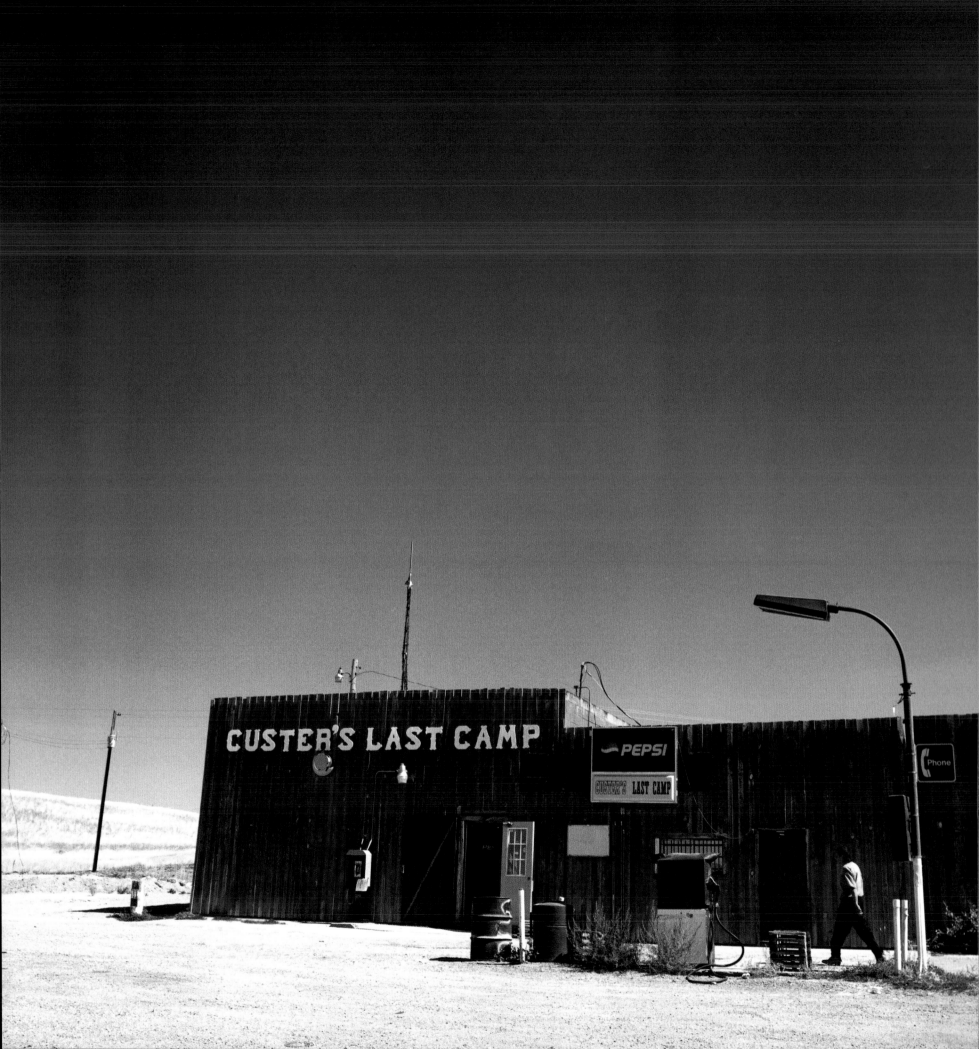

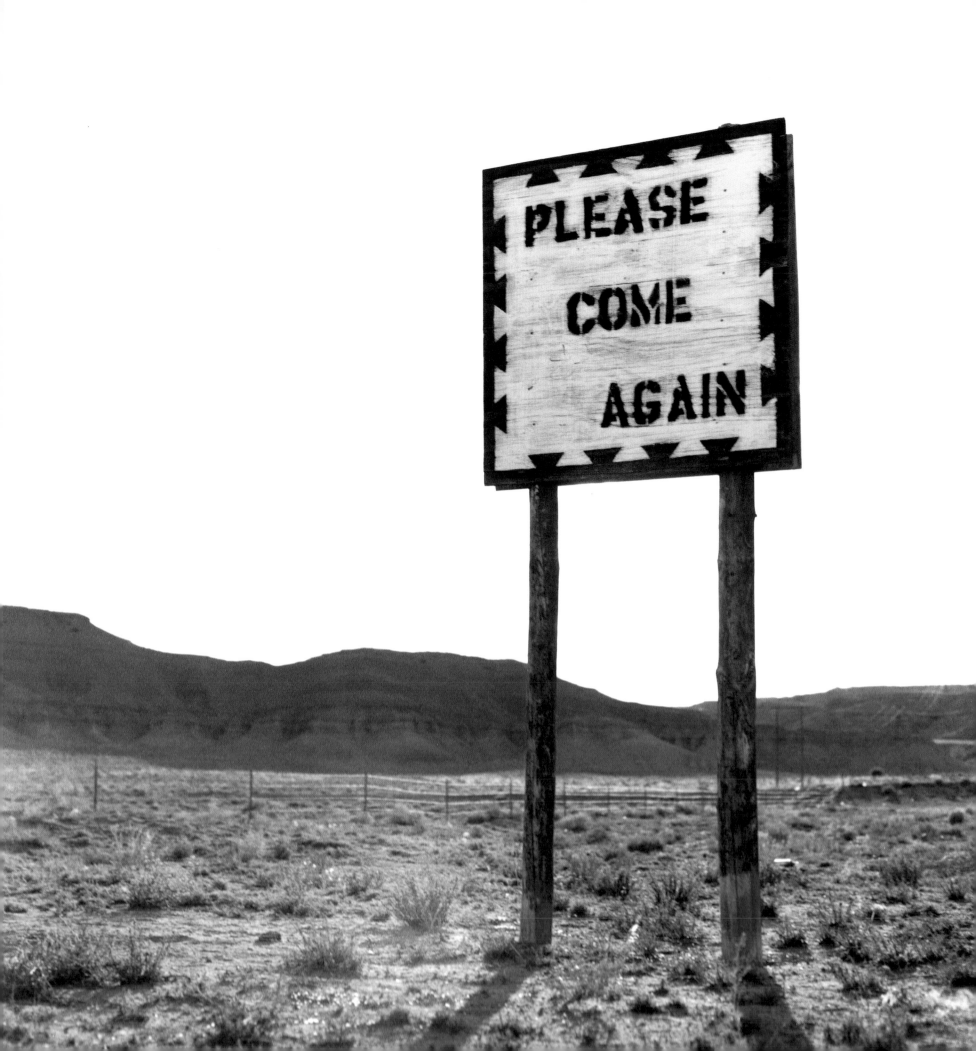

Copyright © 2001 by Gwendolen Cates

All rights reserved. No part of this book may be reproduced in
any form or by any electronic or mechanical means, including information storage and retrieval systems,
without permission in writing from the publisher, except by a reviewer,
who may quote brief passages in a review. Any members of educational institutions wishing to
photocopy part or all of the work for classroom use, or publishers who would like
to obtain permission to include the work in an anthology, should send their inquiries to
Grove/Atlantic, Inc., 841 Broadway, New York, NY 10003.

Published simultaneously in Canada
Printed in China

FIRST EDITION

Library of Congress Cataloging-in-Publication Data

Cates, Gwendolen.
 Indian country / Gwendolen Cates.
 p. cm.
 ISBN 0-8021-1696-5
 1. Indians of North America--Pictorial works. I. Title.
 E77.5 .C37 2001
 973.04'97'0022--dc21

 2001040110

Book Design by Kristi Norgaard

Grove Press
841 Broadway
New York, NY 10003

01 02 03 04 10 9 8 7 6 5 4 3 2 1

A portion of the proceeds from this book will be donated to the American Indian College Fund.

I am especially grateful to the following people. To my father, David Cates, who introduced me to photography and to Indian Country. To Terry McDonell, who inspired me to do this book and helped me so much. To my friends Bently Spang and Marcus Amerman, for their constant and invaluable support, encouragement, and counsel.

Thank you to Morgan Entrekin and everyone at Grove Press, especially Amy Hundley and Charles Rue Woods. Thanks also to Andrew Miller. My gratitude goes to Kristi Norgaard for designing these pages with such care and understanding. My thanks to John Trudell, Sherman Alexie, and Rick West for their contributions to this book. I am indebted to Sid Evans, Michael Lawton, and M. C. Marden who, along with Terry McDonell, worked with me on the *Men's Journal* feature that launched this project. I would also like to thank Jeffrey Kane at Black and White Edge and Ray Higgs at Color Edge.

Special thanks to Pat Benabe, Roger Buffalohead, Caroline Brown, Norman Patrick Brown, Nina Burleigh, Blue Clark, Raymond Fogelson, Suzan Shown Harjo, Darwin Hill, Sidney Hill, Richard Hill, Sr., LuAnn Jamieson, Birgil Kills Straight, Miriam White Lorentzen, John MacAloon, William Nabers, Leonard Peltier, Gordon Regguinti, Scott Russell, Beverly Singer, Zane and Sandy Spang, and John Trudell.

I am also grateful to the family of Laugher's Grandson for all they have shared with me over the years.

I would like to thank all the Native people who generously agreed to participate in this book, who gave me their time, their stories, and their trust.

I drove along endless roads under huge skies. I drove past Black Mesa, past Red Cloud Indian School on Pine Ridge, beside the mainline of the Santa Fe Railroad on my way to Peach Springs. I landed in a bush plane on a dirt landing strip beside the Yukon. I went in Merkie's boat to the mouth of the Klamath River. The Quinault women invited me to come along in the canoe while they practiced racing upstream at dusk. A young eagle landed by the side of the road in Minnesota.

Fire lit the faces of the dancers as they sang during the Buffalo Dance in Oklahoma. The Lakota buffalo distanced themselves from the sound of my camera, which sounded like a gentle gun to them. At night the dark was so black, and the air was so clear. Golden light over the canyons, pale light over the badlands, mist over the rivers. Dust at the rodeo, on the dirt roads, mud when it rains. The land is radiant.

Sometimes I had to eat more than one dinner because it's impolite to refuse an invitation. Other times I grabbed Fritos at a lone mini-mart in the middle of nowhere. I ate moose in Alaska, salmon cooked by the fire on sticks in northern California, mutton and fry bread at Navajo, and dried deer meat in Montana. Whenever Scott takes down a deer, he says a prayer and thanks the animal for providing itself for food. Lamar made buffalo stew and camp coffee to warm the riders honoring their ancestors who traveled south seeking safety at Wounded Knee, only to meet with guns and fear.

I learned the words for salt, pepper, and milk in Mikmaq, and how to say Seminole in Miccosukee. Crazy Horse is really Wild or Playful Horse. *Hozho* is the Navajo way to explain beauty and harmony and so much more. Aaron's Indian name, Egizaa, means wood tick. His grandfather Jim said it describes how he hugs. The word for camera in Ojibwe is *mazinaakizon*, box that makes pictures, and *mii gwech* means thank you. Thank you is important everywhere. Good-bye is too final; there are better words.

Ted and Daniel took the boat out on the Yukon so I could get pictures of guys fishing even though they were busy getting ready for the potlatch. Donald and Mary stopped